The Molly
Fire

W9-CZW-444

The Molly Fire

A MEMOIR

MICHAEL MITCHELL

ECW PRESS

Copyright © Michael Mitchell, 2004

Published by ECW PRESS
2120 Queen Street East, Suite 200, Toronto, Ontario, Canada M4E 1E2

All rights reserved. No part of this publication may be reproduced, stored in
a retrieval system, or transmitted in any form by any process — electronic,
mechanical, photocopying, recording, or otherwise — without the prior writ-
ten permission of the copyright owners and ECW PRESS.

NATIONAL LIBRARY OF CANADA CATALOGUING IN PUBLICATION DATA

Mitchell, Michael, 1943–
The Molly fire / Michael Mitchell.

ISBN 1-55022-676-2

1. Mitchell, Molly G. 2. Mitchell, Michael, 1943– —Family.
3. Painters—Canada—Biography. I. Title.

ND249.M536M58 2004 759.11 C2004-902606-2

Editor for the press: Michael Holmes
Cover, Text Design and Typesetting: Tania Craan
Author Photo: Ken Straiton
Production: Mary Bowness
Printing: Gauvin Press

This book is set in Janson and AT Sackers

The publication of *The Molly Fire* has been generously supported by the
Canada Council, the Ontario Arts Council, and the Government of Canada
through the Book Publishing Industry Development Program. **Canadä**

DISTRIBUTION
CANADA: Jaguar Book Group, 100 Armstrong Ave., Georgetown, ON L7G 5S4

PRINTED AND BOUND IN CANADA

ECW PRESS
ecwpress.com

IN MEMORY OF

Molly LeGeyt Greene Mitchell
1919—2000

J A M
1918—1999

FOR

Jake & Ben Mitchell

I have tried to see this many times. My cousin comes to the door of the darkened house, peers in the window, rings the bell. Waits. No reply. Tries again. Nothing. Takes out the key my mother has given him and opens the door calling her name. Silence. He goes from room to room, turning on lights, calling out for his artist aunt, my mother. The last room is the bath. Her glasses are beside the sink; her robe is folded on the toilet top, the tub is full. She looks so small and pale curled up under water, trapped in ice, locked up under glass. She was 81.

We each face death in our own way. I needed quiet, time to take it in, time to look around. I took the call in Toronto, sat for an hour and then slept. In the morning I booked a flight — a commitment that initiated a series of steps in a journey I had made many times before. Cab to the airport, check-in lineup, coffee in the lounge, boarding — alpha four, delta one — a tightened buckle and the erect seat-back. Then hours of dull limbo — white noise, grey air — followed by the steep and spectacular descent through cuts in the Coastal Range. The world returns in Vancouver as a kitchen clatter of sounds and smells. The body comes back to life.

Next a bus and the long flatland ride to the ferry at the edge of a muddy delta. Back to a fluid medium and the great vortices of Active Pass.

There is a resigned stillness to the little James Bay house. The door to the bath — the vanishing zone — is slightly ajar. I won't look in for a day.

Death is white. I'm sure I can see molecules dancing in the rooms of sad possessions. The tables are dusty, the silver is tarnished, but her place is set. While the

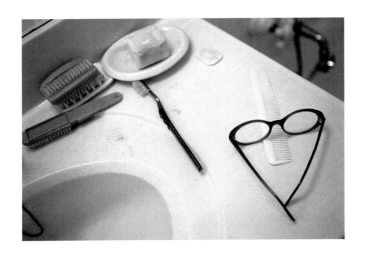

PLATE I

so small and pale

house is merely orderly: her studio is entropic. There is a most terrible silence behind that door.

For a couple of days I am alone. After the first day, I begin to see photographs. I imagine what she saw out the window, glances from the kitchen sink, silhouettes and shadows on the sheers, light lozenges on the floor. I find myself following in her footsteps. Where she would have drawn, I take simple pictures. It's a comfort. It's clarifying. I touch nothing.

Bad weather breaks on the third day — an angry, blaming, recriminating black whirlwind of emotion-driven efficiency. Within an hour my mother's closet is empty, her clothes bagged and at the curb. Bottles and jars are inverted over the sink, dishes clatter into boxes. My father's tools, untouched since his death nine months earlier, are packed and whisked away. Cupboards are purged, drawers are pulled, a life's underwear is exposed by my sister's cyclonic rage at death. By day's end the little world that I have spent three days learning to accommodate has vanished. Molly's life has become a mess to be tidied up.

My eldest son rescues me. He calls from New York. "Do you need company? I think I should come. I'm not leaving you and your sister alone." He arrives and spends two days quietly working and absorbing a litany of complaints against his father. In the evenings he takes me out to Molly haunts and buys the drinks.

A few days of this and then my sister, her husband, and my son, begin to leave — catching planes or driving cars back to their lives. I am left alone with a deadline. The house will be sold and must be emptied.

I pack carefully, make reasoned choices, giving each selection a bubble-wrap surround. My mother's friends and neighbours come by to reclaim loaned books, pick over paintings or take a plant.

Last day. I walk through empty rooms, satisfied, and then retreat to the little studio building in the garden. I despair as I realize that hundreds of pictures remain after all the picking and packing. I sort and pack new piles. More boxes are filled but many more paintings remain. Soon I am stuffing her drawings in with my socks and lining my bags with watercolours. I find still more pictures. My ticket is for the last flight off-island. Are there enough eyes in all the world to look at so many images? Finally I build a fire.

The piles surround me — sheaves and sliding stacks — the legacy of a life of looking. Many of these pictures are unfinished. Some are failures. Still I feel as if I am torching the traces of her hand and the eyes and mind that guided it. Her ideas and observations become heat and light before curling into black ash on the cooling stone. The pictures burn before the mats, leaving receding windows into the flames. I close the door and leave.

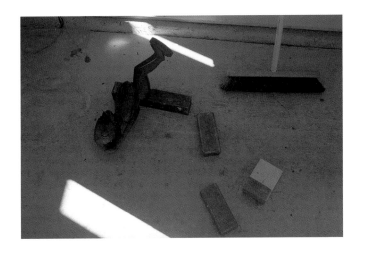

PLATE 2

a most terrible silence

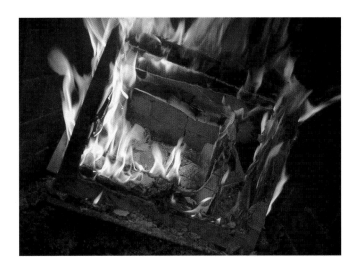

PLATE 3

the traces of her hand

THE ROYAL DRAWING SOCIETY

18 Queen Anne's Gate, Westminster S.W.

Patron

His Most Gracious Majesty The King

President

H.R.H. The Princess Louise Duchess of Argyll

This Full School Certificate is awarded to

Molly Greene

1935

For obtaining Honours in all six Divisions

They thought it strange. So unlike Molly, said the neighbours. She went into her backyard that early spring morning and sat in the sun leaning back, looking, quietly smiling for the entire day. She returned the following morning to the same chair, the same warmth, same sun moving through the small garden, warming the walls of her studio and caressing her face. She was sliding down in the chair, slipping into her girlhood, sunbathing on the rocks of Georgian Bay, lying on the grass of her parents' garden on Hamilton Mountain, a small animal just out of the sea warming on the mud of a million-year-old shore. This was her last spring, her last day, her last few

hours. Down the muddy slope as the day cooled, back into the water, the white enamel of the tub, the amazing clarity of water, and air and mind. So many circles — the retreat to beginnings and the final vortex of the drain. April 9, 2000.

For several months after her death I periodically shift the blue suitcase that contains her sketchbooks. She drew constantly as a child, attended the Ontario College of Art in the late thirties, studying with Casson, Jackson and Carmichael, and somehow, despite marriage and children, managed to paint every week of her life. The suitcase is extremely heavy and inevitably ends up in an awkward place demanding to be moved again. One drained November morning I finally pull it into the centre of the room and release the catch. Dozens of Grumbacher and Strathmore sketchbooks spill onto the floor. I begin to randomly leaf through the wire-bound books, reading her colour notes and examining her drawings. The dozens of books contain more than a thousand sketches and watercolours from the last two decades. These are not intellectual pictures but engagements with the world and the details of life.

I love being a photographer because it gives me licence to be curious about everything — to be nosey. I begin to realize that it was my mother who taught me the rewards of staring. She was completely eclectic:

PLATE 4

her last spring, her last day, her last few hours

drawings of animals, trees, buildings, boats, people, landscapes — all the small details. She made pictures of broken appliances, of dirty dishes, of laundry and garbage. Her best large paintings were lyrical abstractions demonstrating her formidable mastery of the quite unforgiving watercolour medium. While I love looking at these big paintings, they tell me little about her life. But I do know the woman behind the sketches. These are all lived moments. She apprehended the world by drawing it. This was her identity, her diary, her connection to the world.

Henri Masson	Conversation	$25.00
David Milne	Red Church No. 3	100.00
Molly G. Mitchell	Ship Building, East Coast	N.F.S.
Jack Nichols	Sick Boy with Glass	N.F.S.
Goodridge Roberts	Dark Landscape	30.00

— Molly's Diary, 1942, page 4 of an exhibition price list

I had lost my mother once before. It had taken place on that bedrock geography of our lives, the northeastern shore of Georgian Bay — the bedrock because it was the constant. Before I was five I'd lived on Hamilton Mountain, in Halifax, the Gaspé, Newfoundland, Port Nelson, Toronto and Cherry Beach on Vancouver Island. This is what happens when your mother marries a ship captain and

navigator. You move and you move, but you're always by the water.

My connection to the sweet waters of the Bay, renewed every year since, began in the summer of 1944 when I was nine months old. But the time I lost my mother came some half dozen years later. We, my mother and her sisters, my uncles and cousins, as well as my sister, were on the family island some five miles off-shore. It was a perfect August day, heat tempered by the busy westerlies, blue water, blue skies and clouds reaching for the east like little racing Mackinaws. This was the day that my father decided to teach my mother how to sail.

We were gathered on the porch of that dark, sagging barn of a turn-of-the-century cottage. My father launched the dinghy, stepped the mast, tied on the gaff and ran up the mainsail. He set the jib, dropped the centreboard and worked the bronze pintles into the gudgeons. My mother was called down to the dock.

From the porch I can see their heads together. My father's voice is too low to hear but I know he's talking by the periodic sharp cough and clearing of his throat. He steadies the boat for her to step in. When she departs the dock alone, my sister and I take a more critical interest in the proceedings. We leave the shadow of the porch for the sparkling light of the high pink rocks that hump up around our tidy harbour.

She's abandoning us. The wind is brisk and the big

dinghy heels. It's already got a bone in its teeth. The old man coughs and cups his hands around his mouth. "Remember, Molly," he shouts, "whatever you do, don't gybe." She turns back to look at him and I despair when I see her expression. I already knew well why her schoolmates had called her "Fog." Over goes the rudder, the boat and boom wheel in the wind as she clears the point. With a slow sweep she turtles and disappears. There is nothing left but a large cedar-strip shark with a crimson dorsal standing proud.

We are frantic, my sister and I. She explodes upwards and screams, "Mommy's sinking." I too take up the chorus. "Mommy's sinking!" we scream repeatedly. Our plaint bounces off the Rogers' island next door — "Mommy's sinking! Mommy's sinking!" Old Ted Rogers' grey and blue yacht *Arbie* has just pulled in to their island: the crew and passengers, motionless, watch us. It was the first time that I had truly faced the void. My sister and I are, in an instant, orphans.

Of course, being only four and seven and grief-stricken, we had forgotten that Molly was an excellent swimmer. Her crawl was elegant, fast, and barely rippled the water. She did what, when I later became a committed kayaker, I came to know as a wet exit. To our astonishment, she came back from the dead and swam gracefully to shore leaving the dinghy pivoting with its masthead jammed on the rocky bottom. Although she climbed the dock ladder quickly and

gracefully, years later she confessed to me that it was one of the most supremely embarrassing moments of her life. Not the gybing and turtling, but her children hysterically broadcasting to the entire archipelago, that their mother was going down. We made her feel like a rusty scow, slowly wheezing over on its broken back, before shuttering down to the deep, leaving a trail of fetid bubbles and an oil slick. She was, after all, one of the Greene sisters.

 A silver pickup swings off Beach Drive into Oak Bay Marina. It's a perfect summer day — a cloudless sky and the slightest hint of a breeze that barely scuffs the surface of the sea. The small truck backs down the boat launch ramp and stops a few feet from the lip of water and land. A tall, bearded man wearing a Greek sailor's cap descends from the cab and works his way along each side of the box, releasing lines. He will soon be 70. He drags a small white wherry from the box and lets it slowly slide onto the surface of the sea. A pair of brightwork oars lie across the thwarts. This tiny, 10-foot boat is John Mitchell's last command.

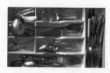 I'm alone in her house some days after her death, packing the books that line the built-in shelving framing the fireplace. News of Molly's

passing has left the house like a small stream dividing into little rivulets making their way out into the city and beyond. Now the phone has begun to ring. I'm surprised, even slightly shocked, at how many of the calls, begun with somewhat perfunctory condolences, immediately segue into a request for something — an article of furniture, her dishes, her paints or certain books. The most anxious and assertive calls are from elderly women who have lent or exchanged paperbacks with her and are now convinced that Molly's children are going to craftily spirit them off to — what, in Western-Canadian eyes, is the greedy siphon of resources, including talent, money, and used books — Toronto.

I know something of her habits, and quickly realize that the most sought-after loaners are books that she has never opened. I suppose that we are all detainees of our own needs and values, but the insistent importance ascribed to some of this stuff amazes me. They are mostly cheesy historical or romance novels and not the kind of thing I'd ever seen her read. But then, of course, one never knows. And after death we often discover that we didn't really know the deceased.

A few years earlier I'd done this same book-packing job at the house of my wife's mother. On the west side of Rosedale her big downtown Toronto house was filled with art and bookcases, even a wheezy harmonium. In addition to a large body of literature, there

were hundreds of volumes of philosophy, Sufi texts as well as the complete Gurdjieff and Ouspensky. It was an impressive library accumulated during a life-long devotion to mystical and spiritual pursuits. As I pulled these volumes down I discovered that there was a second layer of books behind this spiritual fascia. There were not dozens, but literally hundreds of Harlequin romance novels, many of them quite steamy. As this sophisticated European woman was slowly dying from cancer, a secret she kept from everyone for two decades, she had sought solace, not from the great texts, but from escapist pulp. When her friends and colleagues came to pick through her library, none of them would even look at this stuff.

I dutifully hauled huge orange bags of these romances off to various used book dealers. After all, a book is a book. I instinctively respect things between covers. But absolutely no store would take them, not even for free. I got quite desperate after being turned down again and again. My last stop was to see a buyer of old magazines and other quick reads who had a shop out east on Queen. He was a skinny guy with an Elvis hairdo and a permanent butt on his lip. Even he airily waved them off and told me to leave them all on the curb outside for the garbage truck. As the bags were now giving way, I began to stack the books neatly along the curb, consoling myself by building a small cityscape of romantic skyscrapers as I went along. A

big woman guarding several shopping bags at a nearby bus stop watched me with interest. I finally magnanimously offered her the pick of my literary skyline. She laconically replied, "No way — they're not books."

The surprise at my mother's was to find several books inscribed with an illegible male name. Each ended with the salutation, "My favourite song is Molly O." These books were buried down in a corner with various volumes she'd won for performances at Strathallan, Compton and the Ontario College of Art. It was a safe bet my father would never look there. The intention of these dedications was clearly romantic.

> "She's plain Molly O, simple and sweet,
> my heart is gone, I lay me at her feet:
> So light her tread, so fond her gaze,
> Who would not love my Molly dear?"

Is that the Molly O!, William Scanlan's bright little waltz of 1942? If it is then I've found something interesting, for she'd already married my father. I would be born in a matter of months. A letter fell out of another book. Another sly reference to Molly O. This had always been my favourite corner of the bookcases in each house they owned. I realized now that her little cache was always to the right of the fireplace — every house had had an open fireplace flanked by book shelves — and her secret garden was always down low

just above the baseboards. As a public school boy I'd often returned to this shelf for her *Lysistrata* with Beardsley's naughty illustrations. How I loved that slim volume of Aristophanes with all those eager little breasts, delicious bellies and salacious bums.

> Molly sighed, then she cried, "Don't you think you'd
> rather stay?"
> Michael winked, said, "I think this will be a lovely day."
> They sat for hours — on the same old stool,
> Spooning like a teacher never taught at school. . .

Now if it's that Molly, O! then the song is Irving Berlin's from 1911 and things are perhaps less interesting, although I could pretend that it puts me in the picture.

> Mike O'Toole, on a stool, sat one Sunday morning fair,
> Molly O, pure as snow, happened to be passing there,
> She smiled and said, "I see you're all alone."
> Listen to some blarney Michael brought from home. . .

Now I'll never know Molly or Molly O. Stripping the flesh and guts of a house, packing them within the bones of the place, consigning to family, neighbours, movers, shippers and one's own baggage, makes things go astray. They leak out into the world and perish without provenance and I now have memories with no

object. Those dedicated books and papers are among the lost, for the cartons and crates now unpacked have no more secrets. Their contents have shed their old dust and taken up residence back here in central Canada to gather dust anew.

O the voyages of objects! I live in Toronto's downtown in what was once a farm house. The ceilings are high, but the clock from my parents' house is almost stooped beneath them. Made for a Mitchell in 1742, it survived almost two centuries moving about Northern England with my ancestors, then sailed around the Cape, crossed the Indian Ocean — my grandfather was an engineer in Burma — and the Pacific to Vancouver Island to chime out the quarter hours of my grandparents' lives for many decades. With their deaths that great column of Oak set off again, crossing to the mainland and riding the train east to Ontario. It timed my teenage years, recording every quarter hour in which homework was not started, and every chore not completed. Innocent of location and, even in a strange sense, time itself, it continued to announce the cycle of the tides thousands of miles away from where it stood and to wheel up lovely little paintings of long gone phases of the moon.

My father was the same age I am now when he felt the siren-call of his birthplace and decided to go back. The big clock, bundled in blankets, boarded a

huge van and struck out again for the coast. Back home again in Victoria it led a chorus of mere mantle clocks in a timing of the days, satisfying a naval navigator's compulsive tracking of the hours, and driving poor Molly from the house. Those clocks were so numerous, old and inaccurate that they truly took their time. The changing of the hour took close to ten minutes as various big hands reached the top, clanging, ringing, chiming, buzzing, thumping and cuckooing their individual versions of truth. Additionally, a clockwork recording barograph ground away in a glass case, its small pen scratching out every deviation of air pressure. There was no peace. What seemed to be a comfort to an old man, a kind of dominion over time and weather by measurement, made Molly and me frantic. I couldn't wait to escape those bookkeepers of mortality.

Molly's house is now almost empty. I kneel next to an old German clockmaker on the floor of the living room. I've hired him to disassemble and safely pack the big clock — the movers won't touch it. We remove the gold finials atop the case, clean the brass works, wrap the huge iron counterweights and wind many feet of chain. This ten-foot-high monstrosity is a north of England country clock, oak instead of mahogany, spherical bells instead of chimes; its chief claim to distinction at this point is its age. Now I'm its custodian and I'm about to send it, once again, across

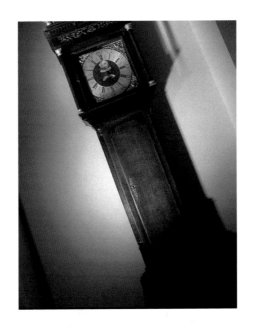

PLATE 5

the great column of oak, 1742

the country to Ontario. I watch men load it on a truck. It's cleaned, adjusted and ready to go when it arrives but I'll never wind it in my lifetime — for me every tick is painful. Yet I take comfort knowing that one of my two sons will one day have it. Jake, the elder, is a gentle, patient man. Maybe he'll pull those weights to the very top of the case when he's packed my house and let that old man run.

 Vancouver Island: 1983. It has stopped raining and the cloud cover has begun to lift. Jake Mitchell and I leave Molly's car and stumble over driftwood and beached logs toward the water's edge. He has just turned six — we're pals. We work our way along the cobble beach, poking kelp bulbs and collecting the odd shell. I demonstrate stone skipping, successfully getting several triples and then an impressive "fiver," but he's still too young to master it. I remain the Dad who knows stuff. The sun briefly burns a hole in the overcast and then retreats leaving an afternoon of humid heat. Waves of tiny breakers arrive exhausted at the shore then limply curl, dump and suck on small stones, rattling them back into the sea. We've ambled far enough to make the car seem very small, high and lonely in the large empty parking lot where several pages of newsprint languidly roll like sunning cats. We soon clear a small point and lose sight of it.

It's a half-mile walk along a curved, sweeping beach to the next headland — we decide to make for it before retreating. Jake runs ahead, hopping over boulders and hurling sticks into the sea. Suddenly he stops a hundred yards ahead of me and drops to his haunches. His head is tilted downwards. He's very still. I double my pace to catch up and find him staring at the body of a gull.

"Why isn't it flying?" he asks.

"Because it's dead."

"Dead?"

"Yeah, it's dead."

"But it's not moving!" my son says.

"The life has gone out of it."

He looks at me intensely then turns to the carcass at his feet. A small furrow appears above the bridge of his nose.

"Will it ever fly again?"

"No."

"Will it ever move?"

"No."

"Can it see?"

"No, Jake, it's dead. Its life is over."

He turns to the bird again. A series of emotions flutter across his young, androgynous face — puzzlement, anxiety, anger, disbelief — as he struggles to absorb the idea of death.

"Never, never, again?"

There is now pain all over his luminous face.

"Never, never, again, Jake. It's all finished. Over."

He gets up slowly and begins to walk back toward the car. A little joy seems to have gone out of his step.

"I'm not wearing no dead guy's watch!" My younger son, Ben, glares at me from the top of the stair. I stand on the landing, arm extended, momentarily mute, my father's watch in my hand. I'd bought it for him — the legacy of having earlier given the women's version to my mother. My father had fussed about that gift until I relented and purchased one for him. Both are mates for my own. My son, Ben, turns away. I've offered something before he's ready for it. Jake approaches me a few hours later and tells me he would like to have the watch. I realize that he's overheard the earlier conversation. He is trying to make up for his much younger brother's clumsiness. He wants me to feel better.

My father pulls on the oars as his little craft crosses the ghost course of the Nootka canoe Tilikum before rounding Turkey Head. Mary Tod Island, a low grey rocky hump, falls off aft. He keeps rowing.

I start awake. The hands of my alarm glow green in the dark bedroom.

3:16 a.m.; my parents' house is silent. I'm 13 and have just dreamt about my hamsters — they've staged a breakout and are running amok in the basement, mounting each other and crapping with abandon. Then I realize that I've neglected to feed them for more than a day. Tormented by guilt I get out of bed, slip my windbreaker over my flannel pyjamas and begin to advance as soundlessly as possible down the dark stairs. The old house always protests at every step but I make it down. No one stirs.

I swing open the basement door to a cell of cool, damp air and a faint whiff of hamster shit. Night basements always spook me and I can't find the switch. I retreat into the kitchen where I know I'll find a flashlight in a drawer with the knives. Again I stand on the landing facing the abyss. My weak yellowed beam sags in the blackness ahead. The stairs are steep and without risers. Fearfully I force myself to descend. The concrete floor at the bottom is as rough and cold as a glacier.

This is where my father keeps his boots, tools and guns. I shuffle cautiously into a corner behind the furnace. My two dozen hamsters are hunkered down in their cages — little red malevolent eyes in the darkness. I begin to organize their food and water, more than a half-hour's work. The hamsters eat with ingratitude. One takes a desultory spin in the wheel.

Then I hear some dull thuds in the house high

above followed by rhythmic steps on the second floor stair. My father's unmistakable stride across the ground floor ends with the drag of the basement door and a wedge of light. I douse the flashlight and crouch behind the furnace. He clumps down in the darkness and makes his way to the front of the furnace. The cast-iron door croaks open and bangs against the huge cylindrical body like a badly tuned bell. The room is licked with a deep orange light that outlines the huge furnace hunkered under the joists, spreading its ducts off into the gloom. The shovel crunches into the coal bin and scrapes across the floor. Coal whumps into the firebox and flashes deep red. More shovelfuls. The furnace stirs to life, waving its arms malevolently as the flames dance. I hold my breath until the shovel clatters to the floor and the iron door crashes shut. The big Hydra is gone. Footsteps fall away into the upper part of the house. I am alone at the bottom of the world.

 A pair of sunbathers on Oak Bay Beach turn over and glance out toward tiny Harris Island. A small white rowboat is heading south a hundred yards offshore. The oarsman has a white beard.

 Their cars are rolling up my little street of red brick Victorian row houses.

I see them now from my upper storey, parking under the big winter-bare trees that keep this neighbourhood of foolish bargeboards framing little peaks and towers. Molly is in from Vancouver Island and staying in my house, hence the arrival of her brother and sisters to greet and gossip over dinner. The long table is set; flowers sweeten the alcove; there's a clatter in the kitchen. We're ready.

The bell rings and in they come, all together, this gaggle of shuffling siblings, now scattered mostly through their 70s. Looking down the crowded hall I see an aunt's haloed head, some furs, some pearls and my uncle's shiny skull. They haven't been together in one place for many years. Everyone wears glasses.

They come to the long table in the middle of the house and, with apparently little thought, arrange themselves in a row along one side. I soon realize that they are seated in their birth order, with Molly in the middle: seat number three. The four siblings drink sherry and soon begin to work their way through wine. Stories about their children are exchanged, next news of friends, and then they begin to reminisce. Soon the oldest sister is admonishing her brother; he in turn gives my mother a poke in the ribs, and she in turn victimizes the baby, now 65. In a minute they are all arguing, shoving and pushing. Decades are dissolving, I'm kneeling at a door. My mother's childhood

flickers briefly through the keyhole and then pulls back to the bright light of the noisy present.

CERTIFICATE OF BIRTH Light clangs down on the delivery table where two doctors plant their feet against its base and pull hard on high forceps. My first son comes out so slowly I fear they will snap his neck. While the doctors attend to his mother, exhausted from a 36-hour labour, a nurse hands me my boy bundled in a pink blanket. Like me, he stands at the head of a new generation — I'm the oldest of all the cousins and the first to become a parent — but he's not going to lead off wrapped in pink. I cradle my 10-pound son in one arm while rummaging through a wall unit in the delivery room until I find a blanket that's blue.

From the very first day, small, sad Jake would have nightmares — waking up screaming every twenty minutes for two years. The first day or two I would look at him and wonder what his dreams could be. What did he know after all? I finally concluded that his nightmares could only be a reliving of his nearly catastrophic entry into the world.

A week later we carried him down to main entrance of the Wellesley Hospital. I fetched my van in a heavy spring downpour — it was early April — and began to drive very gingerly eastwards through the city toward

our little cottage on the Scarborough Bluffs. The rain-wet streets had never glistened so vividly, the soaked trunks of trees had never been so black. Every car on the road was menacing. I felt as if I had stolen something.

The first night at home nobody slept. The small, winterized cottage was barely 30 feet from the lip of the high bluff. Two hundred and fifty below Lake Ontario gnawed at soft clay buttresses while spring runoff sheeted across the narrow lawn and undermined the lip. All night I could hear large chunks separate and thud down the soggy cliff. Several times small trees went over as I stood at the window listening to my new son howl over his mother's murmurs in the half-sleep dark.

Those early weeks and months were so completely exhausting, and so amazingly intense. After all my struggles with my father I couldn't believe that I'd become one myself.

October 1943. Molly has gone to stay with her mother, Elizabeth, at The Willows, a big stucco house with fan windows that her parents built across the highway from the old mill in Ancaster. Toward the end of the month Elizabeth Chapin took to driving her very pregnant second daughter, Molly, over cart tracks and country roads on the theory that this was the best way to induce an overdue delivery. Finally they made a run

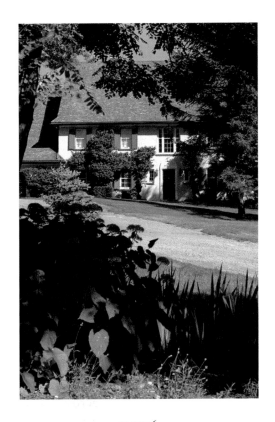

PLATE 6

the Willows, Ancaster

to Hamilton General a couple of days into November under leaden skies. John Mitchell was at sea, somewhere mid-Atlantic, under the same dark sky. When he finally saw me, his first child, I was already walking.

After a few weeks Molly gathered up her child and caught the Halifax train, dismounting in the Gaspé where she and her sailor husband were renting a small farm for part of the war. She was largely alone in a tiny farmhouse with no running water and a wood stove. She had never cooked in her life — Dot and Daisy, who worked for her mother, had done that. She hadn't even planned on being a mother — it was her husband's idea. He was convinced that he would sink, flailing in the icy North Atlantic, as had so many of his friends. He was only 24. He wanted to leave evidence that he had existed.

As she struggled to wash diapers in a galvanized pail steaming on the wood stove, heat milk in a chipped enamel pan and bake bread in an outdoor oven during the short December days, I lay in a room under the eaves, oblivious, slowly peeling wallpaper off the ceiling sloping over my crib.

Molly, 23 years old, was too tired to paint.

 A small white clinker-built rowboat clears Gonzales Point as a dozen players golf through an early lunch. The day is still fair. The little boat makes for McMicking Point.

1933. A young woman rides an abandoned rail right of way along the top of the Niagara Escarpment — one of those pretty sisters, the Greene girls — then down through the maples and oaks to the cedar bottom where sulphur water comes out of the rocks and the ponies drink. She's leaving The Willows, the big house with the fan windows, the large gardens tumbling down to the brook in front of the house, acres of lawn and flowers — a picture book life before the four children set off on their adult lives and the maids and gardener move on to lives beyond service.

Four decades later she rides an old horse named Lady along the high moraines rising from the north shore of the lowest of the Great Lakes. With her children gone, she has returned to her first loves: painting and riding. She and Lady travel over and around the high gravel hills that mark the terminus of the Carolinian forest. Along the old fore-shore, far below, the odd great elm geysers up in the corner of a fallow field. In winter she stays on the concession roads, bundled in her crimson cutter while Lady steams in her traces.

I enjoy animals, but this horse and I never made peace. Lady disliked men and I, accustomed to riding mules "Western" when I worked for several years in the mountains of Oaxaca and Chiapas, have a difficult time posting "English" on a big hostile mare. When

we'd rejoin the road a mile or so north of the farm, she'd shift from canter to gallop as soon as she saw the outline of the drive-shed down the hill ahead in the distance. Many times she threw me by making a hard, fast left into the lane, occasionally dragging me by one leg, my head up above the gravel and body twisted out to avoid the hooves as she raced malevolently to the barn. Then, I'd make myself take her out once more, wilfully prolonging our argument. And she'd take me down again.

After one of these exchanges, I tumbled bruised and stiff into bed in the old stone house. I was alone and soon fell off into sleep and dreamt.

I lie face down in the gravelled concession line just below the house. I look up road, as the ground begins to thump faintly, and soon see a dark presence rising over the earth-curve of the cresting hill. It's an enormous bull, running head-down toward me, huge muscles knotting and releasing beneath the shimmering blue-black hide. I can see the twin tunnels of the nostrils now, the wet leather of its nose and carbon-glazed hoof. We're both on the same rail, this huge boiler of an animal and I.

I hold my ground. Then the unexpected, though anticipated, happens. The big animal machine swings hard to its left, like the horse, and makes for the barn. As it recedes, a fir tree breaks through the spine, rising rapidly from the hollow between the working

shoulders, sucking life from the host until only a great green tree rises from the dust.

I woke up in a fever. I recognized the bull and realized that I was the tree.

A welded aluminum charter boat planes westbound through Enterprise Channel following a morning of whale-watching on the Strait. It sits high and proud, trailing a geysering, rooster tail aft. A small white rowboat bobs on its wake.

1969: Oaxaca, Mexico. The rains will soon climb over the mountains, bringing an end to our season of archaeological survey work. We have less than six dry weeks to examine another 100 miles of the tropical thorn forest lying between the coastal range and the great blank face of the Pacific. The coast highway has yet to be built here and the resorts are not yet even dreamed of — the scrub forest is as empty as it has been for millennia. I have been working with this group of Americans for a couple of years now — five white Californians, a transplanted Nicaraguan and a troubled Cuban. We travel in two beige Jeeps heavily laden with bags of potsherds and dried food — mostly rice and beans — as well as jerry cans of fuel and fresh water. At night we string hammocks between trees and powder the

ropes with poison to deter bugs, rodents and reptiles. Our biggest fears are the wild boars — vicious, fast and unpredictable — and people, especially the army — all too predictable and violent.

The crew has recently mutinied against our leader's timorous driving — electing me to take the wheel of the lead vehicle. Despite the appalling condition of this dirt cart track, the only passage through the bush and around the lagoons, I have managed to handily double the pace. Until now.

I have been sliding and grinding up this track since five in the morning. It is now nearly noon and I've come to a stop, flummoxed. I can't believe it — here I am in the middle of nowhere, on a trail to nowhere, and there is suddenly a fork in the road. Both routes meander off into soggy-looking ground that promises to bury our Jeeps to the axle. The bush is very dense. I have no idea where either fork goes.

Everyone climbs down from both vehicles to offer opinions. There is no consensus. We're all getting tired of each other and beginning to squabble. Backtracking down the trail on foot to clear my head of engine noise and argument, I soon find a small clearing and stop to light an unfiltered Delicados. I squat on my haunches in the shade of a few scrubby trees. Despite the midday heat, the silence is delicious.

Then I hear voices — *Mixtecos*. I rise to my feet to greet them knowing that their Spanish will be equal

to mine. Two elderly campesinos approach; one leads a heavily laden mule. Trusting that they will be the solution to my dilemma, I greet them and explain. Together, we trudge back to the pair of parked Jeeps. I repeat my question, asking which is the route to the northern part of the state. They debate in Mixtec — I understand nothing. In simple backcountry Spanish they again ask me what I want. I again explain where we wish to go. Both men renew their convoluted debate. One suggests the path to the left: the other seems to favour the right. The sun thunders around us; the old men argue vigorously; my fellow crew members get impatient. The Cuban re-asks the question but the old men ignore her — they don't like her accent. My reframing the question only energizes their debate further. Ten minutes later they finally reach a consensus — *a la izquierda*, to the left.

I thank them, mount the Jeep and grind off on the sinister path. They're correct; the trail is quite passable as the soggy section proves to be short and shallow. Speeding up I shift into second and then third. The cart track straightens out after a couple of hundred feet and then abruptly rejoins the fork to the right that we have just left. After nearly an hour of talk and delay I'm back where I started. I've just learned another lesson about Mexico.

The next few hours are an uneventful blur of scrub, heat, jostling and noise. I drive across a couple of

rivers with water squeezing in under the door seals. At one point the second Jeep slides down a bank and has to be winched back up to the track — normal stuff.

By late afternoon, hungry and tired, we decide to take advantage of relatively level ground to the west and head for the seacoast to overnight. We are only a few miles inland so it takes barely an hour to reach the Pacific. After coaxing the Jeep through the last line of trees behind the dunes we suddenly emerge on the most startling stretch of deserted beach I have ever seen. It extends for miles and miles to the north, finally disappearing in a shimmering haze of distant mountains. However, to the south, it abruptly terminates in a high broken cliff about a mile distant. Water from a large lagoon spills over the beach not far from where we've emerged. Several of us wander over to look and are at work immediately.

This kind of survey work involves hours of walking, head down, scanning the ground for any signs of prehistoric settlement — potsherds, projectile points, obsidian flakes, even small treasures like tiny jade beads brought to the surface by burrowing ants. This location, the juncture of a lagoon and the sea, would have been perfect for pre-classic settlement — the riches of the sea supplemented by hunting in the lagoon and a little primitive farming right where we stand. The evidence of this lies at our feet.

We begin walking a loose grid, filling our bags with

the castoffs of three millennia. It is obvious that a test pit will have to be dropped at this site and a careful catalogue of the centuries made. However, this will take several weeks, an assault on our schedule that, by the terms of our funding, we can scarcely afford. There is a conference after supper. I, as the only single male in the group, will be left behind while the rest of crew continues northward the next day. They will come back for me in a few weeks.

We are out of our hammocks before dawn. Camp coffee is made, some sea turtle eggs are boiled and hard biscuits passed around. Food is divided up — I get a large bag of beans, of rice, two pots, a shovel, artifact bags, a notebook and pencils. They toss me a bundle of stakes, two spools of line and a screen. I have my own level, trowels, lupe and machete. My pack is dropped in the sand and they are off. As the first line of light outlines the mountains to the east, I stand watching two Jeeps disappear into the dark trees. I will be alone for nearly a month.

We have pre-agreed where the pit will be dropped: I stake out a six-foot square, string some lines, and set to work. The stratigraphy is complex and dense with artifacts. The top layer is rude country pottery, ollas and bowls, poorly fired from inferior clay. These pots are clearly historic so I work through them quickly. By eight in the morning the sun is high in the sky and the temperature is pushing 130. I take a break.

Grabbing an aluminum pot I head back toward the trees, swinging my machete as I walk. Living here, I've learned a few tricks from the farmers. I soon find the variety of palm that I want and begin to hack at the trunk. In 10 minutes I am through and the forty-footer comes down where I planned. I set up my pot to catch the fluid already seeping from the cut-off. After a few hours of intense sun I'll have a bucket of pulque — a self-fermenting, low-alcohol, palm beer to keep me company after work. There are plenty of these trees — I'm living next to a forest of 24s.

I return to work and keep up a steady pace without lunch until evening. I light the one burner stove and put on the rice and beans. It's now time for the beer. The nearly full pot sports a good head of foam liberally seasoned with dead flies that I pick out with a spoon. I feel wonderful — relaxed, clear and calm. As I become aware of my peace, I sense its source. With all my busy intending I'd not really appreciated the sound of the sea. Now the surf's rhythms roll over the beach, burying me in their sway and ebb, messengers from a Far East, far over the horizon. I feel my body slowing down. I drink and eat slowly, all the while watching the waves. They approach the shore on an angle, sweeping northward with their inshore ends curling baroquely up the beach beyond me and then onwards toward the misty infinity far to the north. As the day leaks away, they begin to phosphoresce, making

rolling curls of glowing green foam racing one another up the beach to the world's end. Rolling, breaking, sweeping, retreating, repeating.

The perfect nighttime temperature soon dissolves the barrier between the body and the world, between the mind and the body. The beat of the waves becomes the beat of the heart and the circulation of the blood — life at its purest and simplest with sleep at its most perfect.

The days are differentiated only by new stratigraphy and the steadily growing pile of backdirt. After a week I hit a layer entombing a clay whistle. The previous year we'd worked a ceremonial site high up in a remote arm of the Valley of Oaxaca. There were centuries of little grey clay effigies — mould-made figures with a whistle hand-built on the back — abandoned and buried around the main mound. The early whistles at the bottom were simply a hollow, walnut-sized knob with a finger hole poked in. We'd retrieve them from the soil, gently shake the dirt out of the hollow and blow them. It was like playing an empty pop bottle. You had to blow at just the right angle across hole to get a note. They were not easy to play. Most didn't work at all.

A couple of layers up were later models. Some pre-Columbian genius had invented a little nose of clay that protruded near the hole. We soon discovered that lining your lip up to the protrusion before blowing

always gave a note. The mysterious whistle-blowing worship that had been important at this temple had clearly gotten much louder as there were far fewer defective whistles. The effigy on the front, however, remained the same.

Several feet higher up the whistles underwent another evolution. Someone had discovered that a small strap looped over part of the hole — a clay reed of sorts — vastly improved the sound. These little one-noters were now completely reliable. It was very compelling to witness these people refining this simple instrument. As we retrieved these things from the various levels, we felt as if we could see a human mind at work, gradually problem-solving. I began to feel a real kinship with these ancient people, a feeling that lasted until our dating results came in from the laboratories in the U.S. It had taken these people about 600 years to develop a very simple instrument, an evolutionary pace so glacial that it still remains hard for the modern Western mind to fully comprehend it. They were clearly intelligent but their priorities were quite different from ours. This was a culture with a huge respect for tradition.

The whistle I unearth near the beach is a variant of the last type. The effigy is missing — any attempt to connect the two cultures is hopeless. I keep digging, screening, sorting, digging.

Work the previous year had brought one other

encounter with the songs of time. Late in the season, after my crew had departed for the U.S., I stayed on to work with another group in the Mitla arm of the Valley of Oaxaca. We were excavating an impressive Classic period ceremonial site built by Zapotecs at least a millennium earlier. As it had been occupied for a long time, our trenches were several metres deep. Every few days we'd find the remains of an ocarina, a small clay flute with a handful of finger holes. They were always broken. The American archaeologist who was supervising this site became obsessed with finding one that was intact. A pale, late middle-aged man who'd gotten skin cancer from so many years under the crashing Mexican sun, J.P. would visit the site once a week. He'd emerge from the shadowed interior of a big old American car with every inch of his exposed skin — hands, neck, face — caked in a paste of white lead to deflect the punishing rays of the sun. He'd slowly walk our trenches looking like a cross between The Mummy and Michael Jackson. Every week he'd ask for ocarinas and every week we'd hand him a new box of fragments.

Eventually our small crew decided to give him a treat. There were a number of local Zapotec potters who specialized in Pre-Columbian fakes: a few were very skilful. We engaged one of them to make an oca-rina in the style of the ones we were retrieving. It was

duly made and carefully aged by burial in the potter's yard. When it was delivered to us we spent more than an hour carefully inserting it into the appropriate stratum. Only the characteristic lip of one end was left protruding slightly from the tall section of a trench that J.P. was sure to inspect at the end of the week. When we saw The Mummy's car lumbering up the slope toward us, we set up a lookout behind the rock face above the cut. Sure enough, the old man came slowly down the trench as we watched, breathless and giggling. Initially, he walked right by it leaving us feeling foolish after so much effort. However as he began to retrace his steps, we could clearly see his large straw hat moving between the high narrow walls. The hat reached the ocarina and stopped. We could hear digging. He triumphantly retrieved the little flute and, turning to the light and us began to carefully empty the interior. We were so excited we couldn't breathe. Satisfied that all the soil was out, he brought it to his lips: blew a volley of notes and tossed our beautiful little instrument over his shoulder and shuffled off. A little pile of shards lay behind him in the bottom of the pit.

J.P. had been a jazz musician as a youth in San Francisco. He knew music — he knew his scales. Our potter, scion of generations of assimilation and the Catholic liturgy, had made a diatonic flute. Its

European scale — the Do Re Me of our childhood songs — had unmasked our laboured deception. We all went back to work.

The shimmering ribbon of dazzling sand, perfect as new snow, was now my only home. The waves sweep in hour after hour, day after day, week after week. Their sound becoming the whole rhythm of the body, with breathing, heartbeat, digging pace and the patterns of the mind all playing out together or in multiples of the great meter of the world. While space may have separated me from all that I had known before, time, the great count of the universe, was keeping us all in the same dance.

It was in this seeming wash of connectedness I often thought of Molly, her pencil connecting her to the same pulsing world that I was in even though she was thousands of miles away sketching, painting, drawing. We were still together in this sparkling soup of uncountable trillions of atoms that made up the air, the water — and in clusters, made up ourselves. In time we would exchange these tiny building blocks, surrendering ours when we died to be made into something else.

She drew around this. Her method of image-making was much less objectifying than that of the photography and filmmaking that I was soon to take up — the viewfinder always creates separation and distance. She was always totally in the world when she made good

pictures. Making images became, for both of us, our way of staying awake, of being vibrantly alive and present.

During those long dancing days of solitude I'd often take a break during the heat of the day. Dropping my clothes I'd walk down to the lip of the sea and wade out through the surf. I was frequently accompanied by little four-foot sand sharks that poked harmlessly around my legs. As the days went by they became more numerous and curious. We often bumped into each other — their bodies solid and abrasive — as we swam together in the shallows along the shore.

As I headed into my fourth week, the layers of habitation in my test pit began to thin out. I soon found out why. Overnight the pit bottom stained dark with seepage from the lagoon. I'd clearly reached the beginning of human time in this little corner of the planet. My job was over.

Over the next couple of days I busied myself with some organizing and note-taking. I took many long walks and spent more time in the sea. One evening, as the light warmed and the air cooled, I waded into an ocean as clear and flat as a frozen pond. I'd never seen it so calm or so strangely silent. The sky was without a single cloud. I stood for a long time in several feet of water feeling suspended from the sky rather than supported by the earth. It was a moment of an immense

calm that I had never experienced before or since. After many minutes of complete peace I sensed a faint throbbing pulse approaching from the south. As I turned, a white Cessna suddenly shot out from behind the rocky headland and banked toward me barely 50 feet above the sea. In an instant it was abreast, pushing a great wave of engine noise over me and into my little world. Four dark faces were pressed to the windows, looking down at a skinny, lonely white man standing naked while a vortex of little brown sharks wheeled and turned around him in a glowing, golden, glassy sea.

 I have been alone in my mother's house for three days since she died. For two, I couldn't face the haunted bathroom. Its tub now a giant drain in which my mother, curled up, swirls around the dark eye of the centre — the top of a line to the middle of the earth. It will take courage to stand in that bath, to pick up her glasses, to put away her clothes.

 At Harling Point Chinese dead sleep between Penzance and the sea as a rowboat with a single seat clears to cross Gonzales Bay. The weather remains fair, the tide stands.

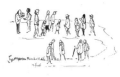

My old friend Alyson and I drive in through rows of metallic grey and bronze SUVs, each hunkered down on the slopes flanking the north side of the polo grounds. It's a dazzling afternoon in late June, three years after Molly's death. A high clear sky arcs everywhere but to the south where a cloud bank squats over Lake Ontario, some 25 miles away. The local club, innocent in white, is facing a Michigan team flying bright red polo shirts. When the announcer sings "The Star-Spangled Banner," few Canadians leave their seats or picnic blankets — we're angry with the U.S. again. Everyone, however, stands for "O Canada." The Americans begin the game by playing very aggressively, riding fast and hitting hard — many neck shots, and long backhands. The Canadians are more deliberate, less showy, more accurate. In the end, we will win.

There are two crowds here. On the north side are all the people who have paid to get in. They come equipped — folding tables and chairs, big shade umbrellas and coolers. Across the field, 200 yards to the south are the elegant tents of the corporate sponsors. Between those tents are a series of patios with hundreds of white moulded plastic chairs arranged around large circular tables. There are waiters in black-tie. That side has big hardwoods shading the seating.

After three chukkers the field empties for halftime. Several ponies are led off to trailers in the parking lot. A few people launch kites at the eastern end of the field. Most people unpack their picnics and pour their wine and beer. It's becoming very hot.

Alyson and I rummage through the groceries that we have bought on the way up. We have bread, olives, cheese and pears. She has chilled a bottle of white — it's her birthday. I open it, breaking the cork, and pour. Little chunks bob in our glasses.

The cheese sags in the plastic packs.

Wine is making me dim in the heat. My arms and the back of my neck burn in the high sun. I glance across the field, envious of the corporate tents, umbrellas and shade trees. It's one of those worlds that appears perfect from a distance until the trees there suddenly start to toss in the heat. My mind begins to focus; the trees twist violently. I see an umbrella go down, its cover floats off, and the frame — a long aluminum pole with a radius of naked ribs at one end, begins to cartwheel across the field. Then a chair rises in the heat and whips around in a circle a few feet off the ground. Another follows. And another. In seconds a huge column of white plastic patio chairs is rapidly spiralling upwards — 50 feet, then hundreds, and higher. More and more chairs follow. Blankets and tablecloths dance in between them. A few tables lift off and soon an entire patio has been vacuumed up.

The spiral of spinning chairs must be a thousand feet high. It dodges out onto the playing field.

All of us on the north side have dropped our sandwiches — our mouths are still open. As I watch the great funnel of plastic chairs and lunch plates lurch toward us, a small shrill voice in the back of my mind is yelling at me to act, to run. Instead, like everybody else, I just stare. The spinning chair cone is whipping toward the announcer's tower, picking up divots along the way. At the last minute it stops, feints and doubles back about a hundred feet. Then it's off and spinning again, heading straight toward us. I dive for my light jacket and throw an arm over our basket. About 40 feet in front of us the column disappears. I look over. Gone.

It's strangely still for several seconds. Then a car alarm begins to shriek. I turn to the row of shiny 4 x 4s behind me. One of them is shaking, headlights flashing, its antenna whipping a small violent circle. The twister has touched down again, pulling a rearguard action on the stunned picnickers. Twenty feet to my left a family has brought their aged grandfather. He sits high, strapped into a tall, wheeled chair. He's wearing clip-on sunglasses that are flipped up above his eyebrows like little open hatch-covers. There's a ring of mayonnaise around his mouth and crumbs stuck to his chin. A large beach umbrella shades him. A side table and lap tray hold his food; his descendents are

slumped in folding chairs around him, eating. In a flash he's alone. The disturbance has snatched up everything in one sweep of a hand. The old man is left hatless, tray-less and alone, in the bald sun while the family scrambles off for their things. He looks like a crumpled monument. His big umbrella is already hundreds of feet above us.

The twister retreats back over the parked vehicles. Clouds of dust from the roadway are sucked up, defining the tornado's cone. The storm lifts off again and slouches off to the west. For almost an hour I can still see tablecloths, umbrella covers, and paper plates lazily arcing in the clear sky. Somewhere to the west, plastic chairs are falling into gardens.

When the polo ponies come back out, I suddenly see Molly posting on a dappled grey as it canters to centre field. I know that it's silly — she was a great rider but never played polo; besides she's dead — but I can't shake it. It's her in dazzling whites playing for our side, and we're going to win.

 Glancing seaward between the headstones of Ross Bay Cemetery one can see a tiny white boat with a solitary oarsman stroking westward 200 yards from shore. Thin puffs of cumulus form across the Strait.

The downtown run out to Toronto's airport is dismal. The grey concrete of the snaking expressway is followed by low industrial units flanking the QEW after the Humber, next a string of suburban mid-rise, mirrored-glass office towers with corporate tenants changing yearly, more ramps, more greyness, and then the budget hotels ringing the airport. It could be anywhere in North America, or, increasingly, much of Western Europe.

I wait in Arrivals with Tamils, Cantonese, West Indians, Portuguese and Italians. I feel like the lone WASP in Upper Canada until my parents clear the sliding doors at baggage pickup. They're neatly dressed in travel tweeds, handily surviving their early seventies despite liquor and tobacco. I drive them down to my sister's, where they'll stay for several weeks. This will end in tears: the old man inflexible, tense and irritable — my sister frustrated and impatient. Molly will get through it all with avoidance and a bottle of Gordon's.

I don't hear from them until an awkward dinner is arranged ten days later. We go to a café with a patio. The old man thinks the food is weird. Molly has to shell the fish for him and dice the vegetables. The rest of us try not to watch. My sister is on simmer.

Two days later I get a call from my father. Things have not gone well. They've moved out — they're

going home— he has something for me. I meet him the next morning in the lobby of a big downtown hotel. He and my mother are clearly stressed and anxious to be off. Even coffee is out of the question. He hands me a grocery bag with a red maple leaf printed on white plastic. It's heavy. We say our goodbyes and I descend to the street where a sudden summer downpour is tap dancing on the pavement. I dodge across the darkening street, open the rear doors of my big yellow van and toss the bag under the bed in the back. By the time my key is in the ignition, I've forgotten all about it.

My thoughts were of the visit — old patterns repeated once again, unstated expectations, mysterious needs, a lack of the will to communicate. My children have once more reached out to their grandfather and received nothing in return. My younger son confronts me in the hall, declaring, "Your dad's a loser, Dad."

It's hard to argue but I have some understanding of a truth beyond. My father, in fact, was extremely emotional — he'd had a life's training not to show it. His father forever packing his leather Gladstone and departing for the northern reaches of British Columbia to build yet another bridge or design a jetty whenever his edgy wife drove him crazy. My father's years of boarding school were followed by his being sent to England to study for master's papers on the *Conway*. Originally launched in 1839 as the *Nile*, a

92-gun ship of the line, the *Conway* was the pride of the British flotilla that kept the Russian Baltic fleet at bay off St. Petersburg in the Crimean War. It was on her heart-of-oak decks that John Masefield, Poet Laureate, first fell in love with the sea. When John Mitchell first went aboard, she was already over a hundred years old. He and his classmates slept for several years lined up below decks on that unheated 19th century wooden three-master on the Mersey. Then they all departed for steel ships. The Canadian boys joined the CPR and worked their way up a male world on the great *White Empresses*. If they were of my father's generation, their careers were amputated by the war. They were sentenced to iron tubs hastily welded up in Collingwood. Most of these vessels were never intended for transatlantic work. Many sank.

No place for emotions.

Months later my wife, mother of the first Jewish Mitchells according to my father, flew to Israel to visit an uncle and revisit Ramat Gan where she'd spent part of her childhood. After several weeks I made the dismal airport drive to pick her up. Those were also days of big troubles in Israel — bombings, suicides, hijackings. The El Al flights had been moved, to the extreme eastern end of Pearson's Terminal 2. I drove eastward along the lower level through a forest of pillars and discovered that I wasn't allowed to stop. No passengers waited in the gloom, only dozens of soldiers and provincial

police, all turned out in dark fatigues, bulletproof vests, big helmets and boots. They all carried automatic weapons. They waved me off and I slowly did the loop through the ramps around the terminal and headed back — still no passengers, just a dozen stiff boy soldiers with swivel necks. I slowly retraced the loop once again.

I went down the tunnel on the third run through the concrete colonnade. As I reached the end, a fistful of dark helmeted men stepped out from behind the pillars — hands on their holsters. I was surrounded. Wordlessly they opened all the doors of the van and ordered us out. While my older son and I were held to the side they poked through the empty van for a few minutes then slammed the doors and slouched off. A minute later the El Al passengers tumbled noisily out the terminal doors and we were off.

At the house I pulled the two big suitcases from Israel out the back of the van. As I lowered them to the ground, I recognized the white grocery bag under the bed. I dropped the suitcases and crawled in to retrieve it. The bag was still heavy. I struggled with the plastic knots and dumped the contents onto the drive. A 1922 Geco Carabiner, single shot bolt action, with a cut-down WWII German Army rifle stock to mount it on, lay on the pavement. Four boxes of bullets fell out of the bag. The soldiers had completely missed it.

As I assembled the gun, I remembered what it was. My father had been directed to Spitzbergen during one of his horrific autumn crossings of the early forties. His men were to go ashore and confiscate every weapon they could find. When they cached the guns on the aft deck, my father had taken a shine to this very odd rifle and spirited it up to his cabin. Back in Ancaster after the war, he'd gone rabbit hunting in the fields along Hamilton Mountain with the painter Frank Panabaker. It must have made a hell of a hole in a rabbit.

I remembered Panabaker, who rented our island every June, shuffling through the pine woods in his heavy cords to my back cabin with that same gun under his arm. I thought of the service pistols wrapped in oiled paper, tucked in a wooden box, hidden in the basement, and copper and brass bullets bagged in a shammy. I saw the galvanized munitions boxes lining the shelves like books. When I looked down the sight, there was my father running out onto a reef with that old gun trying to shoot snakes. What did this pitted, pathetic, rusty old rifle mean to him? What did he expect it would mean to me? I've used it once. I shot a beaver. It had cut down all my birches and thrown a lodge up over my dock — it wouldn't go away. I know where the body is and five years later still can't bear to go look at it.

A pair of young women in bright ball caps jog the path paralleling Dallas Road. They dodge dog walkers and old men shuffling and grumbling their way between Clover Point and Finlayson. The flag over Beacon Hill hangs limply from the pole. A little white boat moves steadily westward offshore — rowing, rowing. Only the peaks clear the cloud and fog across Juan De Fuca..

Cunarder hull #534 slowly rises, days, to months, to years, from the stocks at Clydebank as the Great Depression crawls into the mid thirties. Two hundred vertical feet separate the keel resting on massive timber blocks from the bridge deck that clears even the dozens of swinging cranes. The timber slitherway, lying on either side of the keel, is lubricated with 50 tons of grease. It stretches for more than 1000 feet down into the Clyde.

John Mitchell, pale, skinny and 16, is bent over his scrapbook in a quiet corner below decks on the *Conway*. He is 8700 nautical miles from home, measuring the long days of his exile by the progress of hull 534. Daily he scans the papers for new developments as hundreds of men working shifts at John Brown and Company drive home her 10 million rivets. He carefully cuts out the stories and photographs, dating each in ink, and pastes them onto the black pages of his

album. A departure present from his mother, its cover features a black line drawing of the Houses of Parliament towering over the Thames at night. The full moon in a windswept sky is stamped onto the green linen board in gold foil. It's echoed by the gold face of Big Ben and foil haloes around each light on the embankment.

It's September 26, 1934, nearly four years since the keel was first laid on the stocks. Two days of high winds have sagged into a third of drenching rain. The king and queen, up from London by train, have arrived at the yards and entered a glass enclosure under the sheer of the bow. The Prince of Wales stands behind them. A quarter of a million yard workers, their families, townspeople and the press stand far below on the ways, pummelled by rains. The liner, "the stateliest ship in being," declares the king, is about to be sent forth "with a name in the world, alive with beauty, energy and strength." His words are broadcast around the Empire.

Then the queen comes forward, tripping an apparatus that smashes a bottle of Empire champagne from Australia on the side of the hull. As shards tinkle down the topsides, the queen leans into the chromed microphone and gives the name of hull 534 to the world for the very first time — *Queen Mary*. She presses a button setting a battery of hydraulic rams against the enormous timber cradle beneath 534 and the huge

assemblage of iron and steel begins to slide into the Clyde. As timbers snap and splinter under the bottom, colossal piles of chain, like great rusted entrails, begin to pay out to retard the slip into the river. The previous October the great French liner *Normandie* had slid down the ways at St. Lazaire creating a backwash that swept a hundred people into the sea. On November 3, 1857, the mother of all gigantic iron ships, the *Great Eastern*, had refused to move at all. There was to be no such tragedy on the Clyde. Careful calculations ensured that she settle in afloat only a hundred feet off the ways. As insurance, the mouth of the Cart River opposite had been prepared to admit 534's towering stern. Unnecessary.

Moved across the river to the fitting out-basin of John Brown and Co. for completion, the *Queen Mary* wasn't to·sail until late May of 1936. By then John Mitchell would be preparing to pack his bags to return to Victoria and his parents. He would sign on as a bridge cadet on an *Empress* and begin his many crossings of the Pacific. On the other ocean, a continent away, the *Queen Mary* would work the Atlantic routes for decades. Her 160,000-horsepower engines would push 81,000 tons of liner across the Atlantic just over 1000 times. As she made her last cruise in 1967, the greying boy-cadet from the *Conway* was signing the papers to purchase a 150-year-old stone farmhouse high on the moraines above Lake Ontario. Molly

would put her largest studio ever in the back wing and tether two horses in the barn.

 Scuba divers park their vans and station wagons on the Ogden Point Wharves and stumble like black beetles toward the break-water. One by one they enter the water and slip beneath the surface. John Mitchell alters course and pulls west-south-west to parallel the Ogden Point Breakwater. Half a century earlier, his father, in Harris tweed jacket and vest, stood on a pile of rock, a cold pipe hanging from his mouth, supervising the extension of this breakwater and dreaming of his end-of-day sherry. The breakwater he engineered now shelters pilot boats, cruise and cable ships. His now-elderly son clears the little lighthouse on the point and swings northward past the Coast Guard Station. Still rowing.

 "Who the hell are you?" My sister blanches at this greeting from her father. I've been out to Victoria to see him in hospital several times since his stroke. This is her first visit and he's angry and confused. It's the first full sentence I've heard him utter in months.

We don't know what to do — my mother, sister and I — so we stand off and watch while two nurses bundle him into a wheelchair from his bed. He's so

small now, so bent, so lost. It's painful to watch, to see a tall, handsome, striding man diminishing before our eyes.

Now he's in the chair, his backless hospital gown supplemented by a pink flannel sheet. The IV is hung on a chrome hook above his sloping shoulder. I begin to roll the whole rig, with its trembling bags, through the maze of beds, outbound for the door and the larger world of glistening corridors. There's a cloying, sour smell everywhere: waxes, disinfectants, sweat, shit and disease.

We clear the nursing station and begin the long reach for the lounge. We're making good headway but the commander is distracted. His eyes are unfocused on his lap where his arthritic hands twist and tug at his gown and sheet. He does that a lot lately, puzzling my mother and mystifying me. My sister, on her first visit to see him, keeps up a nervous chatter — Dad this, Dad that — as we steam down the hall. Closing on the lounge, I realize that my father and I have gotten ahead of the women. Once again I'm manoeuvring in close quarters. It's busy in this empty room, a clutter of vinyl armchairs, empty magazines and a television talking to a vacant sofa. Outside it's the usual sad B.C. winter weather — grey, dripping, morbid — so I bring the chair about and face it to the door at the moment my sister enters. Her eyes are on the wheelchair occupant's lap: distressed, she suddenly turns away. I peek

over my father's shoulder. He has clawed his sheet and robe back almost to his belly exposing his penis, a grey blunt cathetered cylinder — chicken parts, gizzards, a life being subtracted.

Thursday, April 14, 1949, Bangor, Wales. ONCE-PROUD WOODEN BATTLESHIP DOOMED TO DESTRUCTION BY THE SEA. The 114-year-old heart-of-oak warship *Conway* lies crippled and helpless on the rocky shores of the nearby Menai Straits, where she has gone aground under tow. There is no hope that she can be saved. The primary concern is to make her fast in her present position so she cannot heel over in the coming winter gales and menace other shipping in the narrow and tricky channel. The *Conway* is one of the world's last surviving wooden battleships.

I have retreated to my small island. This is the fourth day of rain — daytime drizzle, deep night storms. I read, I write, I pace and drink. For the past 48 hours, a thick dark log has drifted a few hundred feet off my shoreline. In the mornings it moves slowly to the west with the offshore breezes. During the rain-pocked days it slowly retreats to the east as the prevailing westerlies build gently against the offshore current. Now, on this last day, toward six o'clock, the west wind, bearer of

good weather, has strengthened and finally carried that black body out of sight. It was the size of a man.

 "I saw your father rowing off the Fisgard Lighthouse last Wednesday. At least I think that it was him — it looked like his boat, and I'm sure I heard his cough."

Sunday morning, October 13, 1929, the Mitchells, A.F., his wife, Violet, and their two children emerge from the 11 o'clock Anglican service in Oak Bay. Although it's not raining, there's a heavy fog and a penetrating damp chill in the air. As they make their way to their car parked down the block, the *Empress of Canada*, returning to Victoria after being re-engined at the Fairfield yards in England, has just taken on a pilot and inches through heavy fog in the Juan de Fuca Strait. She is making for the quarantine station at William Head. She will not arrive.

Just off Albert Head, she grounds on McIlwaine Point — the forward momentum of 21,000 tons, even proceeding very slowly, is sufficient to drive the vessel 200 feet up onto the rocks. Stone pinnacles tear through the double bottom on the port side, springing plates all the way to the forward funnel. It is Captain "Yankee" Griffiths' first disaster in 40 years at sea.

Back at the house on Orchard Avenue, the telephone rings for A.F., bringing him news of the

grounding. His 11-year-old son, John, already in love with ships and the sea, begs his father to drive him out to William Head to witness the rescue and salvage. By the time they arrive in the late afternoon, a sizeable crowd has gathered on the foreshore. Women stand on the rough rocks in fur coats and Sunday hats; the men are all in suits and wool overcoats. The tugs *Hopkins*, *Burrard Chief* and *Salvage Queen*, have fixed lines to the stern and are pulling hard. "Yankee" Griffiths has set the engine room telegraph to FULL ASTERN but the *Empress* doesn't budge.

It takes two more days to get the *Canada* off McIlwaine Point. They off-load much of the cargo and pump 700 tons of sea water into holds in the stern to raise the bow. Seven tugs pull her dead astern as the tide rises and the liner slowly slips free. But on Sunday she had remained hard and fast, towering over the rocks of the point and the little scrub fir up by the path down. John Mitchell stares open-mouthed at the spectacle of the ship that didn't make into port. He dreams of one day standing on the bridge of the *Canada* in a smart uniform with long pants.

Eight years later his dream will come true.

 "Your father's rowboat was spotted pulled ashore on Whiffin Spit in Sooke last Saturday. He was nowhere to be seen."

October 20, 1933. John Mitchell, no longer at St. Michael's, is bent over his desk at Oak Bay High School neatly working up his notes after conducting Experiment Number Nine in grade nine science. He writes meticulously in black ink, each letter carefully formed and sloping to the right. The headings are double-underlined in red and a tidy diagrammatic illustration of the set-up is tipped in on the facing page. The notebook is bound between marbleized boards.

PURPOSE — a. To make a mercury barometer.
b. To create a perfect vacuum.

MATERIALS — Glass tube 4/10" wide, with 1/10" walls, mercury, bowl.

OBSERVATION — A tube made of glass is filled up with mercury. The end of the tube is inserted in a bowl of mercury. The mercury in the tube which is 3 ft. long will drop to 29 3/4" leaving a perfect vacuum at the top. This is caused by air pressure.

CONCLUSION — Air pressure is the same as a column of mercury 29 3/4" long.

The orderliness, the logical progression, the attempt to contain and control, are familiar to me from his wartime navigation logs of a decade later. It's the handwriting that startles me — it's identical to mine when I was his age.

The mercury has been slowly dropping for two days and it's now still and slightly misty. We come down to the jetty on Desolation Sound. We are four — actually, we are five, for I carry my father's ashes in a small softwood box under my right arm. My mother rolls along behind me; her new sailor's walk the legacy of a recent hip replacement. A small raw-aluminum tug idles against the pilings. Diesel fumes. Her shaggy pilot comes out to greet us.

"Hi, I'm Bruce. I'm honoured to be a part of this. I'm totally into the life/death continuum."

For the first time since agreeing to this expedition, I question its appropriateness. My father, once commander of ships and, for so many years, a towering dark figure in my life, is now powder in a bag.

Can I do this?

We cast off and thump out into the Sound, leaving a long plume of diesel exhaust low over the water. In this cool corner of the world there are only two colours: the grey of the water and sky and a violet

horizon. We reach the bell buoy and shut down. Drifting, I wonder who will open the box. Colourless sky, thick green water and a silver boat — the small, varnished box glows warm in a cool world. Finally, I open it to reveal a plastic bag of grey ash. My sister glances briefly and retreats into the wheelhouse. It's difficult not to be transfixed by how little is left after the subtraction of water and life.

Drifting. Turning. Gulls and cormorants gather on the buoy anticipating life from death.

Then a hand, clawed by arthritis, darts into the bag. Peel vegetables, mix paints, change diapers: women live closer to the ground than men. My mother's arm swings over the water and her hand opens. We lean over the gunwhale and collectively catch our breath. Ashes fall and pepper the seam between ocean and sky. The world inverts as a luminous turquoise cloud blooms beneath the surface of the sea. The old man is on his way to China, once again riding the currents of the great circle route.

PLATE 7

peel vegetables, mix paints, change diapers

BOAT SIGNALING.

RULE OF THE ROAD AT SEA
Two Steam Ships Meeting:
When both lights you see ahead
Port your helm and show your Red.
Two Steam Ships Passing:
Green to Green — or Red to Red
Perfect Safety — Go ahead.

— Captain Walter Mitchell (1856-1938)
Notes on Definitions in Navigation and Nautical Astronomy,
July, 1893

The Commander is on a long journey. Molly hands me his logs when we return to Victoria. His notes from his many Pacific crossings match his grade nine workbook, the same hand, the same black letters and red underlining.

Victoria to Honolulu	2345'
Honolulu to Yokohama	3395'
Yokohama to Kobe	350'
Kobe to Shanghai	792'
Shanghai to Hong Kong	830'
Hong Kong to Manila	632'

There's a poetry to his light and buoy lists that transcends the doggerel of road-rule mnemonics.

Kobe to Shanghai:
Kobe Wharf to Wada Misaki to Tomoga Sima to Ie Shima to Murota Ski to Ashizuri Saki to Toi Misaki to Sata Misaki to Kusakaki Jima to North Saddle to Fairway Buoy to Tungsha Light to Woosung and Shanghai.

Hong Kong to Shanghai:
Tamtoo Head to Pedro Blanco to Breaker Point to Lammock Light to High Brother to Chapel Island to Ockseu Island to Turnabout Island to White Dog Light to Alligator Rock to Tung Yung Island to Tae Island to Namkai Island to Peshan Island to Heachu Island to Saddle Island to Patahecock to Tong Ting to Steep Island to Elgar Island to Button Island to Gutzlaff to Fairway Buoy to Tungsha Light to Woosung and Shanghai.

This was his routine over 60 years ago. I total the nautical miles from the wharf in Victoria to the Manila docks — eight thousand, three hundred and forty-four. He used to do the run on the *Empresses* besting 20 knots. He'll be considerably slower now, but then, he does have all eternity to arrive.

PLATE 8

the commander is on a long journey

Dead trees along water edge like pale grey GHOSTS. Very straight — with fine branches upward curved. Deep yellow green branches curved down. Background delicate. Cerulean Blue green — foreground waterflatgreen. Canoe chrome yellow.

— Molly colour note, 1975, AQUABEE "Quickie Sketch Pad" 6075

My father and I once attempted to share a little voyage together. It was my idea, but it didn't play out exactly as I planned. More than a decade ago I fell in love with the *Thistle*, a little diesel-powered, steel-hulled trawler. After more than a year of long-shot negotiations it was suddenly and unexpectedly mine. With a friend, I re-launched her from the shipyards at Collingwood and set off for the northeastern shore of Georgian Bay. It was a memorable two days on the Sweet Sea.

Under pressure to get that little vessel out of the yards and with work demands back in Toronto, we set off having only had time to take on fuel and water and buy some charts. The weather was fair with seas running less than a metre. The lighthouse at the harbour mouth slowly shrank and then disappeared. Thirty minutes later the Collingwood grain elevators vanished and then Blue Mountain. Soon there was only water. As the loran was down, I kept close compass

watch. Running at five knots, several pleasant hours passed as my little slack-bilged "ship" rolled across the bottom of the Bay. When the shoreline began to lift ahead of us my heart sank. I recognized nothing — it could have been the Skeleton Coast. Where the hell were we? This, of course, is the navigator's nightmare: my father would have thrown me off the boat.

Once we'd established that the compass error exceeded 20 degrees, we ran the balance of the trip on the buoyed inside small craft route. After overnighting east of Christian Island, we began the long leg up the eastern shore. The winds built steadily all morning and by noon we were rolling hard in choppy two-metre beam seas. When we began to bury the rails on each roll, the diesel started to falter. I gave up the wheel to my partner in this adventure and pulled up the hatch in the little wheelhouse to go down below. Now I don't want to make this shippy little vessel sound too grand, but I can, with only slight exaggeration, say that it had an engine room. There was headroom down there if you straddled the keel.

It was also dark and nasty. The exhaust manifold was leaking; oily water slopped back and forth in the bilges; tools and spare parts were rolling along in clanging unison and the ballast was shifting. Swinging my flashlight beam around in the busy darkness, I caught sight of the fuel-line filters. Their little glass housings were almost opaque, so much sludge had

been stirred up in tanks by all the heavy rolling. The little trawler was fuel-starved.

So this initial voyage ended in ignominy. Many hours, and many restarts later, we sputtered into the big Sound, passed Parry Island and left the *Thistle* in town for a fuel-line flush and repairs.

During the subsequent weeks she proved herself to be quite reliable so I took a bold step and invited my father to cruise the eastern shore and the North Channel for 10 days. I was amazed when he accepted. A few weeks later he flew out from the coast and we provisioned the boat in Parry Sound. We slept on-board at the dock and cast off in the pre-dawn light. At five knots it's a long run out to the open Bay. It was a bright day with light westerlies — we made good time. By early evening we'd covered some 50 miles and were emerging from Alexander Inlet. To the west lay over 200 miles of open water, terminating in a thick horizon roiling black like coal dust. I didn't like what I saw and neither did my father. The marine broadcast confirmed the visuals — hell was coming across the Bay.

The sudden violence of summer convection storms over the Great Lakes is hard for sea coast people to understand — I've had the two-ton boat I now own picked up by the sudden hammer blow of a front and deposited a hundred feet off course without leaving a mark on the water in between. We agreed to put in for the night.

I chose a nearby bay with low, treed islands to the south and east and a line of reefs and shoals to the north and west to break the seas if not the winds. There was plenty of room to swing on the hook but just to make sure I carefully set two Bruce anchors off the bows. We made supper in the little galley and then settled in for a night of drinking and attempts to talk. It was very still when we bedded down, he up in the main house and me down below in the little forecastle, sometime after 11.

My father shouted down to me at around two. It sounded like duck-hunting season — the rain was driving like buckshot against the windows. I swung up the companionway ladder and grabbed the big sealed beam searchlight. Our little craft was swinging wildly in gale-force winds. I climbed out on the covered side decks and swung the light around looking for land to see if the anchors were dragging. There was absolutely nothing out there — not in any direction. It was just blackness slashed by driving rain caught in the beam. Once again, I had no idea where the hell we were.

At 4 a.m. I tried again — same thing. At five — same again. This was a big one. I imagined war.

HELP MEN ON H.M.C.S. RED DEER
FIGHT THE SUBS

Every dollar invested in War Savings Stamps between
Monday, June 29, and Saturday, July 31 — by Finance

Minister Ilsley's direction — is for one purpose only, to provide Canada's Navy with more and more of its strongest weapons against the U-boats — depth charges. Depth charges cost $90 each, and H.M.C.S. Red Deer, under the command of Lieut. J.A. Mitchell, could use a couple of dozen of these depth charges.

Monday afternoon, Mayor Hogg received the following telegram from Hon. Angus MacDonald, Minister of National Defense, Naval Services.

"I urge the citizens of Red Deer, Alberta, and district to participate to the limit of their ability in the 'Stamp Out the U-boat' drive being launched in July. The men of H.M.C.S. 'Red Deer,' under the command of Lieut. J.A. Mitchell, are fighting the anti-submarine campaign to the limit of their ability, and the knowledge that the citizens of your district are helping to support them with ammunition through the purchase of War Savings Stamps will be an inspiration to them."

Red Deer Advocate, May 1942

Well, at this moment, Lieut. Commander J. A. Mitchell, Ret'd, has passed out. Having raised the alarm at 0200 hours, he has left his son in command. Well, if he can sleep through it, so can I. I return to my berth.

The day dawns bright and cool. Although the wind is down somewhat, the water boils white on the granitic banks out for a least a mile. The two anchor

rodes are now braided together after a night of swinging in circles as the cyclonic storm swept through. They're going to be tough to break out.

We resume the run northward. A deep-sea navigator, the old man isn't keen on this kind of sailing. Much of the route is marginal, one can see bottom in the face of the waves and there are breakers on reefs to all sides. She rolls and pitches like Molly's horse.

By late afternoon we're in trouble again. We're up on the flybridge just entering a narrow blasted cut when the transmission throws a tooth and dies. We're dead in the water in a vessel with a lot of windage in a stiff breeze. The twin rows of sharp rocks on either side of the channel resemble a shark's jaw and we're coasting into it. I swing down to the deck and launch the inflatable, hoping to take the big boat under tow and keep my nicely-faired hull off the rocks. The ten-horse on the tender is no match for the winds. Finally, I wade into the cut and, standing chest-deep in the channel, somehow manage to hold the trawler off the rocks. It's hard work. The old man comes down the ladder to the deck and enters the cabin. A few minutes later he emerges with two bottles and a glass. He balances them on the rail while making himself a gin and tonic. Then he lights a cigarette and sips his drink. He's not going to look in my direction. It's all going to go away. He had his fill of boats a long time ago.

We arrived at Saint John's at two-thirty this morning in a dense fog, and as usual I was the first ashore along with Bill. Molly looked so delightfully dopey and young somehow. It almost seemed a shame to wake her up. Went aboard the ship around nine o'clock after a somewhat disturbed sleep and got the buzz that we were going to Halifax, when the all too fantastic news of Japan's attack on the Pearl Harbor Base near Honolulu, and also on Manila. The world thought it might happen, but the world doubted if it would ever happen, which all goes to prove that one can't look an hour ahead let alone a whole day.

If only you were with me dearest. I feel I need you awfully and I feel rather low over the new catastrophe.

— John Mitchell Diary, December 7, 1941, 10:20 p.m., St. John's, Nfld.

This is a remote place. We're alone in the wind and our soggy solitudes for perhaps an hour. Then a big fibreglass toy, flying the stars and stripes, appears down channel. I signal to them from the pile of blasted stone, my shoulder jammed against the topsides, but they ignore me and plow on hard through the little cut leaving a wake that throws my little vessel hard against the rocks. When she settles down, Commander Mitchell pours another drink.

Thirty minutes later, a twenty-five foot inboard

launch appears and takes us under tow. An hour later we're snugged up against a rock face in a deep sheltered bay cut into a large uninhabited, well-wooded island. Once our rescuers leave, I work the radio to raise a marina that's about twenty miles back. They agree to send a mechanic and a workboat out the next morning. The old man is quiet and withdrawn so I don't raise the subject of his refusal to help. We eat and sleep. The stars fall out of the sky and ride in the water. The sea is sweet.

As I'm making morning coffee, a steel-hulled workboat enters our haven and comes alongside. I pull the heavy tool boxes aboard and we lift the cabin sole. It takes us a couple of hours to unbolt the transmission, disconnect the shaft and lever the heavy housing into a position where we can pull it up with ropes. I don't know where my old man is, and at this moment I don't care. He's disappeared onto the island for one of his walks. We manage to get the transmission up onto the deck and drag it over to the rail. The mechanic and I manhandle the brute down into his boat. I pass over the tool boxes and he starts his engine.

Suddenly my father appears. He's got up in his town clothes and he's carrying his duffle. He nimbly jumps down into the idling boat muttering something about rats. They pull out; he doesn't look back.

I'm alone, which isn't so bad.

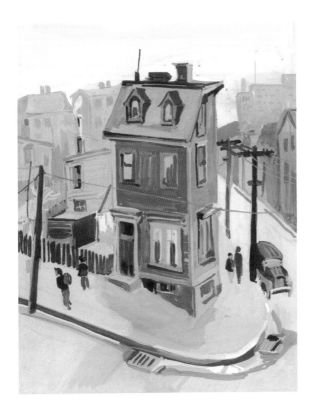

PLATE 9

home in St. John's: watercolour by Molly, 1941

In fact it's quite wonderful. By the next day it's been established that the transmission is terminal — another tooth had broken off long before my time and had sloshed around in the oil grinding up teeth and scouring the housing. The only available replacement is in Atlanta. It will be flown to entry at Vancouver and then on to Toronto. It will be trucked up to Sudbury for pickup. I've just been handed the gift of a week of enforced idleness in a beautiful, lonely place. I've got lots of books, food and beer. And, my kayak is still secured to the flybridge.

I soon make the happy discovery that I'd left a series of nature guides in the boat during an earlier trip. Each day I will take an exploratory walk on my paradise island with one of these books.

I've been passionate about this landscape of undulating granitic rock and wind-trained pines since my childhood. I've dreamt about it when in different parts of the world — India, Peru, the Emirates, Ukraine, China and Japan. Two decades ago I lay one night, in a corrugated iron shack on stilts, my cameras piled beneath my folding cot, in the Nicaraguan coastal town Puerto Cabezas. Running down the coast from Honduras in armed Donzis and cigarette boats, the contras arrived off the port shortly after midnight. They began shooting up the town from the water — periodically junk would come ripping through the sheet metal over my head and dozens of bullets

pierced the walls. I lay very straight and still, pretending to be a stick floating down the Magnetewan River to Georgian Bay — a very thin stick. The Sandinista soldier I shared the shack with had been through this so many times that he didn't even wake up.

This is a young landscape — less than 12,000 years ago it was still under a mile of ice. Less than 5,000 years ago it was still connected to James Bay and harboured whales. The white and jack pines are the advance guard of the northern temperate forest — they're still colonizing the postglacial land and in many areas have yet to reach the coast. Because this evolving landscape is not that complicated, within a week I had identified every last tree, bug and bird in paradise.

Tired of making my encyclopedic inventory, I decided to paddle out past the archipelago into the miles of shoals stretching toward the horizon. As there was a stiff breeze, I stretched a skirt over the coaming of the boat and put on a life jacket. I had a wonderful paddle out through the surf. The skies were deep blue and the bright sun crashed and sparkled off the waves. I soon found myself out beyond the last shoals in very bumpy water. With the period of the waves so short I had no chance to swing my 18-foot boat about between them. All I could do was keep stroking farther and farther out until I was in deeper water where the waves would separate.

This glaciated landscape doesn't give itself up to water that easily. It's shallow out a long way, making the waves drag on the bottom and pile up steep and close. Paddling several miles offshore and struggling to stay upright, I was getting exhausted. There was no one to help.

Then a strange thing happened. I realized that I was not alone. Swimming along beside me looking just as tired and anxious as I, was a very large toad. Not a frog, which might have made some sense way out there, but a big warty toad. We looked at each other and I felt a renewed energy. In dire straits any company is a comfort. Sizing up the next wave I seized the moment, heeled the boat, and with the most powerful sweep I could muster, brought it around in the trough. It was hard work.

Now to find the toad.

He too had come about. I spotted him about a dozen feet off to port struggling up the backside of a wave. I stroked over to be closer and we paddled along side by side for a few minutes. I was working hard not to yaw and roll, or pitch-pole into the bay. He was struggling just to stay afloat and alive. I headed us for land a little farther to the south where there was a break in the banks and deeper, calmer water. Sure enough, I soon had my boat under control despite my rubbery arms. Looking over at the toad I could see that he was largely submerged and stroking sluggishly.

We had bonded: I had to do something. I extended my paddle toward him, slipping the narrow blade under his body and then lifted. Up came the paddle blade, toad and all, which I quickly swung over the bow of my kayak. He hopped off onto the deck of the forepeak and clung like a limpet to the bow every time it plunged. I now had a big warty figurehead.

The rest of the paddle in was uneventful. I reached the trawler and tied the kayak alongside. The toad decided to hang in where he was. We had a beer together and then I turned in for the night.

Next morning he was still there. I made us coffee. Too tired to walk or paddle after the adventures of the day before, I spent the day reading Bodsworth's wonderful *Last of the Curlews*. The toad slept.

On the following day I heard the engine of the workboat approaching from the far side of the island. A brand new transmission and a very large invoice lay in the bottom of the boat. We set to work. When we were finally finished, we settled down to have a drink on the cabin trunk. I looked over the side — my toad was gone.

After overnighting one last time, I cast off alone and set out for my island, some eight hours away. When I arrived it was still windy. Getting into my tiny harbour involves making a quick *S* turn and then throwing the boat hard astern before hitting the rocks. I didn't think I could do it alone, with no one ashore

to grab the lines, so I headed toward my sister's island one half mile away. As I approached I could see some activity. They came down to help me land.

Once the boat was secured we climbed up the rock face to have a drink in her cabin. Lo and behold, there sat my father with a book and a glass. He must have called them to come and fetch him from the marina. We all sat down awkwardly. To break the silence I began to tell the story of my long paddle in the big water and my encounter with the toad. When I had finished my tale of the toad, my father leaned over and whispered in my ear, "Did you kiss it?"

 The little white wherry slips between the lighthouses off Berens Island and rounds Shoal Point. Trollers, trawlers and the odd seiner, lie berthed at Fisherman's Wharf. Tourists eat fish and chips at the bottom of the ramp. Looking up, one sees the passage of a very small row-boat behind the trawls and rigging.

NAVAL MESSAGE

A.I.G. 301(r) C.T.U. ns 24.1.13 from H.M.C.S. Skeena. May 0643h 31st: U-boat considered sunk by H.M.C.S. Witaskiwin and H.M.C.S. Skeena in position 049° 59'N 036° 36'W. Floating wreckage and human remains recovered. Weather report 3865 2263

1234h/31/42

The voyage and my father jumping ship is, of course, very small beer. Take the story of scx42 — slow convoy X. Here is a very large convoy composed of some 60 bottoms, everything from tankers, flush deckers, three island freighters, tall rigged old coasters, even an old blunt-bowed laker. These supply ships set out from Halifax and Newfoundland in the fall of 1941, wallowing along at a painfully slow five knots with an escort of several 190' corvettes. The whole motley procession is led by the destroyer H.M.C.S. *Skeena*. Her roster includes 125 ratings and 25 chiefs and petty officers. Among her 10 senior officers are Lieutenant Commander James C. Hibbard of Halifax, captain. Her chief navigator is Lieutenant John A. Mitchell of Victoria. The *Skeena* is the antithesis of most of her charges. Her 32,000 horsepower engines can push 321 feet of steel through the North Atlantic at better than 30 knots.

Altogether this enormous flotilla is slowly carrying more than half a million tons of supplies and 2,500 men out into the grim autumnal seas of the North Atlantic. The 12-column convoy occupies 34 square miles of the surface of the sea. Destination: the "Black Pit," the unprotected zone of the mid-Atlantic that lies beyond aircraft range and coastal patrols. First challenge: a screaming gale. The whole convoy hoves to for 36 hours and attempts to stay afloat and together. Three merchant ships drop out and return to Sydney.

As the gale subsides, six stragglers, including one corvette, are rounded up and the convoy resumes its thumping plow eastbound to England. The dawn of the next day brings a periscope sighting and a streaking torpedo. A double miss, by the torpedo and by the *Skeena* that has taken up pursuit. Course is altered for the day. By 9:30 at night a full moon has risen dead ahead to the east. At 9:37 the first ship blows up and sinks fast with all hands. At 9:48 another torpedo is sighted and a U-boat steams out of sight and range at high speed. Soon a further U-boat is spotted and then a third. Yet another appears, running down between the seventh and eight column of the convoy. The *Skeena* drops depth charges and fires star shells to illuminate the proceedings. A minute later a tanker blows up and sinks. Three ships down, 95 survivors.

The full moon is joined by northern lights. A couple of big icebergs drift by in the gloom. At midnight it clouds over. Another U-boat appears — later it's learned that this wolf pack had at least a dozen. The *Skeena* attempts to ram it just as the entire convoy changes course. There's confusion, chaos and a near collision in the darkness as the Skeena goes full astern to avoid a merchantman. Next a fuel oil tanker running parallel to the destroyer explodes in a geyser of orange flame and disappears. At dawn the U-boats withdraw to observe the convoy from the margins. Near noon a single sub undertakes a sneak attack taking the freighter

Thistle Glen to the bottom. The *Skeena* races in and dumps 5,000 pounds of TNT overboard. The U-boat dives and hides on the bottom. The *Skeena* stops her engines and listens with the *Asdic* while she drifts. More depth charges and then more silence. A huge air bubble rises to the surface followed by an oil slick.

One down.

In the late afternoon a single Lockheed-Hudson bomber, its bays emptied to accommodate extra fuel, appears mid-Atlantic. It flies a search pattern, locates the enemy and drops some warning flares. The U-boats flee. At midnight two newly commissioned corvettes, the *Chambly* and the *Moose Jaw*, draw near to reinforce. As they approach, several merchantmen locate two more U-boats. Gunfire, rockets, star shells, flares and bedlam greet the new arrivals. Another freighter bursts into flames. The corvettes drop a pattern of depth charges over the sub as it crash dives. Minutes later the disabled U-boat surfaces right beside the *Chambly* and the German captain leaps to safety on the Canadian corvette. The U-boat crew of 30 follows minutes later, refusing to shake hands with their deserting commander. Nine subs are left. Presently, a merchantman puts 70 rounds into a diving U-boat after failure to ram. A corvette lowers a boat in the heavy swells and rescues nine. No more survivors are found.

Throughout all of this the *Skeena* has been racing

about at a rate of knots. She is almost out of star shells and has nearly exhausted her fuel. The convoy continues its crawl toward England. At 5:15 in the morning the sea is light; it's cloudy, visibility is two miles. The cooks make breakfast. Near dawn a lookout on the *Skeena* spots several objects on the horizon. It's soon apparent that five British destroyers are closing quickly to reinforce. After 66 hours at their posts my father and his fellow crewmembers can finally dream of sleep.

Randa, Benury, Jedmore, Garm,
Stonepool, Stargard, Thistle Glen,
Scania, Crossbill, Winterswyck,
Empire Starbuck, Gypsum Queen,
Muneric and Ulysses.

All on the bottom. Lifeboats and lumber drift on a greasy sea. A few men still howl and flail through slow swells of burning bunker oil. As the day brightens nine U-boats slink off for Germany. The three left behind lazily spin down through the depths, streaming bubbles, oil, socks and sailors' caps.

Molly remembers his Newfoundland shore leaves after these duties. He'd come off the ship bent and grim. Silent. Joining her in bed, his legs would begin to tremble, then his entire body would shake, until the

whole bed rattled as she clung to the mattress beside him. Many hours would pass until he'd fall into a restless, thrashing sleep.

February, 1942, a few days before my twenty-fourth birthday, I am a lieutenant, Royal Canadian Naval Reserve, and navigating officer of the Canadian destroyer that is conducting the usual anti-submarine sweep ahead of a convoy of some fifty merchant ships. A lookout spots a dot on the horizon and our zigzag is altered to close the object. Before long, we can see that it is a life raft — nothing unusual as the North Atlantic is littered with life rafts and debris from sunken ships. As it gets closer, we can count seven figures in the raft, but we soon realize that none are alive. As we pick up speed, the raft drifts down the port side of the ship and we are shocked to see that three of the occupants are young nursing sisters of our own age. Somehow we have learned to accept men losing their lives, but the death of young women, those we went to movies with, danced with and picnicked with, this was almost impossible to accept.

— John Mitchell, Remembrance Day, Victoria, 1983

"I used to see your father far up the coast from Victoria in the afternoons, rowing, hour upon hour. He was always alone."

During the summer of 1937 the Japanese begin attacking Shanghai. The CPR puts two *Empresses*, the *Asia* and the *Canada*, at the disposal of the Royal Navy to facilitate the evacuation of the many Westerners living in the European concessions of the city. On August 18, the *Asia* crosses the bar at the mouth of the Whangpoo and takes on 1393 women and children for safe passage to Hong Kong. The *Canada*, outbound from Vancouver, receives orders to do the same. At 6:39, August 22, she departs Kobe and sails for Shanghai. Due to heavy shelling on the Whangpoo, she anchors at Woosung and is met by two warships, H.M.S. *Duncan* and *Grimsby*, loaded with refugees, on August 25. Despite the dangers, several of the junior officers are ferried into Shanghai. John Mitchell clambers over the debris littering the streets in the commercial core. He has his little folding black plastic Kodak Bantam 828 in his pocket. He has never seen dead people before.

All afternoon he photographs the corpses, lying like broken dolls, and sleeping street people on the sidewalks and pavement of the Bund. Weeks later, back in Victoria, he takes his film to a drugstore on Fort Street. For his next outbound voyage he buys a black-paged album and an envelope of photo corners. When he is not on watch, he hunches over the tiny desk in his quarters, carefully captioning each little

deckle-edged print in white ink. When he tires of mounting them, he quietly plays his violin.

A hurricane has straggled up the Atlantic seaboard from the Caribbean, beating up coastal communities along the way until it reaches New York where it begins to thrash up the Hudson Valley and, finally, tumble over the border into Canada. The winds spin westward up the St. Lawrence and cartwheel onto Lake Ontario at Kingston. As the lake widens, the winds accelerate and the waves build rapidly, their peaks tearing away ahead of the rollers. Several bulk carriers, caught out in the middle, have all made runs for shelter.

Almost 185 miles west of Kingston waves twice the height of a man tumble onto Burlington Beach, rolling tons of sand back into the mud-churned waters at the western end of the lake. This freshwater sea is reclaiming the sandpit sheltering Hamilton Harbour and Coot's Paradise. The thin line of frame cottages strung along Lakeshore Road cower under the willows and Manitoba maples as the beach dissolves minute by minute.

The Burlington police appeal to the naval reserve and the sea cadets for assistance. A couple of flatbeds and a dozen pickups are conscripted to run loads of sandbags along Lakeshore Road and Beach Boulevard.

Lieutenant Commander John Mitchell R.C.S.C. is the commanding officer of the "Iron Duke" Sea Cadets Corps. He's gone for hours leaving Molly and me housebound, staring out the rain-lashed windows at the trees tossing violently across the street. In the late afternoon the rain lets up somewhat and Molly decides that we will drive down to the lake to bring John Mitchell soup and coffee.

It's an exciting drive. I stand in front of the passenger seat next to Molly with my chin on the top of the dashboard of my father's new green Vauxhall. The wipers slash back and forth just beyond my nose, revealing downed trees and sagging power lines. Several times we have to double back and proceed cautiously down a parallel street. When we reach Lakeshore Road, where it runs behind the cottages, the scene is chaotic. The lake has advanced to the stoops and porches of many of the cabins and great dirty waves roll over the sandbag dykes that my father and his crew have thrown up along the crest of the beach. Men are still wading in the brown surf to heave new bags on the top of their lumpy breakwater.

The noise of wind and waves is thrilling as Molly and I slowly stumble toward where my father is shouting, red-faced, at a group of frightened young men in soggy wool uniforms. The great boiling freshwater sea is relentlessly clawing back the shoreline and has already pulled and pummelled several outbuildings

into vicious-looking piles of split boards, protruding spikes and shredded Insulbrick. I look up at my father as he takes the thermos from Molly and drinks milky coffee from the metal lid. As he squints out over the thundering waves toward the horizon far to the east, I wonder if he still loves the water. The great grey winter Atlantic that swallowed so many of his friends and took his youth away in the night is right here on this sad little beach with its tumbledown cottages, rusting lawn chairs and baggy screens. There's no glory in all this raging water — just exhaustion, humiliation, hostility and slow defeat.

October 24, 1944. The *Skeena*, on anti-submarine patrol south of Iceland, encounters severe weather conditions. Winds, gusting to 100 miles an hour, drive sleet and snow, forcing the destroyer to shelter in the lee of Videy Island in Reykjavik Harbour. She drops the hook but soon begins to drag anchor as the squalls become more severe and all contact with the island is lost. As visibility returns the *Skeena* is thrown stern first onto the rocks by huge waves and she broaches. By dawn, 15 men are lost: by night, the *Skeena*, the Rolls-Royce of destroyers, is gone.

Papa Duck and I don't know whether to go forwards or backwards. Hunched over

the black wheel in the tiny cabin of this boat, peering through the spray-streaked windscreen, all I see is a cliff of slate-blue water rising just beyond the oak toe rail of the foredeck. The bow of my 50-year-old wooden launch has plunged precipitously into the trough between the first big waves marching into the channel mouth. The screw has begun to cavitate wildly as each wave lifts it free of the water. I glance aft at the alarming noise coming from the stern and see my only passenger — a huge, brown, wicker chair. I've secured it to the floorboards of the open cockpit behind the cabin. The lonely chair is full of ghosts.

I've sold the family island and retreated 25 miles farther north where there's more wilderness, few people, more emptiness. This has been my last trip back to the old dark place to retrieve family treasures. It will be one of the last voyages for the boat as well. Now, only five miles shy of my new cabin, the weather has suddenly held up an iron hand.

As the bow rises on the next wave, gallons of chilled water slosh back toward me and squirt through the window frames of the cabin, soaking the front of my windbreaker and draining into my lap. It's too rough to do this trip but this narrows between the shoals affords no room to turn back. The ghost seat and I are committed. We're on a teeter-totter. I rise: it falls. I sink: it swoops up into the sky. The chair is the seat of souls — I must get it home safely.

Slowly, slowly, we wallow forward. The Chrysler Crown, a wonderful ancient straight six, thunders in the engine box and spits hot water out the transom. It's not a quitter. I can't be one either. We finally reach the turning buoy and point north — a three-mile reach through rough beam seas. The old boat rolls and pitches violently. There's now a lot of water in the bilge. We close on the next buoy, lurch past it and grind on toward its successor. Soon I will be swinging toward the coast and picking through uncharted reefs and shoals making for the mouth of my inlet. There, water will be calm.

We clatter into my little harbour and nestle up to my sagging jetty. I shut down and free the chair, urging it toward the building. It balks at the entrance, its arms seizing the door frame. We struggle: I win. The chair stumbles into the strange room sideways and thuds down onto the floor. I drag it to the other end of the cabin and light a fire in the stove to dry us both out. We can talk when we have warmed up.

Standing in the kitchen making a hot drink, I watch the chair facing the fire. I have seen myself in it, son on my lap, while I read him a story. Molly has sat in it with me on her lap reading to me. I've seen a photograph of her, barely five, snuggling up to her father in it while he sketched for her. And there's a photo in an album where he perches on the seat, legs dangling quite shy of the floor, beside his mother. Even then the chair was

old. It's so wide it will hold two or three. Its big arms have embraced this family through so many generations that it deserves to rest before the fire. It needs to be treated gently: it knows far too much.

Molly rushes down the long drive at The Willows, Ancaster, screaming at a pudgy four-year old in overalls straddling the centre line of Highway 2. Having discovered that one of her father's canes separates into a sheath and blade, I've escaped the house, sword in hand, to take on the world.

I awaken at three in the morning. In various corners of the city, my male friends will be up now, wandering about, trying to return to sleep or even do a little work — we all have the sleep disorders of the middle-aged. Forty miles to the north my oldest friend, Kerry, will be standing by the big windows of his farmhouse, looking south over his fields, smoking, drinking. We are all in our 50s.

I cross the room to my small kitchen, open the fridge and pull out a bottle of ale.

Taking a glass, I return to bed to sip and stare at the ceiling of my studio. I had fallen asleep, perhaps four hours earlier, leaving both a light and the radio on. As I now begin to slide away, into dream but not sleep, I slip back into a beautiful late spring afternoon. I'm

walking home after school through the streets of a small Ontario town. The air — soft, moist, warm — is rich with the smells of new life. My body is silent and transparent — no murmurs, no pains, no limits. I pause halfway down the last hill to my house, radiant with the realization that at this moment everything is perfect. I want time to stop. I'm old enough.

How old was I — seven, nine, eleven? As I begin to drift back to the present, I realize that this had been a real moment. Why had that instant returned now, that experience of complete contentment? I lie, sipping in the semi-darkness, puzzled. Gradually I become aware of the music from the radio. I briefly float off and return to peace, security and contentment. I turn my head toward the source of the sound. Then it slowly comes back. The music is Delius' "Florida Suite," in a Beecham recording that my mother Molly often played when I was a child. Holding tight to my little musical madelaine, I try to understand why this particular music so comforted her. There is no shortage of lyrical, yearning, pretty music — she had recordings and always worked with the radio on — she knew lots of it. But what did Delius — a Florida plantation owner, Virginia music teacher and late romantic composer — say to her?

His Suite's first performance took place at a restaurant in a Leipzig park in 1887. The audience of three consisted of Christian Sindling, Edvard Grieg and, of

course, Delius. The orchestra members, all players from the Leipzig Conservatory, were paid in beer.

SECOND ANNUAL DANCE

H.M.C.S. RED DEER
24TH SEPTEMBER, 1943
SYDNEY, N.S.

PROGRAMME

1. Rise and Shine	Fox Trot
2. Hands to Stations	Fox Trot
3. Colours	Waltz
4. Oropesa Stomp	Fox Trot
5. Request Men to Muster	Fox Trot
6. Bangor Lullaby	Waltz
7. Up Spirits!	Fox Trot
8. Bully Beef Bounce	Fox Trot
Stand Easy	

PROGRAMME

9. Collision stations	Fox Trot
10. Sick, Lame and Lazy	Fox Trot
11. Dodger's Shuffle	Fox Trot
12. Stoker's Serenade	Waltz
13. Darken Ship	Waltz
14. Action Stations	Fox Trot
15. Splice the Main Brace	Fox Trot
16. Smooth Sailing Home	Waltz
God Save the King	

It's almost Christmas. Large, floppy flakes of wet snow parachute onto Bloor Street near the museum. We are rushing toward the Park Plaza Hotel for the annual family Christmas dinner. Up the elevator we go; Molly looks young and wonderful in her new multicoloured winter coat. My father is dressed in grey and black. My mother's mother is organizer and host. At this time, the roof is a bar with a small dining room on the north end. The remainder is a roof deck with a parapet. Granny Greene, as we call her, has booked the whole dining room. Aunts, uncles, all my cousins are there for the roast beef trucked up on the elevator from a basement kitchen. We all sit at a long single table sharing shingle-like scalloped potatoes, khaki peas, squash and genes.

LORD NELSON HOTEL
Halifax, N.S.

Christmas

1941

Dinner

Celery en Branche Queen Olives

Rose Radishes Mixed Nuts

Supreme of Orange and Grapefruit Palmyra

Clear Green Turtle au Sherry

Medallion of Lobster, Cardinal

Mignon of Beef, Lucullus

Christmas Roast Stuffed Turkey, Savory Dressing

Giblet Gravy Cranberry Jelly

Fontante Potatoes

Buttered Green Peas

Baked Squash

Yuletide Plum Pudding Noel Log

Hot Mince Pie Christmas Cake

Ice Cream

Friandises

Coffee

$3.00 per Person

LORD NELSON HOTEL, Halifax

Program

1941

CHRISTMAS DINNER

Ballroom and Lounge 7.00 P.M.

Music by

Nick Schoester & His Orchestra

DANCING

Ballroom 10.00 P.M. to 2.00 A.M.

Music by

Harry Cochrane & His Orchestra

GOD SAVE THE KING

New Year's 1952: a day of slate skies and a razor wind. I'm behind the garage with my new box camera, a recent Christmas gift from an aunt. This leatherette beauty,

black as jet, has a transparent round red window in back — like an animal eye caught by a headlight. I find it infinitely more mysterious than the clear-eyed triplet on the Deco lens board. Numbers, diminishing dots and imperious arrows roll by in the red glow within my picture-making box. The little prism viewfinders — one for horizontals, one for verticals — transform and order reality. Placing a border around part of the world's infiniteness aids comprehension. It brings me comfort and control. I carry it ahead of me like a chalice.

The grumble of tires on gravel betrays the return of my father's car. His new Austin has a deep green body and black fenders. Little lighted orange arms flip out from the door pillars on either side to announce the intention to turn. It's very English and up-to-date. However, my uncle has recently won a new Studebaker in a draw, a Raymond Lowey confection designed for interstellar travel. It makes my father's new car look like a hat box.

I race around to the front of the garage just in time to catch the Austin's boot sliding into the gloom of the garage. Motor stops, door slams, brogues scuff on gravel, then a dark coat and hat emerge from the shadows. I ask him to pose for a picture. He pulls down the garage door and advances a couple of feet. He's tall as a totem in his dark charcoal wool overcoat and black fedora. He stands slightly tilted to the left, hat canted

opposite. The sharp wind tugs at a corner of his coat. I stumble backwards trying to fit his height into the frame. The crude right-angle viewfinder uses a small, angled mirror behind a meniscus. Finding the subject is like searching for a dime in a well bottom. He's there, then I lose him. When he reappears, chromatic aberration wraps a rainbow around his shoulders. He clears his throat, a bad sign, so I quickly depress the shutter. He coughs, turns and leaves. It's over.

But it's not. This photograph, the first I ever made, was to have a very strange journey. Twenty-five years later the little deckle-edged, ferrotyped print fell out of a book in my studio. I picked it up and stared, transported back to the gravel drive and the glacial wind. I decided to put the print on my copy stand and make a new negative in a larger format. In the darkroom I began to enlarge the head and pulled and dried a big print. It wasn't very good so I folded it in half to make it fit the darkroom garbage bin. It was then that I noticed something odd. The two sides of his face were quite different. It was like half a portrait of two people in that coat. Here was a man deeply uncomfortable with the world, his lot and his family. There was anger — we were all to blame.

Back in the darkroom I continued to enlarge it, eventually pulling a life-sized print of the full figure that I later mounted on board and cut out on a band saw. Now I could carry my father under my arm. One

summer night I set it upright in a meadow halfway down the Scarborough Bluffs. I unfolded a heavy tripod some distance away and screwed a big view camera on top. After opening the shutter I ran forward in the darkness through the long grass and lay down with a flash tube in my hand before the cutout. Blue light leapt up the figure. Then I moved in over and farther back and popped the flash again. Crickets chirped and scratched away. I made four more repetitions so that the figure retreated slowly backwards and rightwards out of frame. There was a heavy dewfall that tended to condense on the lens. Each iteration of my father glowed with a luminous halo, floating in the dark landscape. It was a very strange and freighted picture that was to hang in many art galleries over the years.

Eventually Warner Brothers records in Los Angeles bought rights to use it on an album cover for the Seattle band Quarterflash. The recording had one of those hits — "Harden My Heart" — that you heard for months every time you turned on the radio or walked into a shoe store. I recall taking a cab in from Heathrow some months later and riding past Virgin Records on Oxford Street. My father stood in the window, large as life. When he found out, he tried to sue me and I learned something about the power of photographs.

 "I have a photograph of your father that I must give you. I took it a decade ago while sailing with a friend in Esquimalt. We came abreast of a small rowboat drifting off the naval yards. It wasn't until we were very close that I realized the old man hunched in the boat, staring at the base, was your father."

 On my fourth birthday Molly persuaded my father that I should begin to receive an allowance. They decided that I would be refinanced every Friday when he returned after the work week in the city. "Is it Friday yet? Is it Friday yet?" I repeatedly asked Molly for the remainder of the week. The wait for that first Friday was interminable. When the end of the week finally arrived she loaded me into the car and drove to the railway station. Trains loomed very large in those days, not only because I was small and the locomotives were huge, sweaty and black, but because they had, within a human lifetime, pulled the country together by dragging long lines of passenger and box cars across the continent. Those giant mechanical snakes were freighted with meaning and metaphor.

The dark beast came ground-grumbling into the station and crunched to a standstill. Dozens of grey men in long dark coats and face-shadowing fedoras descended and dispersed. My father was at the far end

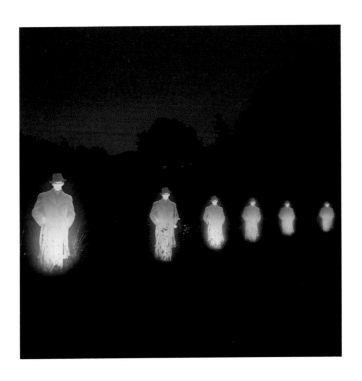

PLATE 10

a strange and freighted picture

of the platform. He came toward us in those brutal brogues that many men wore then, their laminated leather soles and thick uppers like an armament for the foot. I suspect that the taste for these heavy shoes, the notion that the foot should be isolated and insulated from contact with the earth, was the legacy of a youth in the services. Indeed, this soldier-foot stuff seems the most visible and enduring remnant of military training. I've known many ex-servicemen, including the most unwilling Vietnam vets who, though otherwise dishevelled, disorganized and hostile to authority, regularly gather all their families' shoes— wives', sons' and daughters' — and vigorously clean and polish each one on an elaborate and orderly polishing box. The ritual is terminated when all the shiny shoes are lined up in a neat row, as if for inspection and parade. My father owned a varnished shoebox, its wooden sole and negative heel supported by two little columns above a little mansard roof. After Molly died, it was one of the first things my sister and I pitched.

After a perfunctory kiss on Molly's cheek, he proceeded to the car and queued to escape the lot. Once back home I orbited around my father, trying to be noticed but not annoying as I wanted to begin my new life as a kid of means. Finally Molly intervened and reminded her husband who promptly changed allowance day to Saturday. I'd have to sleep on it.

Following breakfast the next day he took me aside

and surprised me by offering a choice. He extended both arms, hands palm up, with a single silver coin in each. I was to select one. No one's fool, I went for the larger of the two coins and a quick reading of my father's face told me I'd gotten away with it. That afternoon Molly and I made our way on foot to the old service station by the highway, which had a small wooden concession stand with a large shutter, hinged at the top and supported by a stick. It was a stretch for me to reach up and deposit my precious coin on the counter of that treasure house. Rows of bright foil bags, brilliantly coloured paper wrappers, glass jars of chromatic gum balls, long strips of white paper with tiny half beads of candy stuck to them — green, yellow, blue, red and purple — and small boxes that promised both sweet stuff and a prize. The old lady behind the counter patiently explained what my silver coin would buy and waited while I agonized over the choices.

The following Saturday was a repetition of the first — the selection, the walk and the big decision. After several weeks of this I finally encountered another kid at the stand. As he was ahead of me, I was obliged to wait until he had finished his deliberations. I knew it wouldn't take long as this slightly older boy only had one of those pathetically small and thin silver coins that I had passed over. I was outraged when he was handed twice what I'd been receiving. The

storekeeper and my mother tried to mollify me — without success. I felt betrayed. Then the shopkeeper produced a pair of coins, as had my father, and carefully explained the difference between a nickel and a dime and the relative values of apparently similar metals. When Molly finally understood the game that my father had been playing with she angrily marched us home and confronted him.

He was sheepish, what else could he be? Looking back from the present I can now see that this was to become a pattern. When he taught me how to sail, he explained the perils of a gybe but never how to execute a controlled one. Then he'd race me in our cedar-strip dinghies, skilfully gybing around the turning rock and beat me back to the dock. All of this ricochets around my brain whenever I confront one of my sons across a pool table or slip ahead of one of them on a bicycle or in a kayak. I know that they're convinced that I withhold information and fail to teach them how to use tools. I'm not conscious of competing, but I surely must be.

John Mitchell rows past Laurel Point and elects to hug the south shore of the Inner Harbour rather than cross to Songhees Point. He rows outboard of the *Victoria Clipper* and the *Coho* — both are loading for the States.

He crosses James Bay, then ships his oars and holds for a float plane to taxi outbound. The wind is rising but there are no seas in this protected Inner Harbour.

Natrix sipedon slips through the water — slithering, sibilant, sinuous and sexy. I watch the four-foot black water snake undulating just offshore below the high pink rocks. Its body is as thick as my eight-year-old arm.

My father emerges from the big, dark, board-and-batten cottage. The screen door slams behind him. Black hair, icy white skin and a boxer bathing suit. Long pale feet move a pipe and thick-bottomed glass of rye. He coughs and moves toward a bench on a high dome of gneiss. He sits down, crossing his pale thin legs. The wind whispers through the white pines and small waves lick the rocks. It's late July. He doesn't see me crouched in a cleft.

The snake oscillates along the high rock dome searching for a landing. Commander Mitchell's pale blue eyes are focused somewhere just short of infinity. He's lost in his tobacco and alcohol — staring out across the bay toward the islands several miles to the north. The snake carves *S*'s in the thick water — side-slipping along the rock face, its head high, black tongue flickering, near me. Up above I hear ice cubes clink in a glass, then throat-clearing. There's a desert clarity to the light. Sky, rocks, water, pines — needle

sharpness everywhere but in the delicious depths of soft water caressing rocks and sliding along the thick dark body of the snake.

Then I hear the bench fall backwards and the brilliant crash of the rye glass on rocks — the serpent has been seen. My father is now up and moving, passing behind and above me, oblivious to my presence. His furrowed face has turned bright red as he races over the rocks throwing stones, sticks — anything he can find — at the big dark snake. His movements become stiff, jerky, convulsive. The tendons in his neck cord out rigidly, the deep flush of his face has begun to cloak his shoulders. He is frantic, pitching stone after stone at the snake as it swims along the shore. *Natrix sipedon* dives easily and my father stiff-legs it back and forth across the shore rocks, his head bulled-down and glistening with sweat. The snake resurfaces 20 feet down shore and my old man is clawing through more loose rocks and tossing volleys that geyser around his fearsome serpent. A pale man on fire scrabbles along the shore. Snakes make him blind, mad, crazy. He's terrified. The snake is all control.

A great serpent with the feathers of a Quetzal once held the high Mexican plateau. There was a time when a Rainbow Serpent churned outback dust in the Aborigines' mind. And the Kwakiutl once whispered tales of Sisiutl, a serpent beast with a head at either end. My father is in thrall to them all. I am outside —

feeling nothing. It's just a snake. But I greatly fear the old man's flailing loss of control, his enormous terror.

The little white wherry lies against the float dock, its painter made fast to a wooden piling, black and rank with creosote. Coiled, wet, glistening, the balance of the line suns on the deck of the dock. The wherry's oars are neatly shipped, a beige windbreaker is folded neatly beneath the seat. The only crew member has gone ashore for a pint.

Stepping down from the train I emerge from shadow into light and heat crashing all around me and spinning up from the white dust at my feet. My head pounds as I try to keep my balance in the dazzling mid-afternoon light of southern India. Three of us are walking toward four distant *gopurams*, shimmering temple towers rising above the Tamil Nadu town of Chidambarum. As we pass through the outer temple wall, a stone Shiva dances around the *gopuram* above us, wheeling upwards through over a hundred poses until reaching the peak 150 feet above our heads. The temple compound is enormous — the perimeter wall encloses a sacred square of more than 30 acres.

We bend to the heat and remove our shoes for the long barefoot journey toward the next ring of walls,

nesting, one within the other, in this huge Dravidian shrine to Nataraja, the dancing Shiva. We shuffle through a gateway and make for the thousand-pillared hall at the centre. We take our time and soon dusk is upon us. As we pass inside between the rings of columns surrounding the core, the ground falls away. We descend through ranks of pillars down stone steps in ever-increasing darkness until a great black cube looms up before us blocking our way — the very dark heart of Nataraja's shrine. We stand surrounded by hundreds of devotees, motionless, silent, expectant, in the dim-dancing torchlight.

Minutes stretch in the darkness — it's suffocating, claustrophobic and daunting — so many people so quiet and still. Finally, a bell rings. The sound, coming from somewhere off in the distant recesses of the colonnade, is very small but unmistakable. It gradually slips away like the light. Quiet. Another bell rings — larger, lower, longer. I know this one — my father's ship's bell lifted from the bridge when one of his vessels went into lay-up. I've heard him striking it amidst the humping rocks of the bay. I'm now very focused and alert. The familiar ring dies away. A brief quiet follows — only the whisper of a thousand people breathing.

Suddenly a larger bell rings, then another and another and another. More hidden bells clang in the darkness and the cacophony mounts, building and

building until my head is a hollow ringing, screaming sphere and every organ in my body is vibrating, sickeningly to the great circling engine of noise roaring through a thousand stone pillars in the blackness. The unrelenting sound expands and expands until I feel ready to fall down and vomit. The sanctum before me suddenly bursts open and dozens of idols within explode into flame. The bells cease and their diminishing sound swings round and round the great hall, decaying as the violent light from Shiva and his burning consorts gets hotter. Then doors of the sanctum santorum close with a crash. We are left drained, stunned and stupefied in the dark. Silence seeps back. The ritual is over. We leave for a night of restless sleep in the heat.

Late the next morning we board a bus for the great temple town of Kumbakonam a few hours away. It's a long dusty ride in the heat with many stops on the route. As we approach Kumbakonam the many *gopurams* of the town's four enormous temples climb skyward in golden dusk. I'm beginning to understand what the many ceremonial centres of Oaxaca — where I'd once done archaeological work — must have been like when they were living places. We descend at the bus station and make our way toward Big Bazaar Street.

The market is still open. Here and there stall owners are lighting lamps as night falls. There's a commo-

tion down the street as a very large elephant emerges from one of the temple gates. It has no rider. This magnificent creature wears a crimson blanket covered with bells — in fact the whole animal is covered with hundreds of bells all of an extremely distinctive shape. Each golden bell has a knife-edged brass ring turned around it just below the shoulder. I think of Saturn.

The elephant makes its way from stall to stall, pausing at each to extend its trunk to the owners, each of whom offers a few rupees. It then flips its trunk backwards over its head periodically, dropping the offerings into a large basket on its back. It's a hypnotic sight — we watch open-mouthed until the rounds are complete and the great beast retreats into its temple. We begin walking again. We need to find somewhere to eat.

Many of the stalls are beginning to close up. We move on to a new street where most are already shuttered for the night. However, near the end of the block light spills from a single large stall. We walk down to investigate, hoping to get food.

It's the shop of a cookware vendor. Huge aluminum pots are stacked along the canvas walls right up the roof. Between them are many columns of smaller pans of all shapes and sizes. There's a small open space in the middle where two men sit on a carpet under a bare bulb drinking tea. They get up to greet us.

These men are brothers. One owns the stall, the other, a scrap metal dealer and ship-breaker, is visiting

from the opposite coast. We immediately fall into an animated discussion. Back in Toronto I had been working on a project to turn two vintage Lake Michigan railway ferries into studios. I'd struck a deal with the Harbour Commission for a thousand feet of seawall near Cherry Beach. On options I'd gotten two 330-foot ferries from the 1920s as far as the north shore of Lake Erie where they were at this moment frozen into a little harbour near Port Colborne. I loved those old ships. Each had a pair of triple expansion steam engines of a magnificence that would make you weep: such beautiful doomed technology from the days when big machines just whispered and sighed rather than crashing away like the engines of hell. I was going to give them a new life.

The shipbreaker pulls a calculator out of his dhoti and begins punching numbers as he interrogates me about my boats. In a minute, with a big grin, he announces that I am paying $350,000 for the ships. He is right. He knows the spot price of scrap steel in every part of the planet. It is his business, but still, I am impressed. As the conversation winds down it ends the way so many in southern India do. He asks me if there is anything he can do for me.

During the first few weeks of travel I didn't take this goodbye seriously. I thought that it was as empty a salutation as "Have a nice day" or "Take care." It is only recently that I've begun to understand that when

people in the south say it to you they mean it. "Well yes," I say, "there actually is." I tell him how entranced I was by the sight of the alms-collecting temple elephant. If there is anything I want to take away from India it is one of those beautiful brass bells. We have travelled by bus and bicycle with one tiny backpack each so it will have to be small. But it will always remind me of people and places from one of life's richest experiences.

"It will be no problem," he says. "Just return in a couple of hours." So we set off once again to try to find supper. Dinner turns into a long meditation on life and death. One of my travel companions has been living with an aggressive cancer for several years. This Indian adventure is a brief remission trip during which he has hoped to find absolution, salvation and a renewed life. He is still very ill, frantic and desperate. This evening we are dealing with his condition by drinking many quarts of Bullet Super Strong Beer. We are all getting less and less coherent.

"Oh shit! I forgot about the bells," I suddenly exclaim. "I've got to go — the brothers may still be waiting for me." I throw some rupees on the table and set off through the now very dark streets of Kumbakonam. After a few wrong turns, I finally spy the stall down the next block. Miraculously the lights are still on. When I reach it, with a mixture of breathlessness and guilt, I freeze in the dusty street. The

place is totally transformed. The pots and pans have vanished. The whole stall glows with a golden light reflecting off dozens and dozens of bells.

I must be standing in the street for quite a long time because finally one of the brothers comes out to get me. He explains that they sent runners — young boys — out to various foundries around the town and have had them bring in all the bells they could find. I feel very awkward — there has clearly been a misunderstanding. Apologetically I begin to explain again that I am travelling largely by bicycle and carry only a small backpack. I only need one bell. "We know that," he says. "The important thing is that it be the right one — that it be your bell."

They pour me tea and hand me a bell to ring. I listen carefully and put it down. I am given another. I drink tea and ring bells well into the night. Some are tiny things that can be held between two fingers. A couple of them are as big as washtubs — it must have taken several people to carry them there. There are bells of every conceivable size in between. All are the same beautiful shape. I ring them all and finally find one that speaks to me. I am lucky — it is only about seven inches high. I drink more tea, ring more bells and then return to my choice and play it again. There is absolutely no question in my mind — this is my bell. The older brother places it on a scale. Three kilos. He pulls out his calculator, runs up some numbers and

asks me for two dollars. India is the moon, it's hell, it is heaven, it's Mars.

I brought that bell back to Canada, took it home, and lost it. It was gone for nearly a decade and then one winter day, unpacking some boxes, I recovered it. Never again would I misplace it in a move. In the spring I packed that bell in my bag and took it north when the ice began to break up. I ran it out to the island in my boat and hung it from a rafter beside my father's ship bell. They were the same size. They sound the same note. One is a little sharp, the other slightly flat.

 Puberty falls like a rough stone into glassy waters after first light. In an instant the water follows the stone down a polished hole toward the depths, then, after briefly erupting into a small squirting geyser, collapses into glistening rings rolling outwards, searching for the shore. The rings touch everything. All is charged and changing.

Friendships shift, you avoid your siblings and hide from your parents. You desperately need to elude the whole adult world of teachers, policemen, neighbours and relatives.

We'd run off to the rail yards. There was only one train a week. It would steam down the main line from Toronto, go onto a short siding, and then clat-

ter through a manual switch and crawl through the fields north into town. It was an old Canadian National 4-6-4, #5431, a coal burner, pulling a handful of boxcars of lumber and a caboose. The rest of the week the place was ours. We soon learned how to jimmy open one of the old wooden warehouses flanking the tracks. Straw and excelsior lay on the floor and sunlight knifed through the planks in the walls, slicing up the dust. We'd go down in small gangs, boys and girls, climb the loading platform and breathlessly giggle our way through the crack in the sliding door. Once inside, we'd take off our clothes.

It was best to go there with the Dutch girls. The four sisters had everything. The oldest, well into her late teens, was already a woman, big, fleshy, and knowing. Her fifteen-year-old sister was lithe and quiet. Marta, just passing twelve, had a soft round belly, high breasts and strong white thighs. The youngest was a tiny sylph with large pink nipples on her flat chest and a soft mound, split like a mouth, between her legs. She was the only one without pubic hair.

We'd tumble, crawl and explore, sharing our bodies, the slight acrid smell of urine, the faint, sweet, whiff of shit and the near perfection of youth. Pale figures in the golden darkness slipped quickly through the sunlight slashes from the unbattened walls. It was our Eden.

Then the oldest girl would get anxious. Slowly

we'd all pull on our clothes and one by one dance through the crack in the door out into the brittle light of the day. A crow often called from the roof. Pickups rattled down the cinder road behind the big sheds. We'd all climb the hill back home to the smell of furniture polish and the ticking of a dozen clocks. The adults were in charge again.

I'm holding a late 19th-century photograph made by the Steffens Studio in Chicago. A photographer of the period would have called it a cabinet card — a mount slightly over four by six inches, bevelled and gilded on the edges, with a radius on the corners and an embossed imprint. The albumen print on the mount records a moment in the lives of two very pretty young girls: Molly's mother and her older sister.

I never knew the older sister, Molly's Aunt Louisa, but the younger and prettier of the two, my grandmother, Elizabeth Chapin Greene, was a major figure in my youth. She was tough, you couldn't get much past her, but she could also be very generous. The daughter of a successful Chicago stockbroker, she brought a respectable inheritance to her marriage. But she also married well, not to money, but to talent, charm, hard work and decency. My grandfather's family, the Greenes, had been knocking around the western end of Lake Ontario for a few generations.

As far as I can figure out, the family had two trades, Anglican ministry or lawyering, business and dissolution, with successive generations alternating between the two. As Church of England ministers, they set up an early parish near Dundas and Burlington. A branch of the family did missionary work on the B.C. coast — my distant cousin, Canon Greene, and his little steamer, both mission ship and church, being well known in the coastal communities on the inside passage and up to Skagway and the Queen Charlottes as the *Columbia Coast Mission*. That was where the two unrelated families, Mitchells and Greenes, first unknowingly intersected: many of the breakwaters and wharves that sheltered the mission ship on her journeys up the coast were engineered by my father's father.

Across the country and a generation later, the Greenes and Mitchells were also accidentally crossing paths. A web of convoluted knots and unravellings took me to the eastern arctic several times, which in turn got me involved with some Inuit artists who then connected me to Canon Greene's son who was running a gallery of Inuit art in Toronto. His beautiful green canoe would occasionally arrive at my island after a night crossing on Georgian Bay. Looking like Hemingway, past 70, and usually with a woman many decades younger in the bow seat, he was nearly as skilled an embroiderer of fact as myself. When, at

some point in his 70s he decided that he could no longer tolerate sleeping on the hard rocks of the bay in the cold rain, he passed on all his canoeing maps to me, including an elaborate map, that he'd hand-drawn, of all 330 islands in that mystical and remote offshore archipelago, the Bustard Islands. He too was a painter.

As was the Greene who married the broker's pretty daughter from Chicago. By day a businessman who served as president of several corporations, chiefly ones making cigarettes and cigars, he was, by night and by Sundays, yet another painter and sometime sketcher with various members of the Group. I remember sitting, more than a decade after my grandfather died, with the printer Chuck Matthews and A. J. Casson at the former's house and having the two men say to me, "Here, borrow these drawings. If you're even half the man that Lorry Greene was, we know that you'll bring them back." It made me feel very small.

Was my Greene grandmother tough? One time when my parents were away on a business trip, my sister and I were deposited with that formidable woman at her country place, Four Oaks, outside of Ancaster, Ontario. It was a rather charming white clapboard place that rambled along, in various extensions, under some ancient giant oaks overlooking a wheat field that

rolled off down to the west toward Dundas. I was back there recently. The house still stands but the rolling field has been sold off and subdivided. We live in a culture of amnesia — there are only presents and imagined futures — so I was very touched to discover that the new street was called Greenefield.

When we stayed with her we always fell into a pattern. My sister and I would be playing along until an argument. Sue would throw a tantrum, I'd punch her and she'd go crying to our grandmother who would tell her to work out the business with me herself. She would return shouting and, of course, I would then go to my grandmother for backup. No deal. At this point my sister and I would become allies with a mutual hatred of our heartless grandmother. Now side by side, we'd approach her to ensure that she understood how cruel she was and how superior was her daughter, Molly, our mother. In fact, she'd better know that we were now leaving and going back home to Mommy. "Fine!" she would say, and off we'd set, two determined preadolescents, on the 30-mile walk back home.

This occurred a number of times. We'd usually get down the long drive and then a mile or two down the public lane to the highway. The old highway was narrow and home to considerable truck traffic so we'd be obliged to walk in the ditch. It was scary and exhausting so at some point we'd be forced to give up. Our

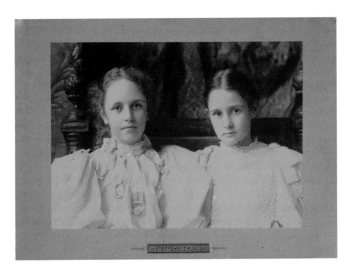

PLATE 11

the broker's pretty daughters, Louisa and Elizabeth, circa 1890

defeated return was always humiliating. I'd have trouble reaching the large brass lion knocker and Elizabeth Chapin Greene would take her time answering it. Around this time Molly tried taking a leaf from her mother's book and dumped both of us out on the shoulder of Highway 2 in the middle of winter. She drove off, spinning a mixture of gravel and ice into our faces. Experienced highway walkers, we trudged home through nearby fields. Years later, Molly confessed that she was nearly paralyzed with guilt all the way back in the car and while waiting for us in the house telephoned every friend that she had as a distraction.

Not so her mother. Now when I think of Granny Greene, I'm impressed by the intelligence that adaptability requires. Here was a woman who reached adulthood during the nineteenth century and lived late into the twentieth. An adult before automobiles existed, she spent the last quarter of her life jetting to Europe every summer and to Barbados for the winters. She shared this extraordinary shift with her many grandchildren. Thanks to her interest and her pocketbook, we were all sent off on a version of the grand tour. As the oldest of all the cousins, I was the first to go. At 15, I was bundled off in late spring on the Montreal train at Union Station in Toronto, then down to the Port of Montreal by cab and onto the *Empress of France*. There followed an amazing voyage

down the St. Lawrence, past the cliffs and battlements of Quebec City and out the Straits of Belle Isle, all the while dodging an armada of icebergs. I can still feel the deep chill that would envelope the decks as we steamed by each aqua island of ice. I spent the eight-day crossing playing strip poker with a variety of not-so-proper young girls from remnants of the Commonwealth — Kenya, Australia, and Malta. I was learning things — just as my grandmother wished.

As a callow youth of 15, I can't claim to have appreciated what she did for me at the time. I am pained now to think of the bills I ran up, staying for six weeks in a hotel suite in Knightsbridge, and I recall with amazement having rented an Austin A35 — I had neither a driver's licence nor experience. The only incident that I now remember is getting lost on a roundabout in Plymouth and being screamed at by bus and lorry drivers as I wobbled round and round the centre island in that little white car, trying to decide where and when I should bail out of the circle.

Much of that trip seems an improbable dream and in many ways it was. One of my big passions at the time was astronomy. Since I had little money I built my own telescopes. Many winter nights, after doing my homework, I would solemnly walk for two hours around a stool in the basement to which I had glued a glass blank for an eight-inch reflecting telescope mirror. Night after night, for month after month, I

rotated one thick blank on top of the other, with ever-finer grades of jeweller's rouge in between, as I slowly, painstakingly, ground a parabolic curve into the glass. That telescope did get built and I did get to see Saturn's rings and the moons of Jupiter. On my English trip I stayed with a cousin of my grandmother's who had been a rear admiral in the Royal Navy. He took me into his backyard in Gilford and showed me his observatory. It had an enormous brass refractor telescope on a fluted cast-iron pedestal centred under a rotating dome. My telescope was a cardboard tube, azimuth-mounted on a wooden ladder.

In Lancashire my two great uncles, Frank and Jack Mitchell, took me on numerous day trips and hikes. We'd set off each day in a 1935 Daimler limousine, regularly refreshing ourselves at inns and pubs. One day we made an expedition to the site of a key incident in a somewhat obscure narrative poem that they treasured. During the long outbound drive, a grumble of alarming noises began to issue from what was then, at least, a 25-year-old transmission. Though not yet a legal driver, I had some mechanical expertise, busying myself, at that time, with the systematic desecration of a perfectly preserved 1927 Plymouth Coupe purchased from a farmer near Peterborough. A neighbour and I put motorcycle fenders on it, changed the wheels, and painted that little coupe baby blue. When my partner paid for a brand new Oldsmobile V8 to re-power it —

the cash handover was in the Rosebowl Diner in Oshawa — he was putatively given a map of the nearby Lake Ontario shoreline with an *X* marked on it. The motor, supposedly lifted during a GM nightshift, was wrapped in tarpaper and buried in Oshawa Beach.

My two great uncles seemed not in the least concerned about the drum kit beneath the floorboards. We carried on, paid our respects at the riverside location of the ancient drama, and limped off in our thumping limo for tea. I eventually got tired of being patronized whenever I attempted to alert old Frank and Jack to the dying transmission. When we emerged, drunk and sleepy, from a very leisurely lunch, I discovered the reason for their lack of concern. They had a second, almost identical Daimler, with a second, nearly identical driver, waiting for us in the car park. We swept off, our schedule uninterrupted, leaving the original car and driver, like an abandoned tea trolley.

Forty five years after this trip I found a thick bundle of aerogrammes carefully sealed in a "HEFTY OneZip" food storage bag. All dated the summer of '59, they were one half of an astonishingly intense correspondence between Molly, travelling with me in England, and her husband back in Ontario. He had carefully filed and saved all her letters: she had tossed his.

With Molly and I wandering about England and Sue off for a summer of camp, he clearly was lonely

and lost. He had conducted a paper pursuit of her across the Atlantic, down into Cornwall and Devon and all the way up into the Yorkshire Dales. She had tried to mollify him every 48 hours with a brisk log of our adventures spiked with some yearning and sympathy. Although we were officially a trio — Molly, her mother Elizabeth Chapin and myself — we often went our separate ways for several days at a time. While I was enthusiastically logging warships, exploring pillboxes, climbing towers and spelunking, a drama of love, loss and loneliness was being scratched onto little squares of thin blue paper. They would have regularly passed each other mid-Atlantic on the 18-hour mail flights. He was clearly trying to get her to come home.

21st June, 59
Empress of France
Last night they had a special evening of the "Empress Daily" consisting of six passengers cutting long pieces of tape with curved nail scissors. You were to bet on them. I won on a long-haired man — enough money to keep me in cigarettes at $2 a pack for the rest of the trip. Michael seems to be hitting it off with Erica, a young woman from Kenya who is traveling with her mother. Your lazy son is just getting up at 1 o'clock. There was a dance last night and he danced with me then disappeared. He was the last in the cabin, well after 1 A.M. The party was fun but I missed you.
Molly

July 27, '59
Basil Street Hotel, Knightsbridge
Well I suppose that you are running out of socks . . . I feel
like a nun or a girl in boarding school. I'll probably break
out of my cell with a Hell of a yell so watch out!
Molly

August 2nd, '59
Ibid
Terribly sleepy but I'll make a start anyway. I am trying
to get as many replies off to you as possible. You sound so
blue in yours. I hope that your endless bad dreams go away.
 We are all together again so Michael is back in the room
with me tonight as mother wanted one to herself as usual.
It works out better as she can have a rest without being
disturbed by him as he is always slumped over his diary
and nearly asleep. He is so long-winded about his adventures
of the day that he has a hard time getting to sleep before
midnight every night.
Molly

August 12
Looe, Cornwall
O.K. So I just got an outside report on your trip to G.B. and
I hear that you're a bronzed, handsome, bachelor. Eh! I will

look pale and dried up beside you. When I see these couples
here in the hotel I feel like a widow or a spinster. Dad is
coming over soon to take Mum to Denmark. I wonder if
he could slip you in his suitcase.
Molly

August 20TH
Rock, Cornwall
Well I must go to sleep. Mike and I are sharing a room
again and he writes in his diary for hours until I can't stand
it any longer. He must have a whole book by now. He is so
long-winded. Now the dancing orchestra downstairs is
playing Tea For Two, making me homesick for you.
Molly

August 24TH
Plymouth
We spent the day at Peignton where mother's Puritan
ancestors come from. In the ancient parish church they got
out an old birth book and other records from a safe and there
he was, Samuel Chapin, born 1589, one of the one hundred
people who sailed on the Mayflower in 1620.
Molly

There is also one letter from me apologizing for not writing sooner.

August 26TH
London
Well I'm really becoming an Englishman. I've carefully studied their lingo. A few days ago I went and saw King Arthur's castle, which really isn't his castle and has nothing to do with him at all. It was built in 1200 A.D. and old Art lived in 500 A.D.

We went to Peignton the other day to see the parish church where Samuel Chapin was born, baptized and married. He was Gran's great, great, great, great, great grandfather or something. He was one of the pilgrim fathers and founded Springfield, Mass in the States. The church is full of carved figures of saints but old Sam, being a Puritan, knocked all their heads off. I went to an amusement park and had my fortune told by Madame So and So. She said I have unusual powers of attraction for the opposite sex. What a lot of guff. Today they had rowing races in Hyde Park, an Olympic warm-up by many countries. When the rowing shells raced the announcer declared it was "really ripping, chaps" or "jolly fine race." When the Canadians came out in war canoes he referred to their beautiful boats as "a rather difficult and crowded way of traveling over water." I still haven't seen a cricket match yet. Sinner!
Au Revoir
Mike

 "Hi, Mike. Your father's not here — he's taken his little boat down to the sea again. God's teeth! Who knows where he goes or what he does in that thing. He'll be gone for hours, if not the day. Maybe this time he won't be late for supper." Listening to my mother's voice on the phone I can suddenly see the kind of meal she'll make him. Potatoes will be boiled, she'll thaw some peas and throw a couple of patties from a package — they'll look and taste like skinny brown hockey pucks — into a thin aluminum non-stick pan. Eating her cooking was a job, like brushing one's teeth.

In the mid '60s while at university I met Annick. More than a decade later, after various twists and turns, she became the mother of two boys that John Mitchell wryly called the first Jewish Mitchells. Born in Paris to a Jewish mother, she was at the nexus of two great culinary traditions, although she generally referred to it all as just "fressing." Not long after we met she asked me if there was anything that Molly cooked that I liked. I flipped through years of suppers in my mind, trying to recall anything in Molly's hastily thrown together meals that was memorable. A dim image of a dinner called "Stuffed Flank Steak" finally surfaced. It would appear several times a year — I could eat it. The following weekend Annick

invited me for supper. Beaming, she placed dinner on the table while I opened a bottle of student wine.

"What's that?" I asked her — it didn't look like anything she'd ever cooked before. Her triumphant smile wavered briefly. "It's Stuffed Flank Steak," she replied. I stared at it more closely and then finally tried a piece. A roll of lightly cooked beef was cloaked in a sauce of considerable subtlety. The whole thing was tender and delicious but she'd got it all wrong. Molly's Stuffed Flank Steak had sat on the platter like a long, dried, grey turd. Its only taste was the stuffing, the same one that filled her dessicated chicken and turkey dinners at Thanksgiving and Christmas. If Annick was going to memorialize my best WASP dinner she was going to learn how to leave the oven on and forget the spice jars. John Mitchell would not have eaten it.

2003. I'm sitting on the deck of my sister's condominium eight floors above downtown Toronto. Sue is beside me, giggling, as she hands me a transparent freezer bag full of grubby cards. "What's this?" I ask.

"Open it. I just found them unpacking some of Mum's boxes from Victoria."

The greasy stack of three by five cards is subdivided with crumpled index cards on cream stock. I flip through the tabs: Sandwiches, Frostings, Pies, Salad Dressings, Soups, Fritters, Preserves.

I look under Sea Foods. The first card says "Shirt

Waste $800.00 — Sold." The shirtwaist card is fol-
lowed by "Onion Study — Sold $95." The next card
is a recipe for Seven-minute Fruit Whip with a card
for Fruit Salad Stretch glued on the back. "When
making fruit salad to serve a large group (or to stretch
a small amount of leftover fruit) add cubes of fruit gel-
atin. Make the gelatin with juice from canned fruit."

Thankful I'd missed that dessert. I flip to Soups.
The first recipe is for Ground Meat Whirls — missed
that one too. Next is something called Bovril Melba
Pickup. "Cut day old bread wafer thin. Remove crusts.
Spread Bovril Cordial lightly with pastry brush (Do
not soak the bread). Place on baking sheet and toast in
warm oven until very crisp and golden brown. Serve
with soups and salads. Don't waste the crusts. Dry and
save them for bread crumbs."

I dig further. Hot Relish that is Adjustable. Left-
over Cooked Cereal Pancakes. Peach Whip.
Hamburger Pie. Marmalade Delight. Niblets Brand
Corn "Quickies." Molly had a secret life — I don't
remember any of these. "Easy Lunch: 1 can of Tom.
Soup / 1 can Green Habitat Soup / curry powder /
Crab" — more familiar. Zucchini of the Week. And
then "Minnow Pool — Jan. 23/77, Images West,
$250, sold." This is all classic Fog filing. She's sud-
denly so present I feel very sad.

"Leftover greens can be palatable if seasoned well
with spiced ham spread, heavy cream topped with

crumbs and browned." "Hurry! Please send me __ copies of *Occasions*, The Knox Recipe Book, at $3.00 and one proof of purchase. Please allow 4 to 6 weeks for delivery." Not sent. Money's Mushrooms and Asparagus Recipe is written on the back of a cheque from the Bank of Montreal. Then, I find it. "Stuffed Flank Steak — costs $1.67, May 1948, *Women's Day Kitchen*." Next is a divider card labelled Family Favourite Beef. On the back is printed a recipe for Beef Brisket across which Molly has written in ballpoint, "Don't do this brisket — tastes awful."

Driving back from Ottawa a few weeks after this meeting with my sister, I decide to turn off Highway 7 at Perth and visit Molly's younger sister, Barbara. A retired art teacher at Central Technical School in Toronto and long-time arctic traveller with painter Doris McCarthy, Bar has decided to spend her 70s and 80s in a small overstuffed bungalow in Perth. I've phoned ahead so she has supper for two on the table when I arrive. She's put out a beer for me — her glass is full of a clear but slightly oily looking liquid that I recognize from her older sister's last dinners. I don't think that either of them ever put much mix in with their liquor. In the centre of the table a great truncated cone of rosy aspic trembles on a large plate. Shelled shrimp hang in the jellied gloom like little china comas. As she dishes it out I remember the recipe. Molly had it filed between Marmalade Pudding — costs 29 cents

(October 1947) and Coffee Gelatin Cubes with Custard — Source of Vitamins A, E Complex.

Even death can't vanquish Savory Aspic with Shrimps — costs $1.25, April 1947.

𝕯𝖊𝖈𝖊𝖎𝖛𝖊𝖗𝖘 𝖆𝖓𝖉 𝕴𝖒𝖕𝖔𝖘𝖙𝖔𝖗𝖘. Snow has been riding the high winds of this late winter storm for over 50 hours. From my studio window I watch it slash across neighbouring backyards and swing in wild eddies around the fence posts. As we begin the third day, the accumulation is just topping the sill that fronts my desk. There are reports of 30-foot waves rolling up the eastern coast and Buffalo, once again, is buried.

Inside, I have my own small paper blizzard. This book is built of Post-its — ideas born in the middle of phone calls and memories recovered in the night. The scribbled stickers paper the walls, cabinets and blinds. They hang like shakes from my printer and my fax. They are falling to the floor like October leaves.

I'm getting lost. These Mitchells saved everything. I'm losing sight of what's significant. Always too curious to know how people spend their capital of days, I am less certain what it all means.

July 17, 1908. My Mitchell grandfather, a civil engineer, writes his mother from his Bombay Burmah Trading Corporation offices, some 8000 sea miles from her house in Lancashire. He's upset

because his favourite elephant has died. How will he complete his work? He has spent the previous morning, over his boot-tops in the monsoon mud, sawing off the tusks. He buried them, helped by his coolie, but someone made off with them in the night. Whiskey, his dog, is fine.

He writes her from Oak Bungalow on August 9 to complain he's short of vegetables. He doesn't want a birthday present. A cake or plum pudding in a tin would be nice for Christmas. His assistant has just been quarantined in Mandalay.

He writes again on September 21. All is well. He's got a new elephant.

On October 5 he writes from Ondongau Camp in Burma.

My Dear Father,

Thanks for your note of August 26 and sorry my letters seem to have given some concern. You ask how I like the life out here. It is not all beer and skittles but there is much to be said for it. Everybody gets ill their first rains, it is the natural order of things. I have kept very fit, only three days fever in all. It is seldom I notice the loneliness.

You also ask if there is any serious danger in the jungle business. What there is we seem to escape as a rule. There has been a lot of cholera in the villages this rains. If I thought my constitution was going to pot I should chuck the show.

Yours affectionately,

Archie

October 22, 1908. He writes his mother. One of the tusk thieves has been caught. He awaits the arrival of the magistrate to issue a warrant for the arrest of the other. The previous night he witnessed some magnificent dancing at the fort where there was a gambling festival. Lost Rs 1400/. "There are four floating islands in the lake. One yesterday about 100 yards long was heading straight for here all day but the wind changed direction towards evening."

This adventure ends with malaria. He's shipped out to Victoria to recover. He marries his nurse. She's from Sussex.

Who were these people? I begin excavations in a stack of Mitchell cartons cluttering my studio. Letters, albums, clippings, contracts and cards — it's chaos.

Frank Mitchell's a Highlander who comes down to Lancashire following the Battle of Prestonpans of September 1745, during the Jacobite Rebellion. His son of the same name farms at Rochdale, where he sets up looms in a shed adjacent to the house. The weaving operation flourishes; they hire additional staff and establish a full chorus to perform Haydn and Handel in the loom house. There is also a floral society.

Hard times are the lot of the next generation. Two farms are abandoned by John Mitchell in consecutive famines. By 1829 they're back to the looms. Not their own.

Next generation. Yet another John. By age ten he's weaving fustian and by early adulthood is an overseer in a cotton mill. He takes a wife, joins a lodge, becomes a local official and walks in Queen Victoria's Coronation procession. By 1846 he's owner of a spindle and roller works. He takes on two partners, one of them his former schoolmaster, and converts an old gasworks into a weaving facility. Soon 150 looms are producing cotton velvet. He sells out to his partners but keeps the forging operation in the spindle and roller works. The Crimean War brings a small bonanza. He develops a method of machine-forging bayonets, hitherto made by hand. The Ordnance Office contracts for 20,000 bayonets, 20,000 Minie rifle sights and 50,000 rammers. However, the order is cancelled before completion — politics. But this John is not a quitter. By 1860 he's got a new partner and the pair establish The Primrose Paper Mills at Clitheroe. Success brings a second mill. By 1867 the partners have separated. Each gets a mill and carries on. The Mitchells are dragged into court for polluting local rivers and child labour.

Where does this lead? Politics — where else? This John Mitchell becomes Mayor of Clitheroe for two terms in the 1870s. He makes the local gas and water works public property and has the municipality purchase lands for a cattle market in 1877. The citizenry have tired of stepping in cow shit on city streets. The

next mayor falls ill and deputizes my great great grandfather. Workers in the cotton trade rise up against their masters so Deputy Mayor Mitchell calls in the Lancers to quell the rioting and arson. Until 1890 he holds Her Majesty's Commission of the Peace and marches at the head of Queen Victoria's Jubilee Procession in 1887. Nasty business.

His son Clement joins his father in the paper business — John Mitchell and Sons, of course. He also joins the 8th Rifle Volunteer Force. In 1870 he receives his commission as lieutenant and joins his fellow officers and men for a sharp-shooting competition on the Pendle Hill Range. They shoot at 200, 500 and 800 yards. Clement emerges triumphant with a silver cream jug.

Clement enters local politics — town councillor, then alderman, county magistrate, and finally mayor like his father. He is a founder of the local free library, cricket, bowling, tennis and golf clubs, promotes several choral and operatic societies and conducts a performance of the Mikado. He is still peddling paper through the family business. He dies in 1922 at 81, the same age as my father.

His two older sons, the bachelors Jack and Frank, take over the business, running it successfully for decades. In the early spring of 1947 their younger brother, Archie, makes the journey from Vancouver Island to

see them. On Easter Sunday he addresses a letter to the sole Mitchell of the next generation, his son Lieutenant Commander John A. Mitchell, Hamilton, Canada.

Almonds,
Clitheroe, Lancs.

John Dear,
Frank and I have been discussing your future prospects and also the future of John Mitchell & Sons. In the first place and now that you have been in business for several months, you will by now be able to form some idea of your future prospects. Are they favourable? If not, have you any alternative ideas? Regarding John Mitchell & Sons, it seems a pity for this very old firm to wind up. Frank points out that it is largely a personal business, i.e. dealing with people who are also personal friends. Perhaps you would be able to carry this on. He also points out that it would take a year or so to learn the "ropes" and that it would be advisable to spend some time in the paper mill in order to learn details of the paper trade. I think it would be advisable for Molly and Mike to remain in Canada until you found out how it worked out. This is about all I can tell you, John, as to whether you wish to consider the matter further would seem to depend on what appears to lie ahead of you, where you are, and whether you think Molly would like the life here under these grey

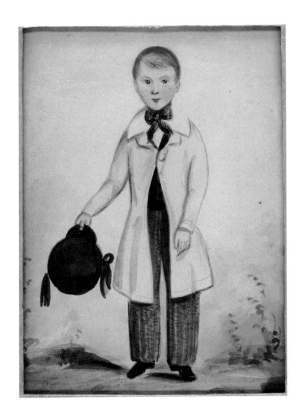

PLATE 12

triumphant with a silver cream jug (Clement Mitchell, 1842)

skies. Perhaps Molly would not be happy away from her family and friends. Regarding the antiquated conditions at Almonds, you know all about that. Still rather cold and sunless but I like it here in England.

My love to you all,

Dad

So here he was being offered a long established business, a big house and the life of a long line of John Mitchells. What discussions took place with Molly and what reply did he send? Given his unhappiness with his subsequent enterprises did he make a huge mistake? Was this the biggest of his many regrets?

The old brothers carried on with the business until closing it and retiring in 1955 after nearly 100 years of operation. Their sister has married out and only the youngest brother, my grandfather, marries and has children, including the last John Mitchell, but he's busy building bridges and breakwaters in the colonies.

The sister, Sara Elizabeth, married a Clitheroe man, Walter Southworth, whose family was, like the Mitchells, in the cotton trade. Some years later the Southworth mills were to combine cotton and nylon in a fabric that achieved notoriety on the other side of the world as a British Expedition began its slow assault on the wolf-jawed slopes of Mount Everest.

It has now been revealed that material for the protective clothing was made at Messrs. J. Southworth and Sons' Jubilee Mill, Clitheroe. Cloth for the climbers' outer clothing and tents was manufactured at the mill, and, while being light in weight, it is extremely strong. Mr. Southworth told a reporter on Wednesday that the clothing being worn by the Everest men had been tested to withstand a wind force of 100 m.p.h. Mr. Southworth said that they understood that a member of the expedition — a New Zealander — had told a friend that their tents — of Clitheroe-made cloth — were a pleasure to live with.

— *Advertiser and Times*, Clitheroe

I have two memories of Sara Elizabeth. When I visited the family in the late '50s I thought that they were all somewhat decadent. A lot of them didn't seem to work — they just lived on family money, spending their time getting drunk at country clubs and speeding down back lanes in their Land Rovers. However Sara, the matriarch, seemed to spend much of her time on her hands and knees in front of her large brick house with a silver-handled knife in her hand surgically removing the few tiny weeds from her otherwise perfect front lawn. I would sit beside her on her putting-green lawn and talk. Periodically we would escape the summer heat together by descending to the huge whitewashed cold cellar of the house where she kept stoneware crocks of ginger beer. There, this old lady

and I would sit on wooden boxes, draining a crock into a pair of cut crystal glasses.

Frank and Jack, my great uncles, were the source of my sister's and my greatest thrills at Christmas. Every November the two old bachelors would wander about the drafty old family house in Clitheroe accompanied by their cook. Her job was to carry a large open carton from room to room. The two old boys would rummage through family cupboards, pull drawers and pitch the debris of generations into the box. When it was full it was sealed and shipped to Canada.

The big brown carton preceded all other presents on Christmas day. Out would tumble Victorian games and puzzles, knives, obscure tools and many objects that forever eluded identification. Somewhere I have a large collection of button hooks.

I did stay in that house, The Almonds, briefly in 1959. The dark pile of grey stone's chief charm was a masonry tower at the bottom of the garden. Here, in a study at the top, John Webster, practitioner in physick, wrote the definitive study of Lancashire Witchcraft. Published in London in 1677 *The Displaying of Supposed Witchcraft* confirms the existence of many "deceivers and impostors" as well as "divers persons under a passive delusion of melancholy and fancy." Webster utterly disproves the existence of "a Corporeal League made betwixt the Devil and the Witch, or that he sucks on the witches body,

has carnal copulation, or that witches are turned into cats, dogs, raise tempests or the like . . ." As a bonus, he also deals with the existence of angels and spirits, apparitions, the nature of astral and sidereal spirits, the force of charms and philters and other abstruse matters. All these troublesome issues are neatly tidied up in 346 pages.

DEVIL and the **WITCH,** This time we have agreed to meet in Vancouver. It's the early 1990s and my parents have now both passed their three score and ten. Yet when we connect in the lobby of a downtown Vancouver hotel they look very good. My father sports a well-cut wool overcoat and a nicely blocked brimmed hat on a rakish angle. My mother wears a smart pantsuit. They look healthy — I don't have to worry for now. As we stand in the empty lobby debating where to eat, the doors of the elevator behind them open and out steps Jean Chrétien. Now, I need to talk to him. *Saturday Night* magazine has been trying for weeks to put us together so that I can do a portrait session for a feature story and cover, but scheduling has been dogged with problems. Each time a date is selected one of us is unavailable. Chrétien nods to me, we met once before, and rushes by quickly, deep in conversation with a companion. No chance.

I explain to my parents what has been transpiring.

My father, a serious political skeptic, seems to have a certain sympathy for Chrétien and urges me to tell him about the session if it ever works out. Molly is curious too. Well, now that a decade has gone by and they're both gone I realize that we never got the chance to talk about it.

A month or so later, a date was finally set. I was to fly up to Ottawa and meet my model at the law offices of Lang Michener. This was to be no ordinary photo-journalistic session. For some years I had been exploring the potential of portraiture done very close up with a large view camera. These images of friends and figures in the arts, while made by contact-printing the entire negative, showed only a carefully chosen portion of the face. I was trying to both comprehend the people before the camera and, in a sense, investigate the limits of my medium. I also wanted to question the conventions and assumptions of traditional portrait practice. Portraits have long functioned as images designed to project authority, dignify power and project aspects of character and personality. They do this through setting, clothing and posture. It is, of course, largely a game of pretend. The result is a bundle of signs designed to present an image useful to the sitter.

Can we actually discover anything previously unrevealed about the subject? Our Karsh, for example, was skilful at applying very traditional means to sum up and package the popular image of public figures. His

Hemingway or his Churchill take everyone's expectations of those figures and neatly summarize them in single photographs. But I cannot think of a single Karsh portrait that reveals, or even hints at some hidden quality of the private person. There are no insights or secrets, just the authorized qualities. I wanted to explore what would happen if one took away all the props — no sets, no costumes, no gestures. I would do this by working at such short distances, that all these elements were outside the frame. Also by working in such close proximity, spatial and — one hoped — other barriers, would be breached. I was trying to achieve a kind of intimate collaboration.

Initially I photographed old friends and my children this way. After a year or so I expanded my circle of "collaborators" by working with people I knew in the visual arts. I was as pleased with these photographs as I ever am with my personal work. They interested me and seemed to interest others as well. John Fraser and his art director at *Saturday Night* were curious what would happen if I tried to work this way with Chrétien. I was far from sure that it would be successful. I had worked with career politicians in the past and had found it a deeply frustrating experience. Once an assignment for a national magazine had necessitated my spending an entire week, from sunrise to bedtime, with Ed Broadbent when he was NDP leader in Ottawa. Add it up, it was a lot of hours together. If you're going

to be in each other's laps 16 hours a day you may as well talk a little and get to know each other. But with Broadbent I found that any question I casually asked him cued another tape in his head, and I'd get a prepackaged speech back. It never stopped, even after I gently confronted him and reminded him that I was only doing the photographs, not the text. For me he was typical of them all, no matter of what stripe. They get so used to performing in public and being managed that they seem to lose touch with the self. How was I going to get anything out of Chrétien? Reading his recently published autobiography, *Straight From the Heart*, hadn't helped. It seemed terribly empty, as if there was nobody home.

Nevertheless, I was curious to see if I could pull anything off and so agreed to try. Working so close up with a large camera demanded a great deal of light. I had to pack many cases of equipment and hence took a fellow photographer, Doug Clark, along as an assistant.

We were ushered into the library of the law firm's Ottawa offices and began the long process of unpacking and setting up. Although we were ready in an hour as promised, there was no sign of our subject. Finally one of his support people came in and asked to see samples of my work. When I showed her a book of my portraits she blanched and rushed into the hallway and disappeared. More people came back with her and

looked at my book. They were clearly alarmed — they felt that the close-ups made with such a large sheet of film were grotesque. This was not going well. Now I could hear them talking to Chrétien outside the door and urging him to cancel the session.

Then, to my surprise, Chrétien pushed in past them and asked to see my samples. He did not look pleased but nevertheless began asking me questions. "Why do you take pictures this way?" I began to answer his enquiries one by one, clearly and briefly. He listened carefully. More questions. I could see his people fluttering around behind him as we huddled in the corner. I had been allotted one hour of set-up and one hour of photography. There were now less than 20 minutes left before his next appointment. Suddenly Chrétien stood up and turned to his staff. "Please leave us alone," he said to them, "let the man do his job."

Now we were on firmer ground. This I had to respect. Doug and I got down to work. Before digital photography most photographers made Polaroid tests before committing to final film. As it was difficult to see the inverted and very dim images on the ground glass of a view camera when working close, I had made "sketching" the final image by making exploratory Polaroids, a vital part of my process. They allowed me to check the lighting, exposure, focus and form of each attempt before making any final exposures. Each

time I made one of these Polaroids, Chrétien would ask to see it. How could I refuse? He was wedged into a very tiny space between my lights and the big camera that was only a couple of inches from his face. Doug would hand him each Polaroid, Chrétien would squint at each — they were almost landscapes with a nose and an eye — and declare it a "lousy picture" before dropping it to the floor.

Yet despite his displeasure, he remained so that I could take another and yet another. I worked very quickly for 15 minutes — these were hardly very studied — before he decided that I'd done enough damage and he got up and left. Although these photographs were subsequently published, they never really satisfied me. It wasn't until several years later when, on a hunch, I reprinted them in black and white, instead of the colour materials with which they had been originally made, that I began to make peace with them. Whenever I pull out the prints I hear Chrétien's voice: "Lousy pictures, Michael, lousy pictures."

As the short E&N island train, an old diesel and a pair of coaches, inches over the Johnson Street Bridge, a little wherry passes by beneath. From the bridge one can see a shoulder bag, a jacket, and a thermos and flask, lying in the bilge. The oarsman pulls slowly but steady.

Another midnight mortality call. Suddenly photographer Ed Burtynsky and I are on the road, climbing the watershed between Lake Ontario and Georgian Bay in my little red van. We share the dark 400 with the stiff headlights of heavy tractor-trailers making for Sudbury, the Soo, Winnipeg, Vancouver.

I struggle in the darkness to both drive and dial the long sequence of digits to get through to Tokyo on my car phone. The closing circle reaches as far as Japan where yet another photographer, Ken Straiton, will be, at this moment, thinking hard about lunch. I don't want to wake his elderly parents fast asleep at this hour on the water's edge in Oakville. Yet I need directions to their cabin, where Martina, our midnight caller, paces somewhere at the end of a labyrinth of unlit lanes beside Lake Muskoka.

Some half dozen years earlier, she, responding to a knock on her studio door in the Cité des Artes building in the heart of Paris, had found our friend and fellow photographer, Doug Clark, standing with flowers in his hand. She, a sculptor from Hamburg, fell in love with the boy from Burlington. They married, had a son, and after several years of Doug's failure to grasp German, finally moved to Toronto. It was a big and, initially, reluctant move for her, but after a couple of years, she'd begun to get comfortable. Now the impre-

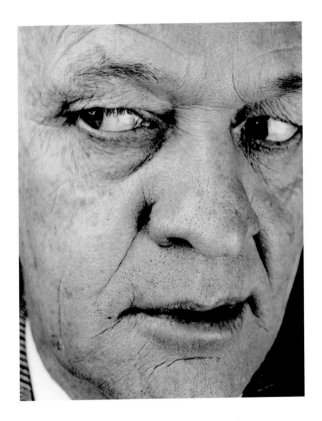

PLATE 13
lousy pictures, Michael, lousy pictures

sario, court jester, teacher and bagman of Canadian fine art photography — our Dougie — was dead.

A year ago, nearly to the day, Tina and I had retreated from the cardiac ward of Toronto General, stunned. Just hours out of quadruple bypass surgery, Doug was clearly in immense pain. He was only 45 but looked twice that. The colours of life had slipped out of him leaving only shades of lead sinkers and stones. Tina and I slowly made our way through a maze of shiny-floored hallways. We had to get outside and breathe.

Six weeks later, at the ragtag end of summer, he was on his way back to his coffee and adrenalin-fuelled, hyperactive self — talking about trading in his personality for a new one, scheming up projects and planning a return to teaching. We all, Martina included, thought he needed a few days off, a short trip away from hospitals and institutional intrusions, before resuming school. My Georgian Bay island was Doug's choice. Ed, Doug, and I took off a few days later — same red van.

As we were leaving, Martina collared Burtynsky and I in her kitchen while Doug carried out his bags. She had him on a vegetarian, low fat, no coffee, tobacco or excitement diet. He was not strong. We made promises. We meant them.

But Doug couldn't keep them. The whole trip up

was fuelled by his wolfing down double-doubles and donuts. Neither Ed nor I wanted to begin our weekend lecturing him so we buttoned up. I knew his heart was weak, his arteries still half plugged, the incisions still healing.

Several hours later I made things worse. To reach my place you park on a reservation and descend a river to reach the open bay. It's all wilderness, seven miles through empty forest, wetlands, and scrub. Heron often fly alongside. You can see bear, moose, beaver and big snakes, but rarely people. We mammals on this river have worked out a truce. I always slow or stop the skiff so bear or deer can complete their crossing. I give the moose space to eat and drink. I dodge the beaver and muskrat. In return they let me observe.

The river has its hazards — small rapids and big eddies in the spring, low water by fall. I run three propellers. One on the boat, one in the dock-shed and invariably one in the shop where it's patiently hammered and welded back into form. It's always the deadheads that get you. Those big water-soaked logs roll and swing down in that muddy soup like slow manatees. They don't come up to breathe but each day they make a little more progress toward the Sweet Sea.

I banked fast into a steep turn about halfway down and hit one. The tiller vaulted out of my hand and the big metal skiff charged the bank at 25 knots. It was just

like those aircraft crashes you see on television — the aluminum tube rocketing through the underbrush, branches squealing against metal, everything coming up fast. Then silence. Burtynsky and I rose from the bilge and looked at each other. You could no longer see the river. Worse than that, we couldn't see Doug. His seat in the bow was empty. I'd killed him.

We climbed out of the boat and scrambled inland through the muck and scrub willows. Thirty feet ahead of the boat we found Doug curled up in the mud where he'd landed, giggling. His pump was still working.

The next day he and Ed were to save me. We were walking the long empty, rocky foreshore — brilliant light, warm wind, the sibilance of the pines and surf on the sloping shore. They grabbed me just as I was putting my foot down on a sunning rattler.

The year that followed this was a new routine for Doug. He organized all his stuff. He began to dress in tailored grey and black. The flack jackets and combat shorts worn well into winter vanished. He bought glasses with severe metal frames. He walked the many blocks to work. He was less manic. He rarely clowned. Life was now serious business — measured in days, not years or decades. One hundred, 200, 300 days — he was heading for a full year of borrowed life.

As the anniversary approached he planned a summer vacation. It would be a quiet one, just his wife and

six-year old-son, for a week at Ken's parents' place in Muskoka.

The day before they left, he walked all the way down below Bloor to visit my west-end studio. He'd just undergone oral surgery. When he arrived, I recognized the ICU skin colour immediately. He looked terrible. The upcoming holiday was clearly essential. And with Martina along he wouldn't be able to eat donuts.

They made it up to the cabin: he slept the first day. Day two dawned bright, warm, limpid, perfect. At breakfast he made his requests. He wanted to drive them to a special spot on the Moon River. After that he wanted to stand with them, however briefly, on the Precambrian shore of Georgian Bay. All this was done.

Then they returned to the cabin and Doug descended to the Lake Muskoka shoreline to swim with his son while Martina made supper. They ate together. He made them laugh. Then she cleaned up while he put the boy to bed. As she was finishing he returned to the kitchen and softly called out to her. "Thank you, Tina."

"For supper, Doug? That's nothing. It was a wonderful day."

"No, Tina, thank you for all of it, our son, for everything."

They went to bed. He cried out in her arms, trembled and died. He'd known all along.

Now he was a body in the next room, in a small cabin in the dark woods. His son slept and she was so alone when she called us — the ambulance would take 50 minutes to arrive. Too late. We were closing in, but still hours away.

Doug had always played the clown, living like a bum in the back of buildings and garages. He called it urban camping. We all bought him lunches and gave him work when we had it. In return he entertained us. But he also always did something bigger — he thought about all of us. Peripatetic and gregarious, he had many circles of friends and acquaintances, many who'd never met each other. Yet he always made sure that the ones that would enjoy and be helpful to one another would eventually meet. He gave us the gift of each other.

I'd never thought of him as heroic. It turns out he was. Before the holiday and the final, fatal, dental work, he'd been to see his doctors. He reported to Tina that they'd told him he was a cardiac success story. They'd actually told him he was in big trouble, that there wasn't much time. His final gift was to his family: a perfect day.

 Fog has cloaked the Strait this morning. Cool and thick, it condenses on the skin and shoulders of the few strollers strung along the coast walk. Very small waves emerge from the

veil above the sea and languidly lick the cobbles of the beach. Just perceptible above their whispered withdrawals, a raw squeak of dry oarlocks progresses down the shore, its source cloaked by the mist.

Molly and I work our way slowly along Government Street near Victoria's inner harbour. She's has just turned 79 and her hip joint has worn out — she walks with considerable pain. Somewhere ahead of us my father, his morning errands complete, is making his way toward us. When we meet, we'll lunch together.

Out over the water a float plane banks in from the straits and begins a rapid descent toward the *Empress*. There's a brisk wind off the Pacific this morning, flags are snapped out, and the floating docks grind against the pilings. Even up here, high above the seawall, I smell kelp and creosote. The harbour shelters the usual mix of odd and foolish vessels. Not the working boats, everything on them does something useful. Their form, while not always handsome, smacks satisfyingly of utility. One respects them — it's the play boats that often stick in the craw. Most conspicuous among the floating follies is a large and very shiny fibreglass yacht that piggybacks a helicopter. This vulgar vessel looks like a '52 Hudson. I'm not an intractable traditionalist — some of the woody houseboats here look like floating Birkenstocks. But I do

love a beautiful sheer-line, a proud wheelhouse and an elegant counter. But then, I remind myself, even the old man himself commanded a few tubs.

Finally I spot him, all decked out in screaming beige and staring at a shop window a block ahead of us. I point him out to Molly who stops her cane-assisted stumping and stares. We watch him walk, head down, a few steps forward. He pauses before the next window and looks in. But then it appears that he's not. I watch him pause at a third window and conclude that he has no interest in the displays, he's looking at his reflection in the glass. I point this out to Molly. "Yes, I know," she says. "But why?" I ask. She turns to me, smiling, and explains.

One of his numerous complaints was that almost all of the old men he encountered on the streets looked grumpy. Tired of this observation, among many others, Molly had told him that he looked as irritable and out-of-sorts as they did and should do something about it. It seems that for the past few months he had taken her retort to heart. Now, whenever he passed a mirror, or reflective window, he paused to examine his expression and make adjustments. He had resolved to be an affable old man.

 The little wherry slowly passes the whaling wall east of the *Empress*.

 Molly has come into Toronto, alone, from the West. There's a show to hang, friends to see and family to visit. She's also having a rest from the irritable dependency of her husband. Times are good.

After lunch on College Street, she and my sister straggle up Yonge Street toward Curry's Art Supplies just south of Bloor. Weeks later my sister tells me that our mother had studied the windows of sex shops all the way to Curry's, leaving a litter of droll observations and lascivious asides floating over the sidewalk. She can surprise.

On the morning of her last full day in town Molly calls me to ask if I will take her to The Earthly Paradise, a William Morris survey at the Art Gallery of Ontario. I offer to combine it with lunch and a deal is struck. After fetching her in my car we crawl down Spadina through Chinatown toward Dundas Street. It takes three changes of the light to make a left at the old Victory Burlesque. Then another two-block grind through a talus of vegetables, shoppers and hand trucks before parking on Beverly. We walk the last block to the gallery. Although she is slower and shrinking she is not yet using a cane. It feels good to be with her.

The gallery façade was not inviting in those days. The old Georgian front, a quiet suite of brick arches

and pediments, flanking a crescent drive, had been ruthlessly buried behind boxes and slabs of gritty grey cement. There was a row of glass doors framed in bronzed aluminum — no theatre, no occasion, just entry and egress. At times like this I irrationally hate Mies and Gropius, not for their buildings, many of which I admire, but for their brutal dismissal of the past — their destruction of an ornamented and historicist classicism for their own version of the same — a classicism that is spare, industrial, and in the pencils of their many acolytes, inelegant and alienating.

We pass inside. It's strangely quiet in the hall. A security guard approaches. There have been more cutbacks. It's Monday. The gallery is closed.

I know that she's going to be hugely disappointed. She stares at the resolute security man, her body weaving slightly, her head tipped back so she can examine this uniformed obstacle through her glasses. Time stops briefly. Molly, rocking on her feet, turns to me, eyes big behind bifocals. Three beats. "Fix it, Mikey."

"What Mum?"

"Fix it," she says again. She's serious. I realize that she has no doubt whatsoever that I can. It's just a big-shouldered institution with a few dozen guards and many locked doors. Fix it, Mikey. I look down at this suddenly irrevocable old lady who's decided that her

son can do battle with the province. I can see that she's not ready to leave.

Why should I have doubts when she doesn't? I ask for the house phone and begin dialling staff extensions. On my third try I get an answer — a long-standing, patient, staffer who's always been a friend of photographers. I explain the situation. She asks me to stay put and hangs up. Molly and I continue to stand in the big grey lobby facing security. It's a long standoff.

Suddenly my curator friend, Maia, sweeps in from a side door with two custodians in tow. We're swept up the big staircase to the second floor. The big doors are thrown open to a huge dark space. A metal panel in the wall is latched open. Breakers rattle like dominoes and retreating galleries of Morris's world spring from the gloom. I stand with Maia at the entrance while my mother stumps off into the room. She makes her way from object to object, completely absorbed, totally living in her eyes. We watch for a long time. Her tiny figure diminishing down the galleries. The paintings, the papers, the fabrics glow. It's so rich in there and she's so small. I want time to float outwards forever. I wish for bright eyes. I want the rooms to be unending.

Molly has only been gone an hour and as she has left her bags with me it is my job to keep the diary going. My God, how I love you Molly my darling. I never knew this could

happen. Sometimes I wonder if all the happiness that is mine is true.

— John Mitchell Diary, December 7, 1941, 10:20 p.m., St. John's, Nfld.

Early one fall, after running home from school, I found the front door ajar. I paused, caught my breath and entered quietly. The house was of a period, high and dark inside — wood and the scent of lemon oil. I dodged the cat and began to climb the stair. Years of sneaking in late had attuned me to the voices of the treads. Steps one, three and seven were loud, but 11 was the worst, issuing a volley of protest under the weight of the foot. When I paused on the landing I heard soft crying. I found my mother curled up, eyes red, in the upper hall closet. She looked up at me — startled. "I married the wrong man."

What could I say, a 12-year-old, rocking from foot to foot, in that brown space, nauseated by the smell of furniture polish?

Then came the cough and the heavy tread of size 12 wing-tip brogues. A dark grey fedora and the shoulders of a wool coat appear on the landing below. A staccato crackling from tread 11 under layers of laminated leather. A clearing-of-the-throat and pipe smoke. I retreated to

my room, leaving them to their low murmurs. Their door closed shut.

I lay under the covers up in my room pretending to be asleep. It was nearly 11.

I soon heard Molly steps on the stair — she still came up to check on us each night. She entered my sister's room first and pulled up her blankets. All was well. Her footsteps exited and then a thin line of light expanded into a parallelogram on my floor — Molly was coming in.

I could feel her warmth as she bent over to give her sleeping son a goodnight kiss. At the moment I felt her lips on my cheek the Leafs scored a goal. I'd mounted my latest project, a crystal radio, on the inside of the bed frame. Two wires — one black, one white — coiled from its terminals through the springs, snaked over the headboard end of the mattress and slipped into the open end of my pillowcase to the single Bakelite headphone buried in my pillow. The signal vibrating a steel disk above the little electromagnet was so weak she couldn't hear it. I'd finally found a way to subvert my 10 o'clock curfew and stay on top of the next morning's hockey talk at school. I was also trying very hard to stay on her good side as I was now in the third week of negotiations for something desperately important. I had to have a pair of white buck shoes.

Donny, Chuck, Frankie and Johnny W. all had

them. Even the pathetic Andrew Turner had a pair and I was still walking to school in something hopeless and brown. Every morning while I was running a greasy brush over my Oxfords under my father's supervision, those guys were skipping breakfast so they could carefully brush their shoes with stinky white shoe paint from a little bottle. Your shirt could be crumpled, you could even have slightly baggy-ass jeans and cuffs rolled too high, but the white bucks had to be immaculate. And they all were. I, however, might as well kill myself, even if I knew the hockey scores.

Those shoes had to be just right. Three-quarter-inch soles in a kind of reddish rubber were mandatory and you had to have the right eyelets and laces. No substitutions allowed. The worst thing you could do to somebody in 1957 was stomp a big dark footprint on the uppers of his white bucks. It would divide the whole schoolyard into two camps — if you were lucky. Because you better have some guys on your side when you squared off in the wooded vacant lot across from the jail.

I was always having trouble keeping up with the codes. White bucks had suddenly appeared just as guys like me were catching on to cleats. All the tough guys had had little crescents of steel tacked onto the hard heels of their shoes. Originally designed to prevent workboots from going down at the heels, these little tap shoe add-ons had become an acoustic necessity.

The tough guys' swagger was scored by the clicking of heel plates on pavement. And they sounded even better when they were gouging up the hardwood floors of my grade seven classroom. Molly had made me leave my shoes just inside the door ever since I'd tacked on my own.

Now everybody was going from hard and noisy to soft and silent, from black and tough to orderly white. I had to catch up. Knowing that I'd get a snorting dismissal from John Mitchell, I'd concentrated all my efforts on Molly. I feigned an interest in her paintings, regularly set the table, dried the dishes and hauled garbage. I ran errands, cut the grass, even vacuumed. But mostly I just nagged, begged, pleaded and ground her down. Finally one Saturday morning when my father was still at his printing plant she relented. We got in the car and drove down Highway 2 toward the city to buy white bucks. I couldn't have been happier. As it was a warm day we drove with the windows partly down and the radio turned to CHUM. Pat Boone, who'd started this whole nurse shoe business, sang a couple of times, doing his antiseptic, Christian white-boy covers of Little Richard and Fats Domino. Everything was perfect until we got to the shoe store.

Molly asked for the shoes and we sat down on the bench. The clerk, bent with late middle age, shuffled off into the back. We had a long, excruciating wait during which I feared Molly would lose patience and

have us leave. Finally the old man returned, pulled up a low chair opposite me, placed a sloping footstool between us, and began to open The Box.

The shoes were wrapped in white tissue. He fumbled with it, turning the shoes over several times to free them from their paper swaddling. Then they emerged — glowing, shimmering, radiating promise — until I saw the soles — thin, black and totally, totally wrong. Molly had won.

But maybe not — I could still claim they didn't fit. We tried eight-and-a-halfs, nines, then half a size up. All too narrow I asserted. The clerk wearily led me to the back of the store where a tall, beige, truncated metal pyramid stood on a low platform. Three hooded viewers angled off from its top. I'd totally forgotten about shoe store X-ray machines. A click of a switch, a buzzing, then a flickering image of the bones of my feet within the outline of the welt of the shoes floated in the viewers. We each stared down at the eerie, green, pulsating evidence — a pair of size nine feet comfortably nestled within a pair of size nine shoes. The machine hummed and crackled with static. "They're perfect," announced Molly while ignoring my gaze. "We'll take them."

I suffered in those shoes for the next several years. At first I bravely painted them several times a week in a pitiful attempt to keep my head up. I soon attempted to double up codes by trying to tack heel plates to

their rubber soles — self defeating as I wanted those shoes to wear out. But Molly had bought quality. I scuffed the pavement, played street hockey, kicked footballs, climbed chain links and waded through creeks, but the big white shoes survived. She even made me wear them to England where the Teddy boys turned their Elvis heads, sneered down from their thick rubber platforms before sinking back into boredom. Molly was not to be defeated and neither were the shoes. They survived three years of abuse before repetitive soakings finally made the leather crack and my feet and I were released.

Molly made one more fashion excursion, this one without me, before I moved out after high school. She came back from Eaton's carrying a long plastic bag by a clothes hanger hook. "Here you are, Mikey — a nice brown suit."

The building boom after the war was a cruelty to the land. Long-established fields were assaulted with survey stakes, stripped of their cloak of topsoil and shaved clean of trees. The builders of those mean little boxes drove Fargo pickups and surplus Willys along the slimy clay roads. Hammer rings filled the December days.

How my father hated that gridiron survey some developers contrived near a field where, in the strangest twist of historical fates, a pig farmer kept

house with Olga Alexandrovna Romanova, sister of Tsar Nicolas II and the last Grand Duchess of Russia. None of it exists now. The town swallowed, the Dew Drop Inn has disappeared, my school is razed, the brickyard closed. It was a long and anxious walk to that school past identical yellow brick houses, protruding like teeth through red clay gums. We'd reach the edge of the known world, a zone of scarified earth, bordering the last of the new suburban drives. Here was our Pillars of Hercules, where we left the familiar streets of the development, our Mediterranean, and voyaged out into an ocean of long grass in a series of abandoned fields.

Our Styx was the CNR main line, a steel river racing between black banks as the locomotives were still steamers and many burned coal. Here we'd found the dark portal to hell, a large corrugated steel culvert that tunnelled under the tracks to the great pits of the brickworks on the other side. Bordering the rim of that huge wound was a shambles of shanty houses where the "Eye-talian" brick-makers lived. The dark sons of those swarthy Calabrian labourers were our barbarian hordes, a band of brutal bullies that stalked us on the way to school.

One bitter November dusk they tied my classmate Ronnie to the tracks. The Parker boys and I were terrified as we struggled with all the granny knots in binder twine. Our initial fear of their return was soon

replaced by outright panic when the ballast of the roadbed began an earthquake rumble. A huge 4-8-4, bound for Toronto, was telegraphing its approach through the ringing rails. Coarse sisal tore our fingers as we dug and pulled at those jammed knots securing a whimpering nine-year-old to the tracks. I remember looking up and realizing that a headlamp searched the curved cut barely half a mile away.

Did we free him and save ourselves? Well, yes we did. But it was very close. While I rolled with Ronnie to the south side of the right-of-way, the others scrambled to the north. A shock wave of hot air, seared oil, and coal dust swept and thundered over us and rumbled, clattered, until the whistle moaned away when the last car passed.

It wasn't all close escapes in those days. One of those brick-boys stomped and shattered my ankle during recess. My parents took me to Toronto to have it set and taped.

We also made our own disasters. The older Parker brother was retarded and had left school for a simple sorting job at the village hardware. He stole bullets from the backroom, taking them home to play in the unfinished attic space where he and his brothers slept. Freddy Parker had a collection of Mason jars lined up on a two-by-four beside his bed. Each held hundreds of shiny brass and copper bullets. He'd dump them on his bed and play a miniature but dangerous version of

his sorting job at work. The following spring he joined us at a campfire some older kids had built one evening in a woodlot behind my parents' house. His pockets were full of bullets, 22 longs, some 30-30s, 38s, and even some giant 45s. He began to throw them into the fire, drooling and sniggering when they went off like little bombs. A few others joined in — the little band's excitement was primal and predatory. Suddenly one of the bigger boys in the inner circle lumped forward toward the fire. By the time we got help he was gone.

There was, of course, an investigation. Each kid present at the fire shooting was called to the principal's office to be interviewed by both the principal and several provincial police officers. Waiting in the dark anteroom — hardwood bench, varnished walls — one could hear low voices and see the adult shapes moving behind the panels of frosted glass. Then reports and howls. Authoritarian wisdom was that each of us should be solemnly strapped after giving testimony.

This schoolboys' world was a recapitulation of the evolution of human culture. We were still at the head-bonking, cave-and-jungle stage; each day a survival struggle.

There was the perilous field, train track, and highway walk to endure twice daily. Even worse for me in winter, because I not only had to deal with deep snow and bitter cold, but survive it wearing sissy breeches

instead of real pants. Then the school yard world of chestnuts, marbles, indifferent girls and violence along those grim basement classrooms with hostile spinsters drilling multiplication and long division.

I'd get home shattered and exhausted. Molly was doing wifely things — cleaning and cooking for a husband and two small children. It was the only time I remember her not having a studio. It must have been a busy and very frustrating time for her but I still had a sense she was watching me. One day I returned home early in particularly bad shape. She sat down and talked to me. She would teach me how to do something that would help me cope.

What was it? She taught me how to knit. She surrendered all her wool left-overs and set me up knitting a big wraparound scarf. For weeks I worked on that banner of random colours and irregular stripes. It got longer and longer until the day it could no longer be hidden. When my father found out there was hell to pay. He stormed around in his dark coat, hat and huge shoes yelling at my mother about weaklings and fairies. Before my wrists got too limp, I was to join the Sea Scouts and learn to be a man.

I can't really remember everything that happened after that. I know I stopped knitting. I know that I never wore the scarf — by that time it was a ridiculous thing, over a dozen feet long. And I know that I've developed a life-long affection for long wool scarves

with stripes. Now, it's nearly 50 years later and I've already bought two of them this fall. And I never, ever, joined the Sea Scouts.

 Lights went out tonight so sat down in living room and knitted in the gloom while Mr. H. sprawled his boney self in the next chair and tapped his fingers impatiently. What a creature. He is too much "Bachelor." He might be more human if he was seduced or something. He reminds me of a staid Frankenstein. Wish my knitting would go faster.

— Molly's Diary, November 11, 1941

 "I like your sweater."

Molly was looking at me and it with an intensity unusual for her. I stood before her, a young man in his middle twenties, fit and dark from a couple of years walking the deserts and coastal thorn forests of southern Mexico. I was weekending at my parents' farm. My new sweater was the colour of a pine tree — solid green in the body and one sleeve. It's big rolled turtle neck was a brilliant orange bisected by a single stripe of royal blue. These dazzling near-complements raced around the neck and then dropped to one shoulder and ran down the left arm. I liked it too.

The next day she came up to me asked to borrow it

to wear while she rode her horse. It transformed her. She was a teenaged girl again, riding fast, back straight, hair bright in the wind. After the ride she kept it on until she went to bed. Leaving a day later, she ran after me to the borrowed car. "May I have it?" I struggled awkwardly. It was late fall, I had no money, I lacked a winter coat. The sweater was a month's groceries, an impulsive purchase. I waffled, wavered and said no, I needed it. True.

She had never before asked me for anything more than help. She never did again. Over the years I used that sweater until it was worn out — but it was never again mine.

Horses have bested me all my life. If they weren't losing me then I was losing beautiful girls to them. I'd be making great progress with some Anglo princess and then she'd discover horses and I wouldn't be good enough to shovel shit in the stables. I even lost Patricia, the most beautiful girl in my public school, to a horse that was both a gelding and blind. To watch those girls around those animals felt like hiding in a women's locker room or peeking through a bedroom keyhole at the most intimate female secrets and rituals.

I once bicycled into a small temple town in southern India and, desperate for shade, innocently slipped

into a dusky building housing a Kali shrine. The interior, thick with darkness, incense and smoke, was full of shrouded people staring with violent intensity at the burnt and horrific image of the goddess. Many slow minutes passed before I realized that I was the only male. The power of so much female presence filled me with amazement and trepidation. I fled outside, relieved to be out on a dusty street in the clanging sunlight. While Kali was all disease, death and destruction, I sensed a cousin concentration when young females were around horses. The charged admixture of mothering, mastery and deep sensuality was totally other to the male mind. They slip away, float back, linger and then are swept away again by these big, handsome, somewhat dim animals. Patricia, Pamela and Leana, all lost and gone. And most of all, my mother, Molly.

 And so I begin, something I have been meaning to do for ages. If I am going to live while history is being made better do something about it. Did a dreadful thing, slept all afternoon, too much party I guess. John's ship will be in tonight. God the week has gone quickly. Always flies when he is here. Guess I love him too much (a fine state of affairs).

— Molly's diary, November 9, 1941

 There was a time that Molly went bad. For several years she'd tried to be pragmatic — grimly churning out skilful watercolours of old horse barns and abandoned waterworks because those subjects sold. Finally she hit her limit. She'd take a break and make sculpture. When I heard of this through her friends I became quite anxious. Sculpture? I couldn't see it. Being a photographer, I only understood art that was flat.

For months she worked away but wouldn't let me see a thing. I'd hear that she'd taken carving classes, then casting and finally some instruction in ceramics. Where would all this go? Finally one Sunday morning I found out. She took me into her studio and slyly opened a cupboard door. I discovered that my mother was not only exploring another dimension, she was making filth. She called them cocktail sculptures. They were glazed and painted ceramics all built around a common armature — a martini glass. The subjects were sluts. Tarty-looking, big busted, nip-waisted, leggy hustlers crawled up the stems, pleasured themselves on the rims and vulgared about inside the bowls. These women toyed with olives and committed unspeakable acts with swizzle sticks and maraschino cherries. They weren't dressed for warmth. Molly giggled.

 O, the girls of Strathallen and Compton, those expensive training grounds for future wives of the upper middle class. My mother and her sisters, children of privilege, idling through the Depression years in the Eastern townships, waiting for final finishing back in Toronto at the Ontario College of Art. The Compton girls wading through the deep snow of southern Quebec, the thick wool plaid skirts of the school uniform regularly re-hemmed in the dorms, each time exposing a little more black-stockinged thigh for the boys down the road. These young women understood early what their capital was — and when to laugh. My mother, even in old age, spoke of her legs as her best feature, as if she were fine coachwork.

 I'm on my way home after school. My pal and I have fallen in with the three best-looking girls in our grade-nine class and we're walking them home. They're laughing at our jokes, professing admiration for our bullshit feats and giving us suggestive sidelong glances. It's beginning to look like we're getting somewhere. We're excited.

This little galaxy of adolescent sexuality comes wheeling around a corner of the block and, just as I'm about to triumph, I despair. My mother is right there,

for all those girls to see. She's sitting in the ditch, her big Reeves pad propped against the culvert, concentrating on a drawing. She's got a cigar in her mouth. I suppose it could have been worse: sometimes she smoked a pipe.

The girls tittered and swept off down the street without us. They carried their binders held tight across their breasts, giving them an armless walk that gave their little pleated skirts a most entrancing, but rapidly retreating, swing. My mother was so focused on her painting that she never knew what she'd done.

After high school, I initially drifted into fine arts at university. Our choices are shaped by our parents, whether they give guidance or not. We live in their world — picking and choosing from what they've exposed us to, having responses that are attractive or reactive. By this time my father was in business, importing and distributing industrial tools. If he'd still been knocking about on ships then I'd have been keen on the sea. But he was now a fish out of water, a tall man with a dark coat and a dark office. Like many of his generation, he'd been vividly alive until 25. Now he was putting in time.

While I was learning to walk, he was leading convoys across the North Atlantic. Soon many of the best boats were on the bottom. By the time I was born he

was stuck with rust buckets — American loaners superannuated from the Great War, or punky wooden minesweepers, too slow and small for the job. As a bridge cadet and navigator on the Pacific *Empresses* during the late '30s he'd loved his work. Heaven for him was a lone night watch on the bridge with the great mother ocean slowing breathing many decks below his feet. Now it was all reduced to nasty spaces, damp cold and a sea bleak with menace. He came to hate his first love — a ship on the midnight sea.

 Well alone again, such is a navy wife, but how worth while it always seems.
Stood on Water Street and saw the harbour go blue with dusk, the lights move rhythmically around and "my ship" go out smooth and impersonally. Now I go back to calendar days. Cold, Dammit.
— Molly's diary, November 12, 1941

 If I had the wings of an angel
If I had the wings of a dove
I would search the whole world over
For a blazer like the above.
For I have looked at the tailoring
In both the Water streets.

So would you do your sailoring
In one with paper pleats.
I hope it won't be forever
As the real thing should arrive
With all my fondest endeavour
And what the shops contrive.

So, Merry seventeenth of May
For it was a year ago
We started on our joyous way
With wedding bells and champagne glow.
— Birthday Card, handmade by Molly,
for her sailor John, 1941

So here they are, coming at the first year of their marriage from very different places. His world was one of cramped and noisy spaces, a deep freeze of iron and steel, a palette that ran from zinc to slate to black. The other side was Molly's world. Shiny tubes of bright pigments, the texture of rag paper, the rich smells of turpentine and oil paint. The world was not something to be instrumental in, it was a bouquet and a banquet. Half the time she was day-dreaming and sleep-walking, nicknamed "Fog" for good reason. Then unexpectedly, she'd be wide-awake — looking, staring, drawing. The line from her pencil her umbilical to the world.

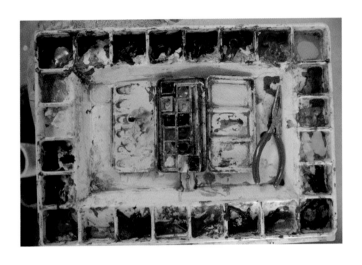

PLATE 14

Molly's world

In the early '60s I was at the grim, grey University of Toronto making my way from one miserable class to another studying Fine Art. It all bore little resemblance to my mother's world. Dry sticks showing yellowed slides and minor artists teaching studio. Brittle women being taught to decorate. My second year they hired a middle-aged American to conduct painting classes in contemporary technique. Weekly, we'd spend three hours pushing paint around in muddy circles. I was feeling quite lost.

Then one afternoon he arrived quite luminous and excited. The previous day he'd been out painting in a huge marsh east of the city. Deep in those wetlands he'd been surprised to discover another painter working the same territory. This artist, he explained, had proved to have a very sharp eye and formidable technique. They'd worked side by side for the remainder of the day, the encounter ending with a trade. Each took away a painting by the other. He held up his prize. I knew my mother's hand immediately.

 Today I am writing like a broken leg. When I finally shut down my computer I decide to unpack yet one more box from the little James Bay house. I pull a carton, slice the tape and rediscover my first big postage stamp album, "THE MAJESTIC." Published in 1955 by Grossman in New York, it claims to "cover the

world" but predictably begins with the U.S. and devotes the most pages to it. Leafing through it reminds me of all the many ways the world has changed. A DC3 wings across a nickel Air Mail stamp. Hitler, dead only a decade, glares from many German issues and even a few of Ukraine. There are entries for British Guiana, British Honduras and the British Solomon Islands. A then recent Ungandan stamp celebrates the Royal Visit of 1952. My 1/2d stamp from Tristan da Cunha features the Queen staring at a lobster. A mere handful of years earlier, Newfoundland released its last postage and most Europeans still had colonies. While it's all still familiar to me, it now seems somewhat quaint.

However, when I pull the stamp albums of my father, grandfather and his father from the box I enter a strange and forgotten world. Where was Heligoland? Who lived in Funchal? Or Grand Comoro, Griqualand, Guanacaste or Gwalior? I spent eight years in University and I've never heard of Hoi-Hao, Holkar, Horta or Malmedy. Hand me a map and I'd blush trying to locate Inhambane, Mongtse, Nabha, Niue, Nowanuggur or Soruth. What ever happened to Patiala, Perak, Packhoi and Poonch? Was Oil Rivers ugly and Rio de Oro beautiful? Was life good in Santander? What did people do in Tolima, Vathy and Vryburg? I'm quite curious about Tete, Thurn and Taxis. You could probably take me to Cape

Juby but please don't ever try to banish me to Bamra, Banat-Bacska, Baranya, Barwani or Bundi. I wouldn't want to die in Eastern Roumelia but I might accept Duttia. While drinking wine in Fiume I could lament the passing of Carinthia, Castelrosso, Chamba and Charkari. I suspect that if you'd written me from Corrientes I'd have agreed to meet you in Fernando Poo. And, was Cundinamarca really on this planet?

A full moon in late September tosses shadows across my bedroom floor. I've been bundled up in blankets, all day, all week, all through the month since Labour Day with many months to go. I play the radio, read, hinge stamps into my album. By the time I finally roll from the bed and try to walk again Jonas Salk will have announced his vaccine and my poliomyelitis will begin to gather dust in the cabinet of curiosities. These must have been Molly's hardest years — a sailor husband unhappily trapped ashore, a son, semi-crippled and bed-ridden, and an often sickly daughter. For those of us born before the '50s, childhood was a pilgrim's progress of disease; measles, mumps and chicken pox — a childhood trinity to which the fates and family added scarlet fever, whooping cough, TB and polio. We spent years in bed, father and children, while Molly nursed.

But this night her duties were to be different. Our

beagle has slipped the shed and sits in my mother's flower garden baying at the moon. I hear gruff murmurs from the big room down the hall. "It's your damn dog," he'd say. Molly's feet hit the floor, the oak door squeals and her woman's steps diminish down the stair. I hear the front door close on the tall dark midnight house. But for the baying of our beagle this old lakeport town is silent. I struggle on the high bed, dragging my useless legs and body by my arms into a position by the window. I now can see the moonlit garden on our landscaped corner lot. This plot is halved by an enormous hedge of Chinese elm with a great black archway in the middle. On one side lies a pretty show world of flowerbeds and ornamental trees. On the other lies the sweet rankness of compost piles and rows of fruits and vegetables and my pussy willow tree. Molly suddenly springs into the public side from the dark opening centring the hedge, her bare feet and flying nightgown as luminous in the blue light as the flowers in the garden. The beagle springs barking from the tulip bed and makes for the tall elm at the apex of the lot. Molly floats fast behind across the big lawn and the pair makes three circuits of that great geysering elm with the dog baying and my mother's nightie and entreaties adrift behind. Down the row of lilac and forsythia, and then kitty-corner across the big square lawn to the pair of chestnut trees and around and back, they glide quickly in the icy

white of the autumn moon. The neighbours' lights begin to go on — yellow squares and mullioned rows below the soft silhouettes of big hardwoods, maples, oaks and elms that line these streets. This is the stage I see from my window in this high house. The deep night sky down to the sinuous line of trees, the little lights of other lives and a woman and her dog swinging around the square lawn in the moonlight.

AMONG THE SEASON'S DEBUTANTS
Miss Molly Greene (at left with dog), daughter of
Mr. and Mrs. L.R. Greene, Ancaster and Toronto, and
Miss Gweynneth Young, daughter of Mr. and Mrs. Alan V.
Young, are pictured above. These charming girls are among
the group of Hamilton debutantes who will come out at the
Charity Ball in Toronto on October 29.

Red scooter flies. It glides down the sidewalks chattering past the trunks of maples and elms. It swoops up and down the curb cuts at the drives, arcs across the rosy macadam to the south side, loops a tree and returns in gleaming triumph. It takes many coats of paint to make a red that deep and lustrous. The big wheels fore and aft are disks of rich cream. The machine is a beauty but, alas, it's not mine.

I'm staying at my grandfather's city house, a three-storey Victorian, on Cottingham, west of Avenue

Road, that he uses three nights a week. A boy down the block owns the scooter, the only one I've ever seen. I'm mesmerized. Every day I watch this glorious machine — a crimson streak between the trees — and dream. It's my apprenticeship in consumer lust.

Almost a week has passed. I've slowly worked my way down the street by moving from tree to tree, inching my way toward the scooter house. Now I'm examining the bark on a big black trunk at the end of their drive. I'm trying to find something fascinating to justify being so far out of my own territory. A lone ant picks at a crevice: a few buds drop from the canopy. The street is empty. Then I hear a back door slam and a scuffle followed by a clink of metal against stone. Suddenly there it is, bearing down on me like a gleaming mail train. The kid swooshes by without even the hint of a sidelong glance. He diminishes toward the brick-paved cross street to the west and vanishes from my life. I won't get a ride on this day.

I skulk home and tell my grandmother what has happened. She's busy. It seems to mean nothing to her. I mope on the front steps for the afternoon knowing that I have to go back to my parents in the morning. All is lost.

Spring turns to summer a few days later. It's always breathtaking but brief along Lake Ontario's north shore. One day the branches end in sticks, then the

next there are buds and little leaves of the palest emerald and the musk of new life. In less than a week the trees have leafed out and the journey through summer has begun. And I have to get through it on a tricycle. I live under a pall that stretches through until fall.

The brassy light of September cools into the bright clear days of early October. Gradually the light weakens until a grey sky rolls over the chilled horizon just ahead of November. Now there's no reason to live.

The first week of November brings my birthday. Every year I wish all through October that the weather will hold so that I can party with my friends around a campfire. Every year I get within a few days and then the sun collapses, a freezer opens in Manitoba, and my mother puts red tissue over a flashlight on the floor. We surround it pretending it flickers and gives us warmth. I'm skunked again.

This fall John Mitchell is ill. It's been three years since he walked the deck of a corvette. After a few months in Sorel, Quebec, laying up naval vessels after the war, he knew he had no future in a peacetime navy. He came to Ontario to join my mother and go into business. He chose printing, an industry that just brought him heartbreak. His despair was expressed through his body. He developed a fearsome allergy to the solvents and inks and took to bed. Molly woke me the morning of my eighth birthday

and took me into her bedroom to see my ailing father. I stood shyly by the door looking cautiously in at this tall man flattened and foreshortened in the bed. His eyes were so swollen and encrusted that I could barely see the February blue of his irises. His hands lay on the eiderdown — huge, cracked, puffy red mitts that swallowed most of his fingers. He was a mess.

His eyes tracked me as I moved tentatively into the bedroom. Not a word was said. Was he angry again? I released my mother's hand and turned to retreat to my headquarters across the hall. As I crossed the hall threshold I froze. I backed, turned and put my eye to gap between the door and the frame. Leaning against the wall, hidden by the swung-back door, was a large, very red, lustrous, gleaming, fast and flashy scooter.

Summer's long dusky evenings send amber fingers toward 10 o'clock. The high tinkle of children's voices is gradually disappearing from the serried lawns and back patios of the suburb. Early cicadas, the ting of tumblers and ice, and low adult voices in the breezeways and backyards are the only sounds remaining. The odd car passes. Once again I am stalling, desperately trying to buy time. I'm terrified but I can't tell my mother because she's with my father.

Again she tells me to go up to bed. I find another urgent question to ask but I can see time's almost up because the old man's forehead is creased deeply and he clears his throat more frequently. Soon he'll blow and I'll be climbing stairs alone to my attic room.

I suspect the future. I know what will happen next. Unhappily I mount the stairs to the top of the house, to my room with the sloping walls. Up there under the roof it's hot and still. From my bed I can see a small section of sky, neatly quartered by the window. Over the next 20 minutes light slowly slides out of the sash. Darkness and deep night follow.

After a time I realize that I can see a small spangle of light. It rotates, quivers, then hits a flash point. Flames suddenly begin to crawl up the far wall and soon spill across the carpet. I race for the stairs and pound down for the front door. When I reach the street I realize that I have forgotten my parents. By now the conflagration is so intense I can't get back in. The shrubs in the yard have ignited. The house next door is engulfed. Now the entire street is burning. Looking through the driveway spaces between the houses I realize that the next street over has also ignited. The whole world is burning. I see people rushing about but they are merely silhouettes in the middle distance. None of them see me. I must find my mother.

I quickly discover that if I stay to the centre of the road I can avoid the worst of the heat and not get burnt. When I reach the bottom of my street I cut across to the next. I will try to reach my house from the back. Once I find Molly I know that everything will be fine. I'll be safe. She'll know what to do. The next street seems much narrower and the flames are beginning to close in. As I begin running toward the street's vanishing point it gets hotter and hotter. I'm sweating. I can't find her. I cry out as the heat intensifies beyond the bearable. Very quickly everything turns white, the firestorm has become so intense. Now I have fallen — and I'm struggling to get back up. The hot light sears my eyes and twists hot nails and wires back into my skull. I can't help but cry out, the pain is so unbearable, the light so intense.

My father is staring down at me. He has turned on the overhead and looks annoyed. His drink is in his right hand, some has spilled on his sleeve. He always makes us feel we should apologize for existing. His children are an annoyance and impediment. He turns and strides for the stairs. The light is turned off — I listen to the clatter of the big wingtip brogues diminishing down the steps. The fire has been quenched for another 24 hours. Once again I have escaped. It's been burning nightly now for two years and won't stop until we move. Why can't I tell them?

June 1st, 1942
St. John's, Newfoundland

Fire bombs are quite small — about the size of a two or
three pound trout. Know how to smother them with a stirrup
pump and sand, and have the means to do so handy. If you
keep calm it is very easy to smother them. If you do not
know who your A.R.P. Warden is, take the trouble to find
out, and get him to show you how to use the stirrup pump
and how to get the fire, which the bomb may cause, under
control with the jet of water, and how to smother the bomb
with the spray.

If trouble ever comes, God forbid we should be unpre-
pared.
Yours very truly,
L.C. Outerbridge, Lt.-Col., Director of Civil Defense
Newfoundland Department of Defence

Those summer evenings were once so
long — a lemon sky, an apple sky before
the shift to dusky blue and the deep dark
of the night. It was 1949 and we were living one
block from the shore of Lake Ontario. Our huge
world was tiny, about two streets on either side of my
parents' first house. In front lay a vacant lot, then the
Lakeshore Highway and the great jumble of lime-
stone blocks dumped from the highway's edge to stay
erosion of the coast. This was a mysterious world of

little caves, powerful smells and percussive waves. It was also forbidden.

My sister and I ranged this small universe, she mostly to the west, past the old corner house with the emerald lawns and the horseshoe pits. This house was the source of two key sounds of our early childhood: the summer evening tintinnabulation of the neighbour's horseshoe-throw, and the year-round sharp rap of a pair of silver candlesticks against glass as the old lady inside went from window to window tapping on the panes to caution passing children off her perfect lawn. In my whole life there I was never to actually see her — she remained only a dark shape behind the rustling lace of her curtains.

My own world lay to the east where, beyond the last house on the block, lay another vacant lot that rumpled down into a mysterious wooded creek-bed. Here we fought global wars among the willows and box elders. Each spring we whale-hunted the giant suckers that migrated upstream to spawn and squeamishly leaped from the creek waters whenever one of the revolting lamprey eels appeared. Occasionally we discovered muskrats and mudpuppies, those strange aquatic salamanders with feathery external gills and slimy hides. To north of both our ranges marched a giant cedar windbreak that no living thing had ever penetrated. It was the edge of the then-known world.

Molly's task, once she'd released us on day-parole

to the world, was to retrieve us for meals or bed. She'd emerge from the front door carrying a large ram's horn fitted with a bone mouthpiece and a brass reed. She'd stand there, arms akimbo, with her mothers' apron and '40s hair, blowing through this upturned bone horn until she'd filled our entire universe with its plaintive song. This distant early warning system was backed by a tracking device, a black cocker spaniel named Dinah. This loyal animal always shadowed my younger sister. Upon hearing the ram's horn, Dinah would leave my sister's side and scurry across the back-yards and up the porch steps to my mother's feet. She would then turn about and race back for my sister, carefully escorting her home through all the perils of our small world. Dinah's movements told Molly all she needed to know — in what direction my sister played, how far away, and whether she was safe and well.

Our world in those years was like a compass card. The known earth was flat, our house, of course, the pivot point, while our journeys swung the needle. Although my sister's world of dolls and party dresses was contained within a few playmates' houses just west of the tapping candlesticks, my range to the east had a gate to another universe. A small stream, a hypnotic fluid medium, always called my friends and I down into her secret domain. If we followed her as she flung her skirts around various twists and bends in her bed, we eventually reached the dark thumping world of the

Lakeshore Highway bridge. Many times we reached the shadowed opening to the bridge only to lose the courage to possess that space and pass beneath. The day we finally did, we were stunned to discover that on the other side she fanned her waters into the undulating fastness of a southern ocean. There lay Lake Ontario, lowest of the Great Lakes, by surface area the smallest, and yet, still no mean sea.

The known world had suddenly exploded. Bounded as it may have been to the east and west and north, it was without limit to the south. Shorelines are powerful places — the meeting of the finite and the infinite. This boundary zone, forbidden to us because of the twin dangers of a highway to be crossed and a sea in which to drown, was the source of pitched excitement. We crouched and crawled through the caves created by the great blocks, overwhelmed by the rich smell of seaweed tresses and the rank odour of shimmering alewives stranded on the cobbles. We were the first people: we became Champlain, La Vérendrye and Balboa. It was a time of amazing moment.

Liberated, we were learning quickly. There was the afternoon a neighbourhood girl came with us down to our sacred stream. Peter and Will waded in ahead and set course downstream for our lady of the bridge and her great mother ocean. Wendy followed, and I drew up the rear splashing through the calf-deep water and

carefully parting the weeping willow fronds. The two boys ahead rounded a bend by a little oxbow and disappeared from sight. Wendy suddenly stopped midstream and nonchalantly lifted her dress high above her bum. She bent forward, moved her feet apart, and peed. Water danced between her legs and a ribbon of tiny bubbles swept off down the creek ahead of her and swept around the hidden corner toward the boys. I was transfixed. I had no idea that perfect girls did this — my sister scarcely mattered.

On this hike we met an older kid who lived beside the highway. Busily trapping frogs, he invited us to shimmy up the greasy embankment behind his house and sneak into the backyard potting shed. There, in the four diamonds of hot light from the mullioned single window, he showed us what he had learned in Sunday school. His secret pleasure was crucifying frogs.

He'd constructed a trio of simple wooden crosses to which he fixed his captive frogs — weak white bellies out, tiny web-fingered hands neatly tacked and tied to the armatures. When he built three small fires and the terrified amphibians began to jerk and jig with pain, his little Calvary was complete. I glanced only briefly at the struggling frogs, for I quickly realized that he was far more arresting. I'd never before seen a face so luminous with concentration. Beads of spittle laced his

lips — his tongue tip repeatedly flicked them off. He was as dazzle-eyed, intense and radiant as a lover.

This was the dark side of the river and the ocean, of our sizzling southern world. Molly introduced me to another, more diurnal and respectable, but equally remarkable. One day in early spring she walked me across the vacant lot before our place to call upon one of the houses by the lake. An old woman answered warmly and asked us in for tea. I drifted in and out of the lady-talk, my returns occasioned only by their allusions to a special kitten-bush in the yard. Finally we all got up, exited through the pantry, ducked the clothesline across the stoop and descended to the garden. She led us to a back corner by the lakeshore cliff and showed me her magic tree.

Her bush at the bottom of the garden, a small soft-wood, was transmogrifying. All along its outer branches, little, furry animals were emerging. Like tiny mice, they had not yet grown their ears or opened their eyes. Feet tucked within their fur and tails still buried in the tree stems it appeared to my hunter's eye that they wouldn't hatch for weeks.

Then that widow did an amazing thing. She pulled a pair of loop-handled Chinese scissors from her apron and began to clip off some mother branches. An orderly old lady, she cut exactly one dozen and then handed all to me. My mother and I set off on the dangerous

block-long journey home. I struggled to both hold her hand and carry my bouquet of dead-baby sticks.

Safely home, Molly retrieved a Mason jar from the kitchen cupboard and half-filled it with water. She gently inserted the wounded end of my bundle into the magnifying vessel and carried it with me to my room. I was told to watch and keep it wet.

In time, white wormy roots began to wiggle from the stems. I kept this sorcery from Molly until they were more than an inch in length and soon to be snakes and eels. The world as it was, was not. I was learning about changelings and becoming, metamorphosis and mutation. Every fixed object of all creation was beginning to demonstrate an infinity of possibilities. The earth was curving: the ground was moving.

Ten twigs survived the white-worm stage. Molly's father, Lorrie, also a painter and a great and gentle gardener, came to visit and helped me plant them in my mother's flowerbed. My most vivid memories of him are his gardening at his country houses in Ancaster — first The Willows, then later The Four Oaks. Short and barrel-chested, he always planted tall flowers — gladioli, big irises, sunflowers. He only wore wool tweed three-piece suits, even when weeding in the August heat. Whether painting or pickerel fishing, he always wore a tie. His silver head would float through bright flowers dancing in the wind while

my grandmother, Elizabeth Chapin Greene, barked orders from the casement in her bedroom. He seemed serenely unaffected. Later I learned that whenever he sensed her approaching attention he shut down his hearing aid. His gardening and painting floated in delicious silence. It was his quiet example that had taught my mother to draw the world.

Summer kept me busy. I explored the creek and caves and travelled northward to the bay. On occasion I conducted inspections of those fledgling pussy willows. By autumn I was preoccupied with school fears and my approaching birthday, always planned as a camp-out and annually despoiled by yet another cruel November. The following spring I received news that we were going to move. Much throat clearing and coughing accompanied my father's disclosure of this upheaval one supper. The following morning Molly and I went out to inspect winter damage in the yard. The snow had hidden some horrors. Its white blanket had tucked in a cozy row of dead sticks in the flowerbed. I was devastated.

Yet a further week of wan spring sun performed a minor miracle. One cutting produced a leaf. Nature had made a select. This little stick, waving its single leaf to the reborn world was the chosen one. As it transpired, it was a true survivor as we moved many times during the following years and my pussy willow always came with us. It survived the yellow brick suburb and

a move to the heart of an early Ontario town. There it lost its trunk because I dug too deep a hole for it. As if compensating for a lowly start in that backyard, it grew and grew there until it attained a height of nearly 20 feet. When that place was sold a neighbour brought in a backhoe and the mother pussy willow was relocated to my parents' newly purchased farm. It now lived high on the moraines above the lowest of the lakes. By this time I was working outside of Canada but Molly maintained our conspiracy. That farm sold for their final move to the West; my Molly-willow was then moved, accompanied by my mother's horse to yet another farm where it flourished for many years.

It's a body-warm early August evening. The cicadas began their high-summer song several days ago. I'm sitting on the very cliff edge of the Scarborough Bluffs, my legs dangling some 200 feet above the sinuous line where the lake licks the gravel beach. The exchange of lake and land is barely audible down below in the darkness. My neighbour, architect Ron Thom, has come down to visit my little winterized cottage hidden in the trees. We sit side by side in the rich darkness, sharing a bottle and talking about Vancouver. After years of designing houses for other people, he has finally drawn and built his own. It slips among the escarpment trees, uphill, at the beginning

of my street. Having known this man for many years, I know how critical is the moment to spring my query. While I must let him tell his story through, I must also fit in mine so that I may make him understand the urgency of my request. And I must tell my tale before he's drunk.

The moment comes, and I begin at the beginning, my childhood walk with my mother, to the shore of this same lake. We both have a Molly in our lives — mine a mother, his a wife. I talk him through my life, carrying my willow tree before me. I explain that I must move in a few weeks to an apartment in the centre of the city. My willow needs a home.

So there it ends. My Molly tree mothered by another Molly. It lives undercover among the softwoods on the bluff, waiting for the shore to arrive. Every March the surface water runs and big chunks of the clay cliff go over in the dark. The big lake licks them away. It's slowly coming for my tree.

From the bar past Swift Street drinkers on the patio can see a small white rowboat pass tugs and a high-prowed wooden minesweeper alongside Harbour Road. It transits the Upper Harbour, rows beneath Point Ellice Bridge and disappears around the point and into Selkirk Water.

Molly paints sitting in the middle of a field — her concentration is absolute. It's a cow pasture with a pigpen under a tree in a corner. Initially the cattle languidly watch her from a distance, slowly chewing their cuds. There are hundreds of them, Holsteins. They slowly move toward her, curious. Circling closer. I watch from the road where I have come to pick her up. Now all I see is a great, slow-turning black and white circle of big-boned animals. She has disappeared within the eye of this bovine vortex, but I know that she's sitting calmly in the still centre, quietly painting. She knows animals.

1961. I have my driver's licence and my mother needs a new car. We agree to share a vehicle. Molly wants something useful but exciting as she's having a small midlife crisis. My father has already had a much bigger one. The man who usually bought English cars in grey, dark olive or black, drove home in the fall of 1956 behind the wheel of a brand new top-end Dodge. This challenge to my uncle's Studebaker had the big V-8, a stick shift and enormous fins that canted outward in a weird amalgam of menace and glamour. Painted two-tone pink and white, it looked like a cake on wheels. Molly, my sister and I stood slack-jawed in the drive.

In the eyes of my friends, my father's folly was my triumph. The Dodge was going be a rocket. Those late '50s cars were the progeny of the new interstate system south of the border. They rumbled up the hills and straightaways with real style but they didn't care for corners. You weren't ever supposed to get off those great highways into the sunset, the west, a new life. Turning was for sissies. Those cars swayed and dipped alarmingly when you tried to turn or rein them in.

As it turned out I did have some good times in that metal stampers' wet dream. My biggest triumph in it actually came to me by stealth. I had offered to drive several couples home from a high school dance — the back seat alone held five vertical or two horizontal. As it turned out my passengers lived all over the county so I was driving into the little hours of the morning. My last drop off, a girl in my class, was at a trailer park on the edge of town. Her father owned the place.

As she was returning home past curfew we had to proceed very quietly. I carefully guided that big rumbling boat, lights doused, between rows of mobile homes. I reached her place, let her out and then began to back up and turn around to leave while she waved goodbye. This was tricky with no lights in the dark. As I eased that big pink car astern I suddenly felt resistance and then heard the shriek of tearing sheet metal. I immediately threw the car into first but it wouldn't move. I was stuck.

The girl rushed over and I got out to inspect the damage. I was in trouble. The rear fins, which overhung the bumper, were completely buried in the aluminum skin of a large house trailer. Eventually I floored that big engine and popped the clutch to extract the fins. I narrowly missed her parent's unit in front of me.

Amazingly there was no damage to the car. The heavy chrome trim had knifed through the aluminum sheeting intact. The only evidence of the mishap were two large, splayed, churchy-looking holes in the trailer. Unbelievably, the owners hadn't woken up. We agreed that I'd return in the morning and face her dad and the music.

Next day I had some trouble explaining to my father why I needed to borrow the car at 7:30 in the morning. But I did get the keys and headed apprehensively over to the trailer park. My friend, her mother and her father waited at the entrance. They looked serious. As her father strode over menacingly I rehearsed my excuses. He grabbed me. It took me a few seconds to realize that he was giving me a hug. It seemed that the trailer owners were four months in arrears. They'd skipped before dawn, slipping out onto the highway without realizing that there was a pair of gothic vents in the side of their house. I had been driving a chariot of retribution.

My mother's car was a different story. She and I

settled on something brand new to Canada. British Leyland had begun producing the first of the boxy, dinky-wheeled, Mini Minors. We bought a model that was somewhat grandly known as an estate wagon. This little woody was bright red and had a tight four-speed box. It was truly fun to drive.

I went a lot of places in that little machine of ours — trips to Montreal, Buffalo, Georgian Bay, until 1963 when I got grounded. Molly got tough. It wasn't because I rolled it. I had, but she never found out. I'd been drinking wine with some friends late one frigid March night. We were parked in a country lane. Bottles emptied, we decided to head home. Of course I had to pull out fast. As I made a sharp left, sliding onto a concession road, I hit a frozen rut. The little wagon flipped into the ditch leaving us unhurt in the way of slack-bodied drunks. Everyone crawled out the sliding windows and easily rolled that little wagon back onto its wheels. A midnight trip to a car wash cleaned up the roof and that was the end of it.

No, the grounding was for a more serious offense, one against propriety. I'd gone to an outdoor dance one summer Friday with a couple of guys who worked beside me in a machine shop. For me it was just a summer job. For them it was a lifeline. They were a couple of primitives from rural New Brunswick who came from real poverty — of jobs, experience and expectations. They were looking for

women but had no car, the essential mating tool those days, and talked me into driving.

The dance was in an open-sided pavilion in a small river valley east of Toronto. Outlined with strings of small bulbs, the simple building seemed to float among the flood-lit cedars and willows of the ravine. Warm air with all the night smells of summer — mowed grass, creek-bed, pop and popcorn — drifted in through the open sides. There was a live band and a candy-coloured jukebox. The music was white-boys' rock and roll. I'm still amazed at how pervasive and persuasive an environment a piece of pop music could be. For 180 seconds, Buddy Holly could wrap your entire body in a song.

So my hungry companions very quickly picked up several girls including a spare for me. These girls reflected a backwoods boy's idea of glamour. They had teased hair, capri pants and blew bubbles from big gum wads. They were as crude as the boys from New Brunswick.

One of my companions soon disappeared beyond the radiant world of the dance floor not to resurface until Monday. He was not alone. The other stayed by me, the driver, and we eventually shoehorned the remaining two girls into that little red wagon.

It was difficult to affect an impressive takeoff with 850 cc's. However, I did manage to throw a few bits of gravel, a pansy substitute for the mandatory tire

squeal. Soon we were headed off into the darkness to do it. After a few miles rolling past dairy farms I began to wonder where. Although my and Molly's car could drop in the trunk of the chopped and channelled Hudsons at the drive-in, it was decided to go there for hamburgers as an interim move. I guess we thought the girls had to be fuelled up first.

The route to the A&W would take us through my hometown. Not a problem, it was past midnight. With a few miles of flat run on Highway 2, I got that Morris up past 50. The first houses of town appeared alongside the road, then a school, a Chevy dealer's and the dairy bar. We were approaching the four corners. As we breasted the pool hall I became aware of activity behind me. When I stopped at the only light in town I became aware of my mother. While she was walking the dog, we were screwing around. The pair in the rear had slid back the windows and slid down on each other — heads out one side, feet out the other. And Molly? She stood there with her irritable dachshund, Sophie, on a leash watching me from every corner of the block and each window of every building. She refused to forgive me. In the morning I turned in my keys.

That was my last run in the Mini but it wasn't Molly's. She drove that little wagon for another ten years. Then she moved west to Vancouver Island with my

PLATE 15

the final Dodge

father and bought another. While I saw less of her in those years, I was around when she sold it. She was in her 70s, it was now the late '80s. Dear Fog had unwittingly bought a Cooper coupe. So that was why men yelled and whistled when she went by. She had the classic package — the hot engine, leather seats, and coachwork in British Racing Green. After several days of bidding turmoil at the end of her drive, that car raced off on its tiny wheels to live in California. Molly then bought a grey station wagon in which she could pack paintings. It was her last car, another damn Dodge.

 The big rig — new brown Ford pickup towing a 20-foot beige house trailer — pulls out of the farmyard. The Ford has an extended cab, auxiliary transmission cooler, heavy-duty tires and a tape player. The trailer is a portable house provisioned with unbreakable plastic dishes, dried foods and tins. There is a short row of paperbacks on the little shelf built-in above a dining area that's convertible into a bed at night. Wrinkle-free, quick-dry items in earth tones — browns, tans, greens and rusts — swing in the little closet. All these goods signal a transition to a new life.

The previous night the swarthy purchaser of my parents' farm had filled the kitchen door and dropped

an attaché case stuffed with bundled bills on the counter. The deal was done. The early 19th-century stone farmhouse was gone, as was the cutter, the crimson Massey tractor and the big beds of asparagus. Molly gave away her tack and her horses. She slept little that night knowing that the steaming rides over the winter hills were over. There'd be no more evenings on the porch off the summer kitchen, smoking and drinking while dusk caressed the moraines before rolling up the distant lake for the night. My father wanted to go home and walk the Victoria streets of his childhood, stare at the sea and nurse his regrets. Anticipation kept them awake — they would leave in the morning, swing by the bank, and then loop across the continent, crossing and re-crossing the border, taking nearly a year to reach the ferry at Tsawwassen. But mostly they couldn't sleep because of the shiny leather case radiating loss, hope and risk from the back of the closet.

The rig ran well. The cab filled with music, the tires hummed and the big beige box trundled along behind obediently mile after mile. They crossed at Lewiston, negotiated some badly signed interchanges and eventually found the interstate that steamrollered for the Carolinas. In the evenings they passed the growling Macks, Whites and Freightliners returning to Florida and the truck gardens of the south. Their

operators dipped their lights and tapped their air horns, easing the little Mitchell wagon train back into the cruising lane along the shoulder. At night they kept to themselves in the dark campgrounds and pullovers, nursing their final Scotches, their books and tobacco. The transition was going well.

Months later they began a migration up the Mississippi flyway, eventually slipping back into Canada near Lake of the Woods. They pulled into a campground leaving much of the South and the Midwest in their wake.

It was a beautiful evening. After supper they walked down to a small lake, found a log seat and made themselves comfortable for the slow slide into darkness. The low sun soon lifted a scrim of ruby and gold above the sharp peaks of larch and spruce. As the lake warmed a large bull moose ambled into the shallows and began pulling up his supper. A loon soloed from the far end of the radiant lake.

While there was still light they set out together back toward their trailer and the promise of a contemplative nightcap. A disreputable-looking pickup with a camper back had pulled in a hundred feet from their brown Ford and trailer. Its crew spilled out of rear doors and set up a circle of aluminum lawn chairs centred on a large orange plastic cooler. Five young guys in John Deere and CAT caps were warming up for

a long night of drinking. They pulled beer can after beer can from the huge cooler, pitching each spent predecessor into the bush.

"She was just begging for it man. No fucking way was I going to do that bitch. Who'd want to look at her in the fucking morning?"

"I'm with you man. No fucking way."

As the little circle of fuck/fuck boys got louder and louder, the adventurers in the beige trailer got more and more annoyed. Finally John Mitchell cleared his throat, got out of his chair and headed for the cooler campfire. In that hundred feet the commander strode across the decks of the *Acadia*, the *Red Deer* and the *Restigouche*. By the time he reached the beer circle he was high on the bridge of an *Empress* with the sea rolling pathetically nearly 80 feet below. He pulled his pipe out of his mouth and gave them hell. The boys stared at him in open-mouthed disbelief. Finally a wiry guy on the far side of the cooler snarled, "Shut up, you nosey old fuck." He advanced toward the retiree in stay-press beige and shot a larger goober at his feet. The others got out of their folding lawn chairs and flanked their new leader. A stocky six-footer on the left advanced toward the startled ex-reservist while shaking a fresh can of Blue. He pulled the tab freeing a stream of suds that arced over the two yards between them, drenching the startled captain/boss/parent who stood red-faced

and flummoxed while beer ran down his glasses and dribbled into his beard. "Fuck off, gramps. Move your fucking trailer and old lady somewhere else, you dumb shit."

The park office was closed. It was dark and he was alone and suddenly old. The five primitives were enjoying themselves. "Let's take his fucking truck." The old man took a step backwards. His face was crimson and creased, his shoulders bent as if his back was broken. The beer boys slouched forward: he backed up two steps and then turned. The evening was no longer beautiful and the road no longer free. His face burned with anger and shame as he retreated in a hail of derision and obscenities. He pulled open the trailer's aluminum door and stepped inside — elderly, diminished.

 At Chapman Point the wherry enters The Gorge, proceeding up Victoria Arm. Once again the oarsman slips his oars, drifts and takes a drink. The passage is dark and narrow. At Dingley Dell they hear him cough and clear his throat. He rows.

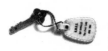 Molly is gone: the house is empty. There is business to be done. Death is expensive. Daily the telephone and the front door present more individuals

and institutions with cup in hand. Clearly I must get a handle on Molly's money.

It's a shambles. I have two boxes filled with old passbooks, crumpled statements and bills, yet I have little knowledge of her resources. A year earlier we'd gone to a Bank of Montreal and signed papers. I'd start there.

Despite having various Molly documents, a statement of joint signing authority, my passport and a key, the manager will not release the deposit box. She's a big woman in middle age, dressed for authority and her new job. While she's enjoying her little bit of power, it's also clear that she's terrified. All letters will be crossed and dotted, all procedures followed rigidly, no mistakes made. Her promotion is precious. I retreat to a law office and re-emerge with a death certificate and my power of attorney. Yet the enforcer prevails. I return with more paper and the lawyer. The crisp dress finally wavers and deflates. I finally get into the box.

The safety-deposit box is filled with duplicates of papers that I already possess. There is, however, much more money in her account than I expected. She could have lived better and travelled more. I leave the cash where it is and decide to pursue other leads. I'd found some cheques from the Bank of Commerce bearing my father's name. I walk several blocks past small, tired shops and stucco houses until I reach a branch by

the parliament buildings. Despite having an impressive pile of papers — I'm starting to understand the rules of this trial — they keep me there for almost four hours. Although more than a year has passed, they have no idea that their customer is dead. Why wouldn't Molly have told them? After a further painful half hour in the manager's office, he finally reveals what's in the account. Eighty-nine dollars.

I have paper traces for two more banks. I spend the next two days sitting under fluorescent lights on plastic chairs. The returns are modest. My enquiries are well organized and polite. The responses are often appallingly inept and insensitive. I'm becoming upset. After weeks of dealing with lawyers, accountants, bankers, local government and hospital security, I'm beginning to see Victoria as the city of the dead. It feels as if there's a whole subculture determined to process and profit from aging and death. The crematorium tries repeatedly to substitute expensive urns for our recycled box. These over-decorated pots are so vulgar that I fear people will assume that my mother had been a tart. The lawyers quote me a fixed fee. Weeks later, as the dimensions of the estate become clear, they announce that fees will be a percentage of the assets. In the end we settle for more than quadruple the initial quote. And so it goes with packers, movers, cable companies and real estate agents. And they get them before death too. Living here temporarily I soon discover that

the more chrome walkers and wheelchairs there are in a neighbourhood, the higher the costs of basics like food. This apparent preying on the frail and the fixed income, along with the relentless rain, is depressing me.

One morning over coffee I leaf once more through the files, discarding papers that recent events have made redundant. I pause at an empty and unused envelope from a Scotia Bank downtown on Fort Street. This envelope has surfaced behind my father's desk during the pre-sale cleanup. It's hardly a lead, but nevertheless, I decide to drive downtown. I almost abandon the effort when I can't find parking within a half mile of the branch. Tomorrow I will return to Toronto and I'm far from the bottom of my chore list. I should stop playing detective and stay home with a broom.

I show my documents to a service clerk. Twenty minutes later I'm interviewed in a cubicle by a department head. I'm then sent off to be interrogated in the assistant manager's office. Finally the manager appears. There is an account in my father's name. It's been inactive for years. The balance is about a hundred thousand dollars, money that I'm sure Molly was not aware off. Whatever were they doing? What else have I missed?

 The city days have a pattern — waking at five or six, making coffee, a quick check

on the world's distemper, more coffee and then the phone. We boot up our computers in the mornings in the way that we once lay and lit a fire. And then there's the mail, that relentless onslaught of pleading, billing and dunning that sustains an ever-renewing load of paper guilt.

These months I find the arrival of the mail the most difficult hour as my parents still live on in lists across the continent. Most of it is a toss: subscription renewals, donation pledges, memberships and gallery openings. I open and scan them. With a big permanent marker I scrawl "DECEASED" across the notices and refold and return in what often proves to be a futile effort to stem the tide. The great mail machine thunders forward and I remain surprised at how the dead continue to run up bills.

Every ten days or so comes the arrival of an envelope that stops the heart. A long letter from a former friend of Molly's arrives, full of news, chatty gossip and affection. Some of her oldest friends don't know she's gone. Sometimes the news travels in the most awkward ways: today I face the most difficult one yet. It's a letter from an old parental friend who some decades ago moved to Florida with her family. Her husband then decamped with their Philippino maid and the children left for their own lives soon after. Wife and mother now lives alone. She has, however, just learned of Molly's passing and has written a long

letter of condolence to my father. It closes with a promise to come and visit him.

Now this is truly awkward. The gossip network across the continent has telegraphed my mother's death but not the much older news of my father's. Her follow-up note is poignant. "Both you and Molly hold a very special place in our family memory. They are happy memories, of happy times with two wonderful people. I called the telephone number I had for you so that I could convey these thoughts to you in person, but learned that it had been disconnected. I hope that this letter finds you, wherever you have decided to be. May this find you in good health and doing the things you enjoy. Lots of Love."

This letter deserves a considered reply but I'm temporarily flummoxed. The letter paper and the envelope are not a match — each has a different address. In the world of the elderly is either to be trusted? After some pacing and indecision I decide to gamble and telephone a number printed with one of the addresses. I don't want to make this call. She answers on the first ring.

I identify myself. There is a silence on the line proportional to the 40 years that have passed since I last spoke with her. Then her voice again, "This is important, I will call you back." We exchange numbers. She's gone.

I sit in this silence. A call from me can only mean dire and unhappy news. She must be composing and preparing herself. I wait. When the ring comes I answer quickly and immediately begin a narration of the past year, outlining the illnesses, the deaths and the funerals. She prompts me through to the end. I begin to realize that she is taking all this in with equanimity. She is much closer to the precipice than I; she receives news of those who have fallen over with a numbing regularity. This is how we get ready to go ourselves.

After we've spoken I'm left swimming around in the past. I begin to remember driving a school bus full of students through a December blizzard in the '70s along Highway 7 to Ottawa. Creeping along, through a near total whiteout, I'm amazed that this little two-lane highway remains the most direct route between my country's political and financial capitals. We still live in a bush garden.

There's has been a student rebellion at the college where I teach. Classes have been suspended and the faculty has been ordered to disperse the students by setting up little voluntary field trips, thus giving the students the illusion of power and control over their own fates. As the most junior on the faculty I have drawn the dullest — a museum excursion to the capital. I must also drive the bus. To my surprise I have a

full house and they're all young women. Eleven hours later, when I finally limp exhausted into Ottawa, I find out why.

By prior arrangement we are to stay at a house owned by the boyfriend of one of the students. Arriving past midnight, I skid the bus into a snowbank by the drive and we all climb down into the icy night. Inside the house our host tells all the women to spread out their sleeping bags in the living room. I'm given a small empty room on the second floor. I am so tired from the long and perilous drive that I fall asleep almost instantly despite the sloshing lovemaking of the host and her boyfriend on the waterbed next door.

A knock awakens me just as I begin to slip into deep sleep. One of the women in my class stands outside the door with her sleeping bag. She wants in. Too exhausted to discuss it or do anything I wave her in and promptly pass out again on the floor. A few minutes later another knock wakes me up. I let another student in. Then there's another and another. When I awaken in the dun light of morning there are six bags in my room beside my own. They're not going to let each other get away with anything. And there I lie, in the midst of every foolish man's dream, and I've slept through all of it. There has been a sea change. These young women, only half a generation younger than myself, have become incredibly assertive.

Three days later we set out to return home. We

have finished late, had supper, and now I'm steeling myself for a long drive through the night. The bus sluices through the rapidly solidifying slush on Carlingview as I head out of Ottawa. My passengers doze or talk quietly behind me in the dark. As the gas stations, franchises and malls slip by, I begin to sense a presence. A minute or two elapses before I realize that I'm about to pass by the high-rise that Molly's mother has chosen for her last days. I have not seen my Greene grandmother for several years. On impulse I wheel the school bus into the crescent drive at the entrance, telling the few passengers still awake as I brake that I'll return in a few minutes. I slip into the late-night lobby and press the 11th floor button in the elevator. The cab rocks gently as it hisses up the shaft.

The dim corridor slips off east and west from the elevator doors, to a dark vanishing point on each end of the building. Both ways there are long rows of closed doors facing each other across the carpeting. Toward the eastern end a single door stands ajar, a splinter of warm light spills onto the floor. I walk toward it, pause briefly, then push on the door.

The room glows — every light is on and Granny Greene sits in bed, propped up by many pillows, waiting for me with a small sweet smile. She has a steaming teapot and two cups waiting on the little Regency side table. A saucer of the sugar cookies that my long-gone

Grandfather Greene and I both loved sits beside her 1920 octagonal Rolex. She tells me to sit down and then pours. We talk quietly for a few minutes and then I rise to go. I touch her fingers briefly as I say good-bye and then head off for my bus idling by the curb. I don't explain to my students where I have been and they don't ask. Soon we are rumbling over the Canadian Shield as a ragged forest slips by in the night. As the first lights of Peterborough wink out of the darkness several hours later, the very strangeness of what has taken place so matter-of-factly becomes overwhelming. There had been no prior arrangement and no communication between us for several years, yet I was expected at that moment and I knew it. We never spoke again. Her death at 93 came soon after.

DELUXE SUGAR COOKIES

1	cup butter
1 1/2	cups icing sugar
1	large egg
1	teaspoon vanilla
1/2	teaspoon grated lemon rind
2 1/2	cups all-purpose flour
1	teaspoon baking soda
1	teaspoon cream of tatar
	granulated sugar to sprinkle on top

Sprinkle each cookie with granulated sugar. Bake 8–10 minutes, or until lightly golden. These can be prepared two days ahead, and stored in an airtight container. Makes about two dozen cookies.

— Molly's recipe box

 Tillicum Road crosses high above The Gorge. Commander Mitchell rows on beneath the bridge.

OLD MAN As my father got older and older he seemed to have less and less to do, yet each task became a bother. He got fussy and began to create work. For a few years they owned a small apartment building in Victoria. He kept it full of young nurses and spinster teachers. If he wasn't rowing he spent his days with a toolbox in the furnace room or laundry. Molly thought he was trying to avoid people. My sister fantasized that he was fingering the tenants' drawers in the dryers.

One year I drove a van out from Toronto to meet him in the Rockies. I caught up to him at a campground somewhere in the Selkirks. He still had the brown Ford pickup and 20-foot house trailer. While he went off to find Molly who had escaped to the woods to sketch, I inspected his rig. He'd bought a

plastic label-maker and he'd been busy. There were many labels of the sort one would expect.

SPARE FUSES. REPLACEMENT BULBS. STOVE PARTS. LURES & HOOKS. KNIVES.

Many seemed inane.

TOOLBOX. GLOVE COMPARTMENT. GAS CAP. LEFT PROPANE TANK. RIGHT PROPANE TANK.

My father was turning 80. When I decided to fly out for his birthday and take my older son with me we didn't know that it would be his last year. We just got on the plane.

We took a room down the street at the James Bay Inn and prepared our minds for a week-long visit. There was a drinks reception at the house where everyone stood jammed into a couple of rooms holding glasses and shouting at each other. They were all getting old and deaf. My father forgot to talk to my son.

The next day a smaller group convened and went out to dinner. Victoria has a number of restaurants serving dull Protestant fare in what always feels to me like a room added to someone's house. They all have awkward side entrances, cream interiors and granny tablecloths. Small cushions covered in fussy prints are secured to the wooden chairs with little cotton straps tied around the spindles. And the floors slope, and the wine is industrial, the food boring.

We ate mostly in silence. During desert I finally screwed up the courage to ask my father to explain something that had puzzled me for years. In one of the big silences I said, "Dad, there's something I always wanted to ask you about." His face sharpened and he paused with his fork above the plate. I could hear my sister catch her breath — *Oh God, there goes my brother again, fucking everything up. Just be nice and it will soon be over.* Everything went into suspension but I forged ahead. "Dad — what's a dunderhead?" My father's world, ever since I was a child, had been populated with men who were either "clowns," "Bloody Brits" or "dunderheads." I knew what the first two were. My sister relaxed with a small giggle. The old man's face was red — why couldn't he just have a good time?

"You," he said. "You're a dunderhead."

And he still didn't talk to my son.

The next morning over breakfast my son pleaded with me to call the whole thing off. He felt like the third person on a date. I agreed. We went downtown and rented a bright red car with a plastic spoiler on the trunk. We threw our bags in the back seat and got in the lineup for the Coho, the Port Angeles ferry. After the usual grilling by U.S. Immigration — why do we let them be so abusive when they're standing on our soil? — we drove onto the car deck. As we cleared my grandfather's jetty at the mouth of the harbour the sun came out and the sea began to sparkle. We'd achieved

a kind of freedom. I was no longer going to try so hard. A gull flew just off the rail, radiant as a dove in the morning light. I photographed it many times. The prints I made later are as luminous as tiny icons.

These ends have sad beginnings. My father called one evening to announce that my mother had had an accident. She'd fallen some hours before and had been unable to get up. He was vague about details and sounded confused. Gradually it became apparent that he had compressed many hours into minutes and thousands of miles into metres. Six hours had passed and she was still curled up on the floor with a shattered hip. He seemed convinced that his children were somewhere nearby and would drop over in a few minutes and help her to her feet. This little ship of marriage that they'd been sailing on for nearly 60 years now had no one at the helm.

A few months passed by. Molly now had a synthetic hip and life had returned to some normalcy. One January day they sat down to lunch. Now even less of a cook, my mother had probably rushed in from her studio, quickly thawed something or opened a can. Their lunch together, largely silent, ended with the old man going off to nap. Did Molly go to her studio? I'm not sure. What I do know is that a few hours later she went to check on him and found him still asleep.

When she woke him he could neither talk nor move. This was when the end began. He'd had a stroke.

I climbed a tall control tower in Antwerp's enormous container port to make a series of assignment photographs of people, ships and cranes. The day's work finished, I returned to Brussels under an overcast sky. After agreeing to meet my client shortly in the hotel bar, I rushed up to my room to dump and recharge my equipment. The message light flashed on the phone. I picked it up and listened. That was how I found out about my father's stroke.

Now it was all different. In the space of a short nap their worlds suddenly contracted. Although he was to live another eight months, he was never to return home. His life was now a hospital bed and occasional hallway adventures in a wheelchair. Hers became a painful daily drive from her house behind the parliament buildings to Victoria's General Hospital, cruelly located well outside the city in the bush. Between the two lay dozens of traffic lights, every red light requiring an excruciating movement of her hip-replacement leg. The drive was one of unrelenting dreariness — gas stations, car dealerships, franchise restaurants, strip malls. Every day it looked more hideous.

Every few weeks I flew out from Toronto and did the driving for several days. I encountered two great mysteries and two solitudes. Looking at him in his

hospital bed looking back at me I had no idea what was going on inside his mind. One began to understand how profound and transformative was the evolution of language. He could neither speak nor write so it felt as if the lights were out. But when nurses officiously bustled in and out, engaging in baby talk around him, I occasionally saw a familiar sardonic cock of the eyebrow or set of the mouth that suggested an imprisoned mind. But then again, I wasn't sure.

I was also uncertain what she felt and thought. Often it seemed as if she was going through the motions, playing the dutiful wife. High-strung, angry, uncertain and often reactionary, he'd always been a lot of work. I'd always thought that his most endearing quality was his passion for his wife. Sometime in 1940, while on leave from convoy duty, he'd walked into a party at an officers' mess in Halifax. From the door he saw a woman in a ruby dress across the room with her arm languidly resting on the mantle of the fireplace. End and beginning, he would look no further. She was it. She remained his passion until his last breath.

Molly and I would do the ordeal by stoplight and strip mall together, the long way out to the interchange where the forest began. The transition marked by a brutal concrete bunker with a blue H on the roof. We'd negotiate the lobby where one of her paintings hung, bump up in the elevator, thread the corridors to his room. Each day there were grim changes in the

four-place ward. Enter new sad stories, exits from life marked by an empty bed. He lay there, grim, grey, suddenly so old, sleeping. Time would grind on, it was like sitting at a wake. Then an eye would open, he'd turn his head and slowly, painfully, reach for her hand with his best arm. They'd hold hands for a few minutes and then he'd lapse back somewhere into sleep. Then Molly would drop his hand and turn to me. "Well, that's enough of this place," she'd say matter-of-factly. "Let's get out of here." And we'd be gone, off to a favourite bar on the harbour. What was she feeling? I couldn't figure it out.

During telephone talks before one of my trips west I'd ask how he was doing. "Much better," she'd say. But then, when I arrived and did the torture-drive, he'd seem the same or, more frequently, worse. There were no longer any facts, just hopes. The line was still paying out the hawespipe, but the locker would soon be empty.

When summer came Molly kept giving improvement reports whenever I called. Tired and feeling somewhat impoverished from so much transcontinental travel, I let myself believe her. Toward the end of August I decided to check for myself and once again boarded a plane. We went to see him on a beautiful late summer morning. He looked like hell. A tiny grey man with bright yellow, rheumy eyes sat hunched in a wheel chair. It was lunchtime and she began to feed

him with a spoon. After a couple of mouthfuls he looked at me. He was clearly humiliated to have me see him this way. It was so awkward that I began to distract myself by reading his weekly menu. I was surprised to see that it included a jigger of Scotch a day. Where was it? Well it seemed that she hadn't ever gotten around to going and buying it. Here was my excuse to get out until lunch was over. As I left the building his nurse questioned my departure. When I explained my errand she cautioned me not to buy a jug of the stuff. It seemed a strange request.

I walked eight blocks to a liquor outlet, photographing the expiring gardens of late summer on the way. Browning petals, drooping stalks and yellowing leaves lined the sidewalk. When I examined the store shelves I began to understand the nurse's order. Once a fussy drinker, his standards had clearly declined. His current brand was available only in the kind of bottle I'd associate with bulk vinegar. It even had the little glass handle cast in. I knew that I'd never get it past the enforcers in the nursing station. Instead I went for a mickey of Bells and buried it in my camera bag. When I returned I placed it on the tray holder of his wheel chair. He bent low, his head wobbling on a stringy stalk, to look at it. His eyes seemed to narrow. He lifted his good arm and began to swing it toward the bottle. As it accelerated I realized that he wasn't going to pick it up. With the quickest movement I'd

seen from him in eight months he swept the offending bottle off his tray. "Wrong!" he barked and then collapsed in his chair. It was the first thing that he'd said to me in months. It was also the last. He was dead the next day.

 Makes me feel like building a little tower, and forever hibernating until you come back or sleep until you are here again. Cold and rainy and dreary tonight. I hope it is not too bad at sea and hope you will be warm, at least your feet will. Love darling to you always and ever.

— Molly's Diary, January 10, 1942

 I've arrived on yet another of my biweekly visits to Victoria — seeing Molly through my father's stroke and descent. She pours me a sherry and invites me out to her studio in the back. She's returned to painting and wants to show me new work.

It's crowded in the small building — the racks are stuffed with portfolios, frames and mats. Several weeks earlier we'd gone for a walk together, working our way toward the mouth of the inner harbour. Whenever she stopped to contemplate something I'd photographed it. At day's end I left the film at a one-hour lab, handing her the little prints next morning.

Since then she's been working up paintings from my photographs. She pulls them out one by one to show me. I'd been quick on the previous visit, catching fleeting movements of the gulls and the curl of a wave at just the right instant. She'd taken advantage of these moments snatched from time's stream and had used them as elements in a series of skilful maritime paintings. You could see that they'd sell well.

Putting them back in the racks she moved a thick wad of new watercolour paper to one side. She'd already worked the top sheet — it caught my eye — so I reached for it before everything was re-shelved and gone. Unlike the other paintings it was not representational. It was a beauty.

"When did you do this?" I asked her.

"Yesterday."

"Yesterday?"

"Yes," she said. "Do you like it?"

It was not a big painting but a quietly compelling one. A red line swooped in from the right edge and embraced a kind of celebration in the centre — red, turquoise, orange, ochre — a glimpse of a tropical sea and wheeling origami around which depths, darkness, and storms roiled. Over the years I'd watched so many wonderful abstracts of hers disappear into the houses of strangers — I didn't own one myself — and here she was, 80 years old and still celebrating life in a

medium — watercolour — that danced out on the edge like live music. Once the song was begun there was no going back — the notes were on the wind, floating, flying — no returns, no second chances.

"Take it, Mike."

"Really?"

"Yes, please take it — I want you to have it."

For almost three years now — a thousand days — it has hung next to my bed, a little square of morning music.

 My mother's small house is dark at this hour but for a single light in the hall from her bedroom to the bath. After three hours sleep I am once again awake and have quietly retreated into the dark living room to sip a drink and await the return of sleep. I don't want to disturb hers. A front has come in across the Straits. The wind whispers secrets in the chimney: the little Japanese maple fronting the house scratches on the window glass making shadow play on the shade. The furnace cycles on and off but the clocks are silent. She no longer winds them. As I lift my glass again I hear the rustle of bed linens at the end of the hall — Molly is getting up to go to the bathroom. Suddenly she passes by the double doors from the hall to the room in which I sit.

She has probably forgotten that I am in the house for the weekend. Or perhaps she thinks that I sleep, or doesn't consider at all. She passes by the opening slowly, hobbling with her replacement hip, bent forward, tiny. She is wearing only panties. Most of the time we see each other through the glass of memory. Features and details are masked by experience and animation of the past. This time there is neither and I'm shocked to realize that the joyful girl is gone, as is the young mother and the kindly granny. What I see is a pale bent crone with breasts like flaps, a formless sagging belly, loose age-spotted flesh hanging from the thighs. All I see is death in the hall and the cruelty of time. I feel the burden of too much consciousness, too keen an awareness of what will come. If animals possess this consciousness it seems to flash only from the terror at the moment of death by predator or catastrophe. Our particularly painful burden is to live with this every week of our lives, every day, every waking moment.

 Christmas 2002. The family's "Best Before Date" is expiring. A card comes from Molly's older brother and his wife.

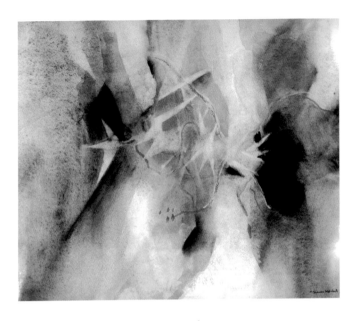

PLATE 16

a little square of morning music

PLATE 17

shadow play on the shears

Greetings of the Season
And
Best Wishes for the Coming Year

Hi.

Just to bring you up to date on your elderly relatives.
Arch had a heart attack in March — a triple bi-pass —
a pacemaker in April and in July a colostomy. Then had his
knee replaced but walking with a cane. I broke my foot in
August and had a pacemaker in Nov. Apart from all that we
are fine and on the road to recovery in 2003. (All in a nut
shell). How by the way are you two?

K.

I have a book launch party a couple of months later
and send them an invitation, although I don't expect
to see them. The Thursday before the event I come
home to a message from my uncle, Arch. "Mike,
please call me when you have time. I have something
I would like to tell you." I too have something I want
to tell him.

In 1956, when I became a teenager, he sent me a
special package for my birthday. He'd turned on the
radio a few days earlier and heard Jerry Lee Lewis's
brand new recording, "Great Balls of Fire," for the
very first time. His note with the package said, "Happy
Birthday Mike. When I heard this song on the radio I

knew it was the end of civilization and thought you'd be interested." The parcel contained not only "Great Balls of Fire," but also every hit 45 for that season. That present made me the most popular guy in my class. It allowed me to make a few moves. I wanted to tell him what that present had meant to me almost half a century ago. I wanted to thank him again.

The sound of his voice on the message tape alarmed me. I didn't call him back right away — instead I called my sister. Arch sounded so small — he was a big man — that I thought that my sister Sue and I should drive out to Oakville on the weekend and see him. Sue wasn't home. Rather than leave a message and start days of phone tag, I decided to call her the next day. Again, no luck. But I wasn't worried as I knew that she'd be home on Saturday.

Saturday vanished in busyness. Waking Sunday, I made a note to be sure to call her as soon as I returned from my early morning circuit of a neighbourhood park. On my way home I stopped for coffee. My mobile rang. It was my cousin. Arch was dead. I was two days too late.

It got worse. His wife, K., tired of lying in bed that morning while she waited for him to make breakfast, had gotten up to help him in the kitchen. He wasn't there. Then she began to search rooms. He was sprawled out in another bedroom, dead from a heart attack.

K. was always an organizer. She immediately began making calls and by noon was well into the funeral arrangements. By mid afternoon she collapsed with a heart attack. The funeral was off.

She survived. After several weeks in hospital she was released. Again she began making calls and funeral arrangements. Only one representative from Arch's side of the family would be invited to the internment at St. John's, Ancaster. My cousin Ann was nominated. However, there would be a reception in Oakville a few days before. I doubled up with my sister and we drove out from Toronto.

The address was a funeral home on Oakville's main street. There it was, tucked in between drapery stores, cute boutiques and a gas station — just another business. Inside, a black board with moveable plastic letters, listed the day's dead. It directed us to the back.

Arch's room — he was not there— was large and beige. His wife, K., sat in a big French Provincial chair in the middle of the far wall, like the queen, while we joined a long line that snaked around the room to see her and say our words. I didn't know anybody there. I couldn't say anything meaningful with dozens waiting impatiently in the lineup behind me. You couldn't sit and have a conversation with anyone — there were no chairs. The place needed seating and a licence. I decided then and there that every funeral home should have a bar. Unctuous undertakers should be

forced to serve cheery drinks — Singapore Slings, Manhattans, Pink Ladies. There should be balloons. He'd been a funny man with heart. A long life — he was 87 — should be celebrated.

And people "die" — they never, never, "pass away."

November 2003, Gourdon, France. I've woken up to a morning from earlier in life. The world seems scrubbed clean and sparkling and the smell of it all keeps pulling me back somewhere, to a time that had magic. But I can't quite touch it, hold it in my hands, turn it over and recognize exactly where I've been taken.

I shelve my plans for idleness: this is a day for a trip. I throw my bag in the rear seat, start the car and back my little rental Peugeot into a narrow lane. In a few minutes I've passed the last straggling buildings on the edge of town and begun to dart through the little hills of Lot, climbing higher on a good road. In an hour I've crested the highest of them to where the late autumn sky is snapped out in the purest blue from horizon to horizon.

It's the third week of November — I've been 60 for two weeks. When I pull over on the summit and leave the car I instantly feel the sun penetrate my clothes, skin, and burrow into my bones. I have no complaints — just a few minutes of peace with the universe.

Back in the driver's seat I begin a rapid descent of

the south face of the Dordogne Valley. A slight breeze has come up and brittle leaves skitter across the pavement like busy russet crabs. Halfway down a deer leaps across the highway and vanishes into the black oaks scrambling up the slopes. At the bottom my road bounds across the big river on six stone arches and swings sharply left into Souillac. I've come on a little pilgrimage to see the automates of Gascon Decamps.

The *Musée de l'automate* is a low building hunkered down behind a handsome Romanesque Abbaye. It's closed. I'll have to wait out an interminable French lunch to get in. I walk along an old leaky canal enjoying the brilliant midday sun. Invisible water is seeping everywhere. I can hear it bubbling under the shuttered buildings and running beneath the deserted streets. Bright green moss grows on tired stone walls.

At three o'clock a couple of small cars pull into the museum parking lot. As I walk over I can hear shutters clattering open and the rattle of keys in those French locks that require at least a couple of complete revolutions before they'll agree to withdraw the bolt. In a minute I'm in.

It's a long dark space. As I move into it alone, little pools of light emerge revealing various tableaux of perfect porcelain dolls turned out in the finest silks, satins and lace. A socialite preens before a mirror, a woman charms a snake, while a girl with russet curls cuddles a bird and a winged clown in pantaloons

strides across the moon. When I step closer they begin to move.

Their eyes blink as they slowly turn their heads. Beneath the beautiful clothes and jewels, behind the perfect china skin, are wheels, wires, levers and cogs. Little motors raise the arms, move the legs and turn heads. A Chinese conjuror covers a large white ball on a table with a copper cone — the vanished ball re-emerges from his mouth. A panther, crouched low, stalks prey. A jazz trio from the '20s — piano, violin and drum kit — begins to play. The three black musicians are dressed in crimson Eton jackets, white ties and grey silk trousers. The fiddle player's fingers move individually along the finger board of his violin. He and his band-mates, unlike most of Decamps' *automates* of the 1920s and '30s, are life-size. Nearby, *Le Rieur*, a balding fat man, squats on a stool, belly-laughing at Decamps' joke.

Deeper into the museum *Le Prestidigiteur* levitates a woman, while a photographer plunges beneath his dark cloth as his subject — a trickster clown — covers his face with a pig's. *La Laveuse Phenix* attempts to scrub a black boy's bum, an old racist joke from before the wars. Well to the back I find the largest tableaux of them all, *La Reine Des Neiges*.

Her majesty, admiring herself in a hand mirror, holds court in a glittering grotto. Great frozen columns support a ceiling bristling with icy stalactites glowing

in the half-light. This confection, Decamps' last, is huge. Two life-size guards in golden breastplates doze on either side of the royal throne while a couple of big magpies, accompanied by a wolf on a fiddle and a fox with a harp, serenade the queen. Rhythm for a pair of dancing seals is kept by a polar bear on percussion. It's a Neverland of snow, ice, gilt and pearls witnessed by a pair of awestruck little children posed left of the throne.

Snow begins falling on Queen Street. I stand holding Molly's left hand while my younger sister Sue holds the other. She wears her new winter coat with a Peter Pan collar over several crinolines making the coat flare out at the bottom. She looks like a little bell.

We are waiting to cross Queen, the no man's land between the retail rivals, Eaton's and Simpsons. Decamps' New World disciples have been at work for months, transforming the display windows facing off across the streetcar lines into a parade of proscenia staging dozens of Christmas dramas. We both know that the elves, reindeer and rabbits of the radiant arrangements are wood, wire and paste, but we let ourselves be seduced nevertheless. We fervently want to believe in the whole mythology of Christmas — the levitating sled, the pudgy old couple packing toys on a glacier and the camel jockey kings. This will be the year that I stay awake all through the 24th and catch Molly committing stocking fraud at dawn.

However, at this moment it's all still intact. The windows' glow radiates out into the street like hearths warming us in a city of slate skies and sharp winds. This will always be the most difficult month.

Mid-February 1952. Molly urges me to hurry up and put my boots on — we're going out. I've already got so many winter clothes on — long underwear, plaid flannel shirt, sweater, thick wool coat and heavy corduroy breeches — that I have trouble bending over to latch on my black rubber galoshes. Now that I'm nine, I receive 20 cents a week allowance, usually paid out on Saturdays by Molly. My father's 34th birthday will be in a few days. We're going out to each buy him a present.

She has hers all worked out — all she has to do is run into a shop and pick it up. Back in the car she shows it to me. As our breath condenses on the windscreen she opens a large flat cardboard box on the front seat between us. It's full of neatly folded tissue paper that she carefully unwraps, revealing a heavy sweater cable-knit from rust-coloured wool. She seems very pleased with her choice and he would wear it for many years. Now that she's finished it's my turn.

She levers the column shift up into first and pulling hard on the wheel bounces the car across the ice ruts by the curb and out onto Hamilton's main street. We

drive a couple of blocks with the windows constantly icing up. She bumps over some more ruts and we park in front of a five-and-dime.

Initially I have trouble remembering that we're here to buy something for my father and not myself. He's seldom at home and when he is he seems either remote or irritated — for me, Molly is much more immediate.

Rows of shallow bins on the long counters are full of trinkets, tools and toys in bright plastic primaries. We go to hardware, then stationary, down to gloves and back to pens and pencils. I deliberate. We retrace our steps. I get briefly distracted by barrettes and bobby pins — I like the colours of the plastic hair clips. I hadn't yet learned that boys and men were restricted to navy, green, grey, brown and black.

I get steered back to stationary where Molly sees a slim mechanical pencil she thinks my father would like. It means nothing to me. I slide down the counter and discover a bin full of neat rows of little books — diaries, memo pads, tiny dictionaries and address books. I work my way through the columns, examining all the variety in the section, stretching hard for the items at the back.

At fingertip distance I find a single, black, leather-bound book. It's very small — little bigger than a double pack of paper matches — but the lustre of the thin leather and the tiny nubs on the spine are a totally new

experience for me. I can't stop feeling the leather in my hand and enjoying the soft flexing of the covers. Each page, in pale blue ink, is lined for three entries — name, street, town, and telephone. This is what I want to buy. It costs several times what I have clinking in my pocket.

Molly has begun to get a sense of her son — at times very purposeful, focused and determined. We begin negotiations. The settlement takes twenty minutes — it's basically a deal of thirds. She'll put up a third, I'll empty my pockets for the next third and I'll have my first experience of credit and debt for the balance. The next week, when I discover there's to be no allowance, I have some moments of self-pitying regret. However, for the present I am satisfied. We line up at the cash.

Molly wakes me early two days later — my little sister has a cold and is left to sleep. My father is sitting up in bed — his reading light is on — he's drinking tea. He knows that something is up. Molly bends over and fishes around under the bed, but comes up empty handed. She gets down on her hands and knees and finally collars the parcel far under the box spring. As she pulls her box out I realize that it's been transformed by wrapping paper and ribbon. I recognize both as refugees from Christmas. On top of her big box lies a tiny package carefully wrapped in the remnants of the same Christmas roll. I feel my face get hot

— I'd totally forgotten that part of giving presents.

Moments later my father is having a second cup in bed — this time wearing a heavy rust sweater over his pyjama top. It makes him seem even bigger. Now it's my turn. I reluctantly approach him on his side of the bed — I'm never sure of his reactions. After placing my present beside him on the bed I quickly retreat. His huge hands make the little book seem very small. He has trouble turning the tiny pages but he doesn't seem displeased. I can breathe.

Over the years as I got older, he slowly got smaller. It took a lot of time and the width of a continent for us to gradually pass in life — he toward a kind of diminishment and myself to a distanced independence. For years our phone conversations were limited to a sentence or two, invariably ending with him saying, "Here, I'll hand you back to Moll." Or, "It's your nickel, I'll get off." My mother would return and we'd chatter away but I could always hear him coughing or clearing his throat in the near distance. He could only participate through her mediation — we got more and more out of touch. He seemed baffled by my comings and goings, my friendships and my many projects. He was often critical.

When I flew out to Victoria after his death I discovered that Molly had neglected to unpack the things he'd taken to the nursing home. The following afternoon I poured a beer and sat with his bags beside me

on the bed. During his last months he'd lived with very little: several changes of pyjamas, a pair of grey flannel pants and his favourite blazer, one of his clocks, a shaving kit and a photo of Molly in a sterling silver frame. I had trouble unpacking his clothes — too intimate, too sad and far too final. I hated their smell but I made myself try on his blazer. It had a red escutcheon embroidered on the pocket — the three crenellated towers of Conway Castle. I was amazed to discover that it was far too small for me. There was a bulge in the breast pocket that proved to be his wallet. I sat down and opened it up. Between his driver's licence, birth certificate, a photo of my sister as a five-year-old and his bank cards was a soiled, narrow nylon strip. I slipped it out and held it to the light. It was my maternity ward bracelet from Hamilton General in 1943. I fished in the lumpy billfold section and pulled out a small black leather book crudely inscribed in pencil on the inner cover, "To Daddy, Happy Birthday, 1952." Every space in it was filled — most had been reused several times.

The last entries were written the year he died.

May 1966. My father has asked me to come home on the weekend as he has a little job for me. When I step off the bus he's waiting at Brown's Motors, a GM dealership down by the creek that doubles as a Gray Coach Agency. He

leads me over to a new car — a sober dark blue Ford — and I immediately realize that the big pink Dodge is doomed. Indeed, this is why he wants me home. The elements have not been kind to Big Pink — rust barnacles cling to the wheel wells, door bottoms and rocker panels. Several hundred pounds of chromed steel have pitted and begun to peel. John Mitchell's fling with fins is over — he wants me to do the rounds of used car dealers and see what I can get for it.

The next day is Saturday. I get up at nine, dress and grab the keys. I spend several hours driving that great lumbering boat onto different car lots. I park it under strings of little light bulbs and plastic pennants, climb wooden steps to the managers' trailers and make my pitch. Fashions have changed — I fear they will laugh me off the lot — but usually they just sneer subtly, tell me there's no market for candy Chryslers and go back to their phone calls. This is GM country. Finally I find a tiny car lot at the north edge of town that has a Desoto, a Plymouth and an old Studebaker like my uncle's. A few years earlier, Uncle Arch, the one who gave me "Great Balls of Fire" and a leg up on my friends, had taken me to a demolition derby somewhere down on the Niagara Peninsula. As all the old beaters rolled on to the track under the lights for the main event I realized that my uncle was crying. I followed his gaze and saw the source of his distress. The last car onto the field that summer night was one of

those old Raymond Lowey interstellar Studebakers —
a perfect match for the one he used to own. "The
headlights still work," he wailed. "They're going to
smash it up. I can't watch. Let's go."

"Please, Uncle Arch, can we stay?" I'd never been
to a demotion derby and was excited. Arch relented
but clearly did not have a good time. Every glancing
blow from a Chevy or Ford directed at that
Studebaker was a slam to my uncle's body and his soul.
The Studebaker soon became the wiener that all the
other cars bullied. As they battered it into a wobbling
carcass of crushed metal Arch crumpled beside me. He
moaned when the last headlight fell out and rolled off
the dirt track. Finally the radiator burst and my uncle's
youth stopped moving. A skinny driver limped off to
the pits.

I phoned my father from the car lot and explained
I had a $250 deal. As the papers were in his name he'd
have to come over and sign the transfer. He turned up
about a half hour later and met the dealer and I beside
Big Pink. In the middle of the transfer a phone rang in
the trailer and we were left alone. As a hundred back-
seat Saturday nights roiled in my brain I heard a sep-
aration and clunk. A yard-long piece of rust-riddled
steel had fallen from the driver's side rocker panel. My
father nudged me. "Kick it under the car," he whis-
pered. I booted it under the Studebaker and slouched
carefully against the doorpost of the Dodge. A minute

later Big Pink's new owner descended from the trailer with a cheque in his hand. We climbed into the Ford and my father slipped me twenty bucks. I stared straight ahead as we pulled off the lot. We drove home together in silence.

 "Home again"

My sister Sue and I finally get our act together — we agree to pass on a funeral and throw a party. I pull several thousand dollars out of Molly's account and we go down to the inner harbour and check out the hotels. We soon agree on the place — a sunken sunroom that will hold a hundred people handily. It has a high peaked glass roof and three walls of windows giving out to flower gardens. It's cheerful, airy and bright. We place an order for a thousand dollars worth of food and drinks and then start to work the phones. This memorial is for both parents.

We get few regrets and wonderful weather. The room quickly fills up with silver hair, shiny pates and assorted canes and walkers. I knew that the elderly could drink but who said they didn't have appetites? The mountains of food go down quickly. Sue and I make a couple of short speeches — so does my cousin John who found Molly in the tub. It's all just the way you'd want it to be except for one thing — the photographs.

We'd found a couple of pictures of my father that

seemed to sum him up nicely. They were propped up in frames on the main party table. It had proved harder to do the same for Molly. Finally I decided to just put out the little leather bound album of photographs that I'd made during the old man's burial trip on Desolation Sound. The little tug was there, my sister and I, and many views of Molly. It was a simple narrative that told the story of the whole day.

It was too loaded. People would approach the table, examine my father's photos and then start to leaf through the book. They'd see Molly walking down a pier, staring at the Coast Range from the bow, having a drink inside the wheelhouse and having another aft. Then they'd come to the page where the dovetailed wooden box is brought out, opened, and revealed to be full of ash. When they'd see Molly throw the first handful and the great cloud form in the water, they'd immediately close the book with a third of the pages to go. Everybody got to the same place and then found something urgent to do. It was all far to close to home — too much like next month or tomorrow when you're 80. Nobody said a word. Nobody saw the beautiful ending of brooding landscapes that I'd laid out. They just kept closing the book.

 Packed up, cleaned up and sold, the life in that house is over. The red door

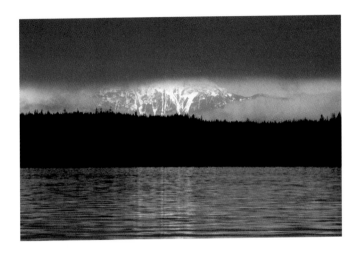

PLATE 18

the beautiful ending

is closed, the lock is set. My cab skirts the inner harbour, probably for the last time. I have no reason to come back. We clear the last of many stoplights in town and make for the airport.

I fly frequently and often cross borders. With time one develops a nose for the personalities in the crews. You get skilled at picking the most forgiving line at check-in, the easy con at customs. When I reached the counter and saw the pair our national airline had on duty, I fell into deep despair. The two big women sniffed a troublemaker the moment I cleared the sliding doors. They drew themselves up into monuments of disapproval. My bag was overweight. I shrugged and offered to pay. Not acceptable. I must unpack, right then and there, before the rapidly growing lineup.

Now this was something I would absolutely refuse to do. It wasn't just the tangle of used underwear and socks that I didn't want to expose. It was my mother. There she was, in her plastic bag, in her little wooden box, at the bottom of my suitcase. I don't know what the rules are on this but, in the eyes of these two women, I had to be breaking more than one of them. There was going to be a showdown.

I already had three carry-ons — my camera bag, my briefcase and a laptop. I would never get away with making my mother a fourth. She was surprisingly heavy, the box was awkward and, besides, it contained a

person. Under my seat? In the overhead bin? I couldn't see it.

This pair were like chunky caryatids holding up an enormous rule book and a lineup. They were determined to prevent the descent of this Dash 8 into someone's yard. We circled each other. My mother and I were going to win this one. I tried sweet reasonableness, then indignation and outrage. It ultimately came down to money. With each round, the charge for excess escalated. When it was clear that a rebellion was fomenting in the line behind me they finally sawed off at $190. Lord, Molly, you have cost me enough in restaurant and bar bills, now you're still dinging me after death! I put down my card and paid. We were soon high over the islands of the gulf on our way back east. In a few hours Molly and I would be flying over the waters of our bay, that sweet sea.

It's been a black and white day on this little island. I've sat alone all morning watching the water, cormorants and the soft shifts of light. Past noon I hear some wheeling gulls. They settle on a small rocky island a thousand feet out and hunker down facing west. More join them. And then more. The air is very still.

A little later I hear the rough honking of Canada geese. I wait. They appear from the east, suddenly, fly-

PLATE 19

the lock is set

ing in a line so low that the downbeat of their wings leaves prints on the water. Their crying recedes west. All is soft and the colour of pearls. Quiet.

Then again honking in the east. The cacophony is more complex this time and presently a larger flock comes in down low. This time I can hear the air move through their feathers as they pass in front of me. Gone to the west. In moments another squadron follows. Then more. The calling recedes. I begin to feel restless.

Suddenly, stragglers come over the pines on the facing far shore to the south. They drop down low over the water and bank, disappearing to the east — the wrong way. I smile at their confusion but my smugness is short-lived for their calling fails to recede. They suddenly wheel about, joined by as many more, and come across and right over my head, long necks stretched straight, wings way back on their beautifully shaped bodies. This time I can feel the down draft stir my hair. And again more, so close that the air movement through their wing feathers and along their bodies separates into sibilants, soft whistles and whorls. Next, silence. I sense that something's up but a neutrality prevails over the next hour. Then darkness. I go inside my wooden cabin to sleep.

I crash back into consciousness. Blue/white/blue light draws the pines all around me. Every needle is sharpened. More reports, more discharges. Ozone.

Sudden winds and water beating, pounding, smashing against the roof. So loud a shout would drown. The cabin drums and shakes. More and more water. I'm under a falls drowning alone. I sit up just before a flash illuminates the room and the wooden box on the bedside table. Twelve inches by six inches by four inches. Four kilos. Seventeen pounds. My mother's ashes waiting here for my sister to come back to Ontario — to this remote river mouth on Northern Georgian Bay. My mother sleeps beside me. Soon we'll take her out to her rocky territory, the rocks she often sat on, swam from, painted, loved. We're already on the boat, this little rocking cabin, surrounded by water, all sides, above, below and now streaming down the walls from the wind-lifted shingles and dancing everywhere on the floor.

ONTARIO COLLEGE OF ART STAGES
ITS ANNUAL COSTUME BALL

Down twenty thousand leagues under the sea, where no submarines lurked and where all was fun and fancy-free, went students of the Ontario College of Art last night. On the seabed they danced the light fantastic. Through seaweed they floated and flew. Bubbles flitted about and burst. Neptune rode his seahorse and waved his trident and all the sea fish laughed and made merry.

— Thelma Craig, *Globe and Mail*, Toronto, Tuesday, February 18, 1941 (Molly's graduation year)

Not far from here French River makes its many-fingered entrance to the raucous waters of the bay. Some three centuries ago Champlain came down these glacier-ground chutes, riding the black water boiling between granitic humps glittering with mica and quartz. Tumbling through the last vortices to the flat water rolling against a thousand stone islets, he reached over the gunwale of his bark boat and cupped a handful of cool water, bringing it to his lips. His eyes swept the landless horizon bending around the world as the water hit his tongue. *"La Mer Douce,"* he declared — The Sweet Sea.

This time, I operate the boat. On my fourth try the big V-6 shakes itself awake and fills the bright morning with its angry clatter and oily smoke. Our little cortège comes aboard and I put the box beside the stainless steel wheel. Yes, it is the same box.

The shift dog clunks in and the stern digs down. We reverse out of my little harbour and swing about to the west and rumble out into the big waters of the bay. The prevailing westerlies have already flattened the offshore breeze of early morning and are building fast. When I've cleared the river mouth, the big full bow begins to dip on the first swells. Champlain's sweet water is already boiling around the hundreds of humping reefs and shoals that escort us toward the horizon. A decade ago, on this very spot, I stared

down over the bow of a small skiff on an exceptionally calm morning in early autumn and realized that we were flying over the bones of a wooden steamer. Today the big swells keep its secret.

The last spar buoy does a one-legged jig in the two-metre seas that continue to build as we plow farther west. The fetch here is a couple of hundred miles — the width of Georgian Bay, the breach between Manitoulin and the Bruce, the breadth of Lake Huron and the mouth of Michigan. We pass Albert's Reef off to port. We're now out about five nautical miles and I begin to pull back waiting for the moment to feel right. The bow drops, I shut down, we begin to drift. It's time to pull the box.

Someone brings out a bottle and we begin drinking, buying a little time before we must open the little chest. This is no easier a second time. There are no proficiencies in burials.

After Molly made her 70s she began to diminish. We no longer spoke eye to eye — I talked to the top of her head. Her woman's bones were dissolving. She developed a hunch, her body curving in on itself as if rehearsing the final fetal tuck.

Sometimes I would drop her off somewhere and wheel away to park her car. Returning on foot, I would see this tiny person in the distance. Bent like a *C*, with a stick — her cane — in the gap, she would slowly crab

up a flight of steps so as to be able to greet me cheer-fully at the top when I caught up.

This was evidence of an opposing process. As her body shrank, the person inside got larger. My father's death augmented her further. Her hip-replacement sailor's roll became heroic. She was always cheerful. Whenever I crossed the country to see her we went out on dates. Dinners and drinking. We'd hit the bars. Talk, listen to music. She'd tell me about the big love of her life, a young doctor she'd met in London who soon died in the blitz. We had more drinks. I paid. I told her that she was the most expensive girlfriend I'd ever had. She giggled. We hit one more bar.

This ruthless process could only end in death. As she shrank so small, her hands clawed so tightly she could barely hold a brush. But then she needed it less, this drawing and painting to apprehend the world. She was achieving a kind of completeness and equilib-rium. Her life was working through. She was drawing a final circle.

 This morning a turkey vulture gyres above the pines, head down, pinion feathers splayed. There's death down below. A night rain has scrubbed the air — I see every split in the rocks, every needle, every leaf with preternatural clarity yet, compared to the vulture, I'm a sightless man.

My sister and I had scattered only half of Molly's ashes on the bay. The balance we split for our own private rituals. That night I had a dream in which death appeared as a lone white pine sweeping a cold sky. I knew it was Molly. In the morning I roused my family and we waded over to the enormous empty island just behind ours. Once there, we separated and began searching the hard rock hillocks and creases for the perfect tiny Molly pine. While this mature forest had some jack and red pines on the margins, white pines were the dominant species. Between and below the giants grew junipers and the odd scrub cedar in a hollow. We were seeking a seedling that sang to us.

As I wandered, searching, I'd occasionally crest a big pink whaleback rock scaly with lichen and spy one of my sons walking head down, searching, a few hundred feet away. A high was arriving so the wind was vigorously chasing off the last clouds. The sharp sun tossed sparks and spangles of mica and quartz across the bare backs of the rocks. The dazzle made it difficult to see into the hollows where the forest kept its nursery. It was getting very hot and, after an hour or so, I realized that, although we had covered a lot of ground, we were all beginning to walk in circles. I turned back to find the rest of the search party.

I was more than halfway back when I felt a gentle tug to the left. Slipping down a small rock face I

reached a depression blanketed with hummocks of vibrant moss and ringed by mature conifers. And there, just off-centre in this mossy bed, was a long-needled, one-foot pine. It was vigorous, symmetrical and the most astonishing shade of blue. Molly.

After memorizing the spot I went off to rendezvous with the others. Catching up with my boys, they told me that they had found this beautiful little pine with blue needles. It had made them think of their grandmother. Consensus.

We tenderly extracted our talismanic tree along with a clump of moss. There was so little soil under it that it looked to be a certain casualty of winter. Back at our island I retrieved Molly's ashes from the same little box of dovetailed pine boards that had held my father's. I like the idea of cremation — not just the cleansing fire, but also the instant reduction to atoms of gas rising up the flue and rejoining the universe as the basic building blocks of creation — infinitely preferable to being recycled through the gut of bacteria and worms.

We dug a small hollow by the wide wooden steps where we have our morning coffee and lined it with Molly ash. We tamped in the tree and brought it a drink from the bay. Now her atoms would flow upwards into the bright blue needles of a brand new tree.

The next winter was not kind. As I ran my boat out through the decaying ice in April to open up the building, I was dismayed to observe the extensive windburn on the south flanks of the pines along the shore. More than half of each tree was browned out — a lot of needles had dropped. I was sure they were dying. However, the Molly tree lived in a hollow sheltered by the steps. It was defiantly green and a little bigger. She clearly intended to survive so we'd always have coffee together in the morning light.

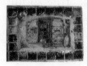 May 2004. A little before noon I knock on my younger son Ben's bedroom door. He's back in Toronto after a winter term at McGill — I want to catch up. There's no answer, no sound — the door is locked. I knock again. Nothing. I retreat to the kitchen and rummage through drawers until I find an ice pick. It slips easily into the small hole centred on the doorknob releasing the lock. As I slip into his room I see that he's there, a six-foot lanky log on the bed — dead to the world. The room smells like an armpit.

When I sit on his bed he groans, rolls over and grumpily greets me. A large portfolio has spilled onto the floor — these are his sketches, acrylics, figure studies and CAD drawings — he's studying architecture. On the wall above his desk he's hung a large beautifully rendered watercolour of a drive shed — one of Molly's.

PLATE 20

coffee in the morning

When she last saw him he was still a boy. He had yet to lift a paintbrush. Now that he does so almost daily, time has taken her away. The thousands of miles between them has now become all eternity, robbing them of the chance to take walks, share the world and make drawings together. She could have taught him much. They would have had a good time. They could have connected to each other the same way each of them connected to the world — with keen eye, a sharp pencil and a curious mind.

I stumble over these boxes daily. Papers seem as heavy as the silverware. Occasionally I give myself to the past for an hour or so and sift through another paper bundle. My parents sound so young in their wartime letters — I don't recognize the voice in their diaries, it reads like stylized dialogue from old movies. Now that they're gone I realize that I never knew who they were. We operate in an environment of roles — parent, grand-parent, child, sibling. This is the nomenclature of affiliation and relationship, rather than a description of individual people. John and Molly — two names. What would I have thought of them if we'd been peers and classmates or neighbours? Would I have had any truck with my father? Would I have thought that my mother was one of the hot women in my class? It's

hard to contemplate. Would I have liked them? What were their inner lives? How intelligent were they? Were their secrets interesting? They undoubtedly had some.

A warm, still, summer night in the late '30s. The *Empress of Canada* is rolling across the North Pacific, eastbound for Vancouver. Captain W. J. Kinley has sent word down to his junior officers and cadets: dress in your best tropical whites and get up to the first class lounge to entertain passengers and distinguished guests.

Manuel Quezon, first president of the Philippines, is making passage with his family. John Mitchell enters the elegant two-storey first class dining room with a musician's gallery at the forward end. He sees Quezon's daughter at a table with her family, screws up his courage and asks her to dance. His summer uniform, made up for him by a tailor in Hong Kong, fits perfectly. He's a tall, slim, handsome man with devastating blue eyes. The Quezon girl has golden skin, beautiful arms and dark eyes one could dive into. They foxtrot over the gently humping inlaid floor under the 16-foot ceiling. The *Empress* rolls. The tiny orchestra plays. A soft, warm salt breeze sifts across the room. They connect.

Many days later they reunite on the return voyage. The ship clears for Manila. An invitation is extended

to the junior officer to join the Quezon family for a retreat in the mountains behind the capital. He accepts. He overstays his leave. The *Empress* lies against the wharf in Manila, her fires banked low. The ship waits, the Chinese crew waits and so do the passengers. When 21-year-old John Mitchell shows up at the quay in a state limo he is not reprimanded. CP is anxious to keep landing rights in Manila. No one is going to argue with a Quezon, no matter how young.

The ship's 12 boilers are fired up, releasing superheated steam to her Fairfield compound turbines. Longshoremen release lines from the bollards. Her 19-foot manganese bronze screws begin to churn and the *Canada* pulls away from the wharf. Black smoke huffs out of the two forward funnels — the aft stack is a dummy — and hangs, stretched out like a ribbon in the heat. She swings until only her stern is visible, slowly diminishing, eventually dropping below the horizon as she steams outbound over the curve of the world. The pale, black-haired Canadian boy and the black-haired, honey-skinned, Philippino never see each other again.

The sky is absolutely clear. Its limpid blue and the angle of the mid-afternoon sun betray the time of year — the last few days of summer in late September, 2003. I've stolen off to my small

rock in Georgian Bay for ten days to trudge through my editor's copy of this manuscript. Some of my mistakes are embarrassing — misplaced possessives, dropped punctuation, and a few careless shifts of tense. I'm only slightly comforted when I discover a few slips that even he has missed. I'd hoped to just deal with larger issues.

A light, warm, south breeze raises half-foot waves that sparkle in the sun. For several hours dozens of gulls have been milling about just off shore. Occasionally they're joined by a large, dark, bird. Hawk, osprey, turkey vulture? I've misplaced my binoculars and can't get close enough to tell — I still should know. Even though today's weather is perfect, as will be tomorrow's, we all know that we're waiting for the same thing.

A hurricane is heading north, taking its time — it's not scheduled to arrive for two more days. The birds seem to know it, as do the wasps clinging to my cedar shakes and the last, lost, monarch clinging to the lee side of my only Jack pine. But for my short-wave radio, I'd be as innocent of the future as the rocks and trees.

I don't want to leave. I'll put spring lines on the boats, centre buckets on the floor and let the building shake. I may not be much of a roofer but I know the structure — I drove many of the big nails myself — is sound. I'm reluctant to surrender the last few days of summer and my last chance to make these pages right.

They are now mere digits spinning on my hard drive, 300,000 key strokes building 56,000 words bundled into nearly a thousand paragraphs. As I scroll through them on the screen I'm embarrassed that I'm old enough to still need the feel of paper in my hands. The previous draft covers the table, the floor, two beds and half a dozen press-back chairs. I leave the screen's cold light and begin to gather up paper, working my way down the big room toward the fireplace. I toss the draft onto the grate and light a match. One corner catches and the sheet edge begins to curl. By the time I've retrieved the balance of the book the fire is wrapped around my words. Paper, paintings and my parents corkscrew up the flue.

The gulls have all hunkered down on the lee side of a rocky islet. The big dark bird is gone.

I sit here feeling beaten up by time. My parents are a memory, my sons no longer live with me, and I have a zipper up my chest where my heart has been repaired. I haven't fully accepted it all. I feel only slightly closer to the battered centre of the whole experience — the cancers, strokes, heart attacks and life itself. And I'm still trying to comprehend the drowning. Predictably, one wishes that we all had talked more before all the losses — I don't know who everybody was.

The surprises after death could have enriched life.

It's a late winter early evening. My boys and I are ambling along the Malecón toward Havana's harbour mouth. An outbound container ship clears the ramparts of El Morro. The sweeping beacon of the fort's lighthouse flashes rhythmically across the ship's white superstructure, diminishing as the vessel slips farther and farther out into the dusky Straits of Florida. We turn up the Prado and make for the Parque Centrale, walking past old men on the benches under the big trees lining the boulevard — so reminiscent of the Ramblas. At the park we cut through the arcade toward the top of O'Reilly and then turn down alongside the Floridita and head for the Bar Montserrat. The dusty street, thick with bicycles and bicitaxis, is backlit by cab headlights farther down the block. Strollers and jinateros jam the narrow sidewalks, slowing our progress toward the bar. The doorman helps us slip through the entrance clutch of hookers and we make our way to three stools at the far end of the counter. Mercifully, the band takes a break and the noises of the street — car horns, arguments, along with a background grumble of engines and conversations — rush in through the window grills. It's another hot, wet Cuban night.

We order drinks — both my sons affect cigars. It's been a good ten days. We three have done these

March trips together for years but this time I sense an ending. They're now adults with their own lives. I raise my drink and tell them that this trip was subsidized by money left by my mother. My youngest holds up his glass. The oldest brings up his. "A mojito for Molly," he declaims. We drink. Molly dressed all these women in tight tops and short bottoms — red, aqua, lime-green and purple — working the bar. They've climbed down from her cocktail glasses for the evening. She'd have liked this place. I'd happily buy the drinks.

Past Craigflower Bridge the long gullet of The Gorge bellies out into Portage Inlet, a land-locked extension of the sea. Here the wherry drifts where there is no longer a way forward and no passage out but a swallow at the gut of The Gorge. Just northwest of Christie Point Island, Highway #1 races beside the inlet. At that point Helmcken Road jumps over it on a concrete span, carrying traffic, relatives, the sick, the dying and the bereaved to the blue *H* by the highway, John Mitchell's last berth. A Molly painting still hangs in the lobby.

My sister calls me some eight months after my mother's death. We haven't talked for weeks, each of us busy with our own life. She has just heard that another uncle has died. A retired major general in the Canadian Army and former ADM, he'd had a heart attack at 46 that stalled his career but changed his life. He gave up smoking, relaxed and lived another 42 years. He'd had more brushes with death — a couple more heart attacks and a freak lightning strike while golfing. He'd died having his second bypass operation. Suddenly, in the middle of this conversation, my sister asks me if I think often of our mother.

"Yes," I tell her. "Several times a week I have the urge to call her suddenly dashed by the realization that she is gone."

My sister confesses that she wants to talk to her every single day.

MARRIED IN EAST

Word has been received by the bridegroom's parents, Mr. and Mrs. A.F. Michell, Orchard Avenue, Oak Bay, that their son, Sub Lieut. John A. Mitchell, R.C.N.R., was married to Miss Mary (Molly) Le Geyt Greene, younger daughter of Mr. and Mrs. Lawrence Greene of Toronto and Ancaster, Ont., on May 17 in St. John's Church, Ancaster, in

the presence of the bride's family and a few intimate friends. The service was solemnized by Rev. W.A. Brown, and the organist was in attendance, the church being beautifully decorated with Spring flowers."

— *Times Colonist*, Victoria, May, 1941

F I N I S.

PLATE 21

bell buoy, Desolation Sound

The cover, endpapers and plates 1 through 4, as well as plates 14, 15, 17 and 19 and the bullets on pages 10, 150, 167 and 221 were all made at the Victoria house and studio building in the two days immediately following Molly's death in April 2000. Plates 7, 8, 18 and 21 were all were photographed near Cortez Island, Desolation Sound, during her B.C. funeral in August 2000.

Plates 5 and 6 were made in Ancaster and Toronto in 2004. Plates 9 and 16, both watercolours by Molly Greene Mitchell, were painted in 1941 and 2000 respectively. Plate 11 is courtesy of Elizabeth (Greene) Meuser, Molly's older sister, while my sister Susan Schelle lent the 19th century watercolour of Clement Mitchell as a boy. Plate 13 was made in 1990 at Ottawa for *Saturday Night Magazine*. Plate 10, *A Strange and Freighted Picture*, was made at *Fools Paradise*, painter Doris McCarthy's house and studio in Scarborough, during the summer of 1977 and was part of the 1978 Art Gallery of Ontario exhibition, *Nightlife*. *Coffee In The Morning*, Molly's rebirth as

a white pine, was photographed high on the north-eastern shore of Georgian Bay in July 2004. She is doing well.

The inset "bullet" illustrations have many sources. Most of the drawings are from the dozens of Molly's sketchbooks found in her studio at the time of her death. The only exceptions are the 1929 cartoon of the Greene family and their car, page 237, and the 1905 pen and ink of Georgian Bay on page 243. Both are by her father, Laurence Richard Greene. Molly painted the small, decorated box on page 21 when she was 12.

The image that introduces all the rowing sequences shows the sextant that my father used on the Empresses and while on convoy duty in the 1940s. On page 255 a 1944 photograph captures him shooting the sun with it from the bridge of the Red Deer.

The many photographs of objects inset into the text are the same objects described in the adjacent paragraphs — the Mitchell's kept everything. The 19th-century telescope was Captain Walter Mitchell's and later adopted by John Mitchell. Its barrel is engraved with the names of all the ships they each served on. The bells are as described in the text. The pine box on pages 55 and 59 sequentially held both my parents' ashes. The modified Celtic cross and stag device served as a kind of family crest for generations.

The one used here is taken from the back of a silver hairbrush.

The camera page 81 is the Kodak 828 he used on the ships, as is the violin. The Red Deer's crest appears on pages 63 and 167; the Skeena's on pages 76 and 84. The bullet on page 58 is my father's recording barometer. The Spitzbergen rifle appears on page 45. The Conway castle image on pages 50 and 55 is from the school's uniform belt buckle.

The bullets on pages 28 and 40 are pre-Columbian effigy whistle fragments from Oaxaca. The octagonal women's Rolex belonged to my grandmother, Elizabeth Chapin Greene. "Deceivers and Imposters," "Devil and the Witch" and the final "Finis" are from John Webster's Witchcraft. The toy steam locomotive was my father's childhood toy. The various marine illustrations — compass rose, signalers, and distress flags — are from Captain Walter Mitchell's note book.

A Havana street photographer made the photograph of me and my sons Jake and Ben in 2001. All the keys were Molly's. The B.C. license plate, LEGEYT, is from her last Mini.

A very special thanks to Duncan McLean and Ross Hookway of Waddington's who generously shared their time and digital studio for the creation of all the black and white illustrations in this book.

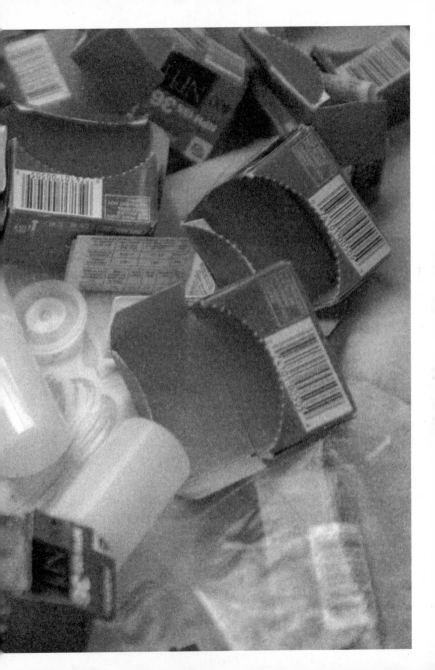